UPLOAD

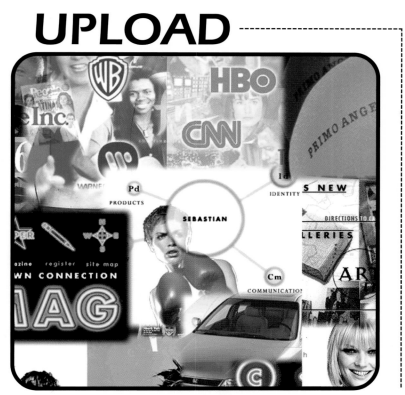

TAKING PRINT TO THE WEB

BOOK
 Design: Daniel Donnelly
 Cover Design: Christian Memmott

CD-ROM
 Design: Interactivist Designs/Daniel Donnelly
 Production: Jerry Garcia
 Web programming: William Donnelly

WEBSITE
http://www.inyourface.com

First published in the United States of America by:
Rockport Publishers, Inc.
33 Commercial Street
Gloucester, Massachusetts 01930-5089
Telephone: (978) 282-9590
Facsimile: (978) 283-2742

Distributed to the book trade and art trade in the United States by:
North Light Books, an imprint of
F & W Publications
1507 Dana Avenue
Cincinnati, Ohio 45207
Telephone: (800) 289-0963

Other Distribution by:
Rockport Publishers, Inc.
Gloucester, Massachusetts 01930-5089

ISBN 1-56496-399-3

10 9 8 7 6 5 4 3 2 1

Printed in Hong Kong by Midas printing Limited.

UPLOAD

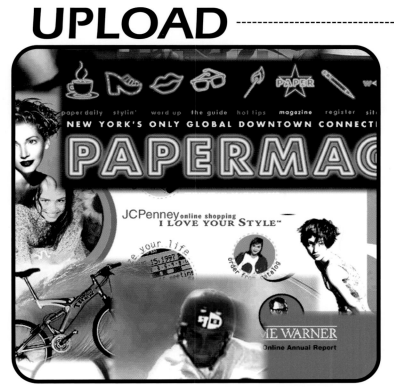

TAKING PRINT TO THE WEB

ROCKPORT PUBLISHERS, GLOUCESTER, MASSACHUSETTS
DISTRIBUTED BY
NORTH LIGHT BOOKS, CINCINNATI, OHIO

CONTE

INTRODUCTION

In the cemetery of good and evil, there lie scribes of the Middle Ages whose beautiful art form succumbed to movable type. Then came the copier, the fax, the computer, and a language called HTML. What leaps to mind is the continual confrontation with change. Most of us—artists, designers, craftspeople—adorn ourselves with garments that signal: "We're flexible" and "We adapt to change." The miserable truth is that we learn our craft too well and fall into a tragic catch-22 situation: the skills, the experience, and the focus that propelled us toward success are also the blinders and tethers that hold us back. Let's take a brief look at some possible occurrences in a transition from "print to Web," a key phrase for this book.

It is my opinion that over time—a short time—a more pure Web experience will take over and subjugate print and paper. In the new world order of nouveau communication, paper will figure as an art form (et papier de toilette). Fewer trees will be cut and bionic "people" will replace the humans you thought you knew. Clean, aesthetically fine imagery will prevail, conveying texture and tapping other senses we rarely use. A variety of vehicles will provide easy access for viewing and transmitting information.

Personally, I love our current models of print products, especially books, magazines, and newspapers. At the moment, the "Web" (the Information Age name that captures the nouveau info-world picture: bionic, Web, cyber, hyper, iber, ic, etc., etc., etc.) is tiring, impersonal, too difficult to read. It doesn't thrill to the touch, but this will change. An extremist in positive thinking, I search for some thread of goodness—no matter how slender—and cling to the universal truth that in the demise of one thing is the tender yet fertile beginning of another.

Website designers come from a huge mixed bag of professions: artists, craftspeople, not-so-crafty people, young designers, old designers, kids, scientists, organized criminals, disorganized criminals, and a variety of near-idiots: anyone can play and display, so what surfaces? Well, it's the same stuff you see on paper, and anyone can participate. Surf and see.

The glaring difference between the limitations of print and the inexpensive global access to the Web is that, over the Web, the entire blue planet can look at our visual yo-yos. Everyone has access to everything, no matter how good or bad—the cheapest thrill in show business. But in this context the more astute print designers and marketers face a number of compromises. Two primary issues are loss of typographic control and slow picture sequencing.

How would you like to ace an extraordinary magazine or book or packaging assignment and realize that only 20 percent of your audience will view it the way you designed it? Many recipients of visual communication have no clue how critical even a slight change in typography, color, or graphic configuration can be to the higher end of visual communication for marketing or entrepreneurial competition, but these changes are significant. Browser text is difficult to manage—you can't control tracking or leading, and the typeface is determined by the user's machine. At this date, the only way to guarantee that your award-winning typography will still look beautiful on the other end is to make an image file, but these can cost you precious download time and are a pain to update. Never daunted by

apparent constraints, designers have come up with some clever tricks for formatting browser type, including using tiny transparent placeholder graphics and spaces between characters.

Page layout is another concern for designers. Because users' machines vary immensely in display capability (e.g., monitor size, screen resolution, bit depth, etc.), a Web presentation developed on a graphic workstation with a 21-inch (53-cm) monitor and 24-bit color will look drastically different on yesterday's Quadra 650 with a 14-inch (35-cm) screen. Bleeds are difficult because Web browsers have a flexible viewing window. Some happy accidents can occur with repeating backgrounds, but most attempts amount to a ten-car pile-up on the Internet Superhighway. Speed, or, more precisely, the lack of it, is the greatest problem the designer faces. I can't express this strongly enough—pages must load quickly or users will leave! Large, complex graphics can take minutes to download. Economy of imagery is a guiding rule.

Publishing a Website is similar to sending out a brochure to be printed on every possible size and surface—from high-gloss magazine stock to newspaper to corrugated aluminum. Fortunately, with the help of faster modems, new HTML formatting capabilities, network languages like Java, and graphic plug-ins such as Shockwave and FutureSplash, designers are gaining more and more control over the appearance and speed of their Web presentations.

So trying to get the same thing out of a Web assignment that one got out of a print assignment has been a major concern for many established designers, but of little concern for the new order—the "new born"—who espouse the most non-readable, non-understandable, dull, boring, and omnipresent visuals in the name of Web formats. However, we are seeing the influences of the designers who also work in print and paper, reversing the order by borrowing Web techniques and applying them to the more avant-garde print media. Here we are witnessing some exciting visual pyrotechnics, an attempt to stretch and squeeze the last few drops out of the rococo era of print before it is relegated to an art form, as scribes, hot lead typesetters, and Linotypists experienced in earlier times.

In closing, and in all fairness to Mr. Donnelly, who selected me to write this introduction, I must confess that, in terms of the computer and the Web, I am more a visionary than a practitioner. Concept-oriented all my life, today I might have been tagged an Attention Deficit Disorder case: I cannot help seeing and acting on one new thought while still in the throes of another. Eventually I have found myself concerned about being a captive of tools, trends, and eras. On the other hand, these tendencies did frighten me into more sober and grand efforts to complete assignments. Frankly, I was always afraid of being stuck with some obsolete tool on a factory assembly line without a mantra to keep me warm and of losing a most precious commodity—objectivity. So, in feeling our way through this new labyrinth of print to Web and Web into the next medium, the key to the maze, I believe, remains the same: how to be the thing and see the thing.

Primo Angeli
Chairman
Primo Angeli Inc., San Francisco

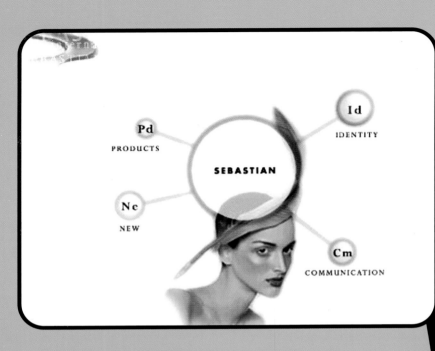

SEBASTIAN INTERNATIONAL

LAND ROVER NORTH AMERICA

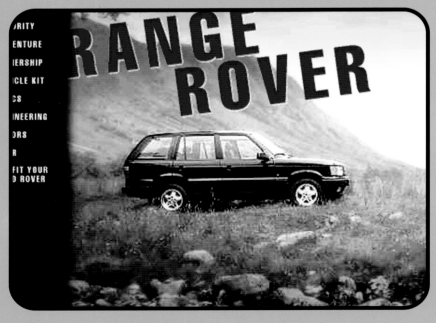

AMERICAN HONDA MOTO

GE WEBSITES S

RGE WEBSITES

C O S M O P O L I T A N
M A G A Z I N E

✓ MENU
───────────────
Models
Photos
Color Your Car
Specs/Features
Safety
Engineering
Get a Brochure
───────────────
Coupe
Sedan
Wagon
───────────────
Drive One Home
Honda Owners
Get to Know Honda
Dealer Locator
Search Engine

J C P E N N E Y
S H O P P I N G

C O .

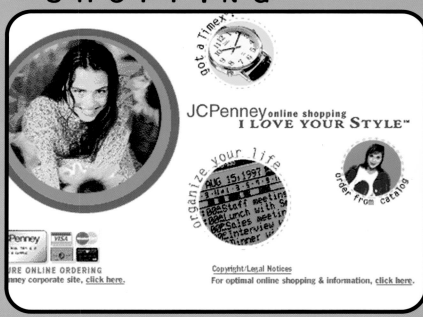

Avalanche Systems, together with Cosmopolitan magazine, undertook the process of designing, marketing, and branding Cosmopolitan for the Web. The designers at Avalanche have produced more than a hundred Websites for well-known clients: Lee Jeans, Vanity Fair lingerie, BMG Entertainment, and Elektra Entertainment Group. ▪ Working closely with Avalanche to design the online resource, Cosmopolitan's editorial team found that there were new challenges involved in designing a Website that they had not encountered while creating their print magazine. ▪ "The biggest challenge was making sure the Website was as clear and accessible as the print version," says Cosmopolitan Executive Editor Catherine Romano. "With the magazine, you read a headline, then the deck, and then the lead or the photo captions. We had to make sure that someone perusing the Website would never be confused. We never assumed that the person would be Web-savvy."

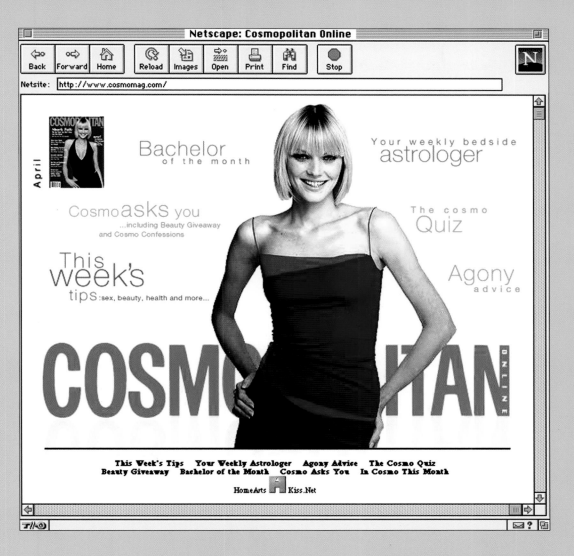

DESIGN FIRM: Avalanche Systems

CREATIVE DIRECTOR: Peter Seidler

DESIGNERS: Andreas Lindstrom, Kendall Thomas

PRODUCER: Katerina Ciani

PROGRAMMER: Craig Zimmerman

COSMOPOLITAN

EDITOR IN CHIEF: Bonnie Fuller

WEBSITE EDITOR: Mark Golin

CREATORS: Bonnie Fuller, Catherine Romano, Keith Blanchard

ART DIRECTORS: Henry Connell, Allison Ward

SITE MANAGERS/EDITORS: Debbie Stoller, Mark Golin

COPY: Holly Troy, Scarlet Fever, Barbara Syro, Andrea Pomerantz Lustig, Hallie Levine, Sarah Feldman, Lori Seto, Wendy Weatherford

TOOLBOX

HARDWARE: Macintosh, Windows PC, Sun workstation

SOFTWARE: Photoshop, GifBuilder, BBEdit

TYPEFACES: Helvetica Neue family

SPECIAL FEATURES: GIF89a animation

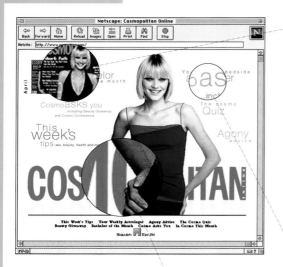

ANIMATION: Each month, the home page features the print magazine's new cover model. To create a small animation of this *Cosmopolitan* cover that loops continuously on the home page, Avalanche used Photoshop and GifBuilder on a Macintosh.

To attain the animated cross-fade of the cover image with the "On Sale Now" text, the designers opened the cover image in Photoshop, set up a series of crops targeting the specific area of enlargement, and then simulated a dissolve by decreasing transparency between several of the frames. They then imported the art into GifBuilder, where they deleted unwanted frames and exported the GIF89a animation.

HEADLINES: The Helvetica Neue type family was chosen for the main headlines on the home page and throughout the site. Pale shades of primary colors were used to give an airy, feminine feeling to the overall design of the Website.

Bachelor
of the month

Cosmo asks you
...including Beauty Giveaway
and Cosmo Confessions

This
week's
tips :sex, beauty, health and more...

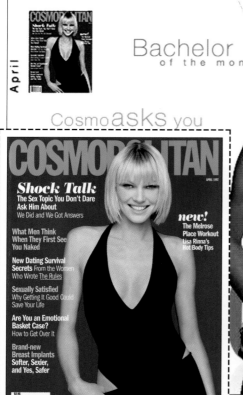

HOME PAGE IMAGE: One of the most interesting and captivating aspects of the Cosmomag.com Website is the use of large images of *Cosmopolitan* models as background JPEGs. Each page showcases a model with type wrapped around the image, or a ghosted background image with HTML text placed on top of the image.

Each online issue of *Cosmo* features an image of the current month's cover model. To add distinction to the online magazine, Avalanche chooses a different image than the one shown on the print version cover. In this example, the model is in a similar pose but wearing a different outfit.

In the initial stages of the home page development, Avalanche realized it needed to create a new online brand. To accomplish this, they reworked the cover logo and featured it at the bottom of the page, rather than at the top, which is the traditional location for most print magazines distributed via newsstands.

COSMO

Are You Holding Out for a Fantasy Man
(or Are You Too Willing to Settle)?

CHOOSING A TYPEFACE: The look and feel of *Cosmopolitan* magazine's current design was created in the summer of 1996 when Editor in Chief Helen Gurley Brown retired and the new *Cosmopolitan* team—Editor in Chief Bonnie Fuller, Creative Director Donald Robertson, and Art Director Henry Connell—put the magazine through a major redesign at the same time they were designing the Website.

One crucial aspect of magazine design is the choice of typeface for body copy and headlines. When deciding on the look for Cosmomag.com, Avalanche had to keep in mind that there would be no advertising to confuse the design issue, and type had to be easily optimized for Web imaging. To find the right typeface, the Avalanche and *Cosmopolitan* designers went through many different typefaces before deciding on the current Helvetica Neue family (below).

TRANSPARENT GIFs: The large background JPEG images used on the *Cosmo* site make it easy to place HTML body text on top of the images, but they can create a problem when bitmapped headlines that change frequently must be placed on top of the backgrounds. To solve this problem, the designers use the PhotoGif plug-in for Photoshop to make the headline graphics transparent GIFs. This allows the headlines to sit on top of an image without blocking it out. An example of this technique can be seen in the "Cosmo Asks You" headline (above left). Notice the slightly rough edges of the type where it has been optimized and made into a transparent GIF.

Cosmo **asks** you

Bachelor
of the
month

Dream Date:

"Going to a museum, then hanging out in a jazz bar."

Nightmare date:

"Going to a fancy restaurant for an

Name:
Christopher Rodriquez
Cranford, New Jersey

Vital Stats:
25 years old
5' 10"
170 pounds

BEDSIDE ASTROLOGER *April*
WHAT THE STARS HAVE IN STORE FOR YOU. BY LYNDA RAY

DIFFERENCES: The typographic contrast between the print and Web editions of *Cosmopolitan* can be seen here in the headings for the print version of "Bedside Astrologer" and its online counterpart, "Your Weekly Horoscope" (above right).

Your weekly
horoscope
March 17 - March 23

The Cosmo Quiz

Plumb the depths of your own personality. Discover truths about yourself even your mother doesn't know.
Dive into this month's four ultra-revealing Cosmo quizzes.

1 How Loyal Are You?

2 Too Comfy With Your Man

3 How Decadent Are you?

4 How good is your judgement

Do you have an idea for a Cosmo quiz?
E-mail us. We'll see what we can do!

How Loyal Are Yo

How Decadent Are You?

COSMO QUIZ

Are You Holding Out for a Fantasy Man
(or Are You Too Willing to Settle)?

Would you recognize good marriage material if he were right in front of you on bended knee? Take this quiz to see if you're setting your sights ridiculously high . . . or pathetically low.
By Mary Ganske

Will only an Adonis do for you?

1 The dinner check arrives, and your date is short on cash. You:
a. Recoil in absolute horror.
b. Pay for dinner—and the movie.
c. Pick up the tab, but if he doesn't fork over some moola next time, he's out.

2 You just found out your new boyfriend has two kids from a previous marriage. You:
a. Fish around to see if he wants more.
b. Ask whether he's considered sending them to boarding school.
c. Spend your free time making fudge.

3 Your boss just axed you along with your entire department. Your significant other:
a. Doesn't return your tearful calls.
b. Immediately picks you up from the office to commiserate over drinks.
c. Drops everything to comfort you. Still, you're pissed that he doesn't bring a "recovery vacation" plane ticket.

4 He kisses like a Labrador lots of slobber, too much tongue. You:
a. Give him a smooching lesson.
b. Immediately find him a new home.
c. Overlook it—he has so many other good qualities to concentrate on.

5 His hair's been thinning the past few months. You:
a. Bail. In your book, bald ain't beautiful.
b. Stick by him. Bruce Willis is way sexier than Fabio any day.
c. Ignore it—and his spare tire.

6 Your new man goes bonkers every time you get together with any of your male friends. You:
a. Think it's sweet. He must really care.
b. Get an unlisted number right away. What'll be next—stalking?
c. Sit him down and reassure him that these guys are just friends.

7 He's been spending a lot of time at his high-stress new job. The best way to deal?
a. Tell him to take an immediate vacation—or you're history.
b. Let it slide—he hates it when you nag.
c. Compromise: You will be more understanding about his long hours if he'll be more responsive at home.

8 Now that you have been living together awhile, you're not having sex so often—though you feel closer to him than ever. Naturally, you:
a. Don't panic. Any relationship has dry spells.
b. Look elsewhere.
c. Hardly notice. You weren't really that physically attracted to him in the first place.

9 He tells you he cannot imagine ever settling down with just one woman. You:
a. Wait a while to see if he changes his mind. If he doesn't come around relatively soon, you'll make tracks.
b. Tell him that you're crazy about him, and if you have to share space, so be it.
c. Figure he's not worth your time. If he were, he'd sacrifice his little black book for you, pronto.

> "A fear of intimacy may be why you set your sights so high."

COLOR: One of the most prominent differences between the print *Cosmopolitan* and the online version is the amount of color and images used on each page. As with all print publications, *Cosmopolitan* must deal with the high cost involved in producing a full-color magazine: color separations, prepress costs, and the paper cost involved with large print runs.

Cosmomag.com, on the other hand, is not constrained by distribution or printing costs, and color is only as expensive as the production time involved with readying art for the Web.

Many Websites are designed around 8-bit color, but Cosmomag.com has a palette that works best in thousands of colors (16-bit). The designers at Avalanche create images with more sophisticated users—and their 16-bit displays—in mind. Then they test them on a 256-color (8-bit) display, adjusting any images that don't adapt well to both palettes.

IMAGES: To flatten the large JPEG images and give them a ghosted feeling, the designers open the original photos in Photoshop, add a white background, and adjust the transparency depending on what is needed to diffuse the image. In some instances they may also need to reduce the saturation. This allows the designers to place HTML text over the images and have the copy easily readable. Reducing saturation also makes it easier to optimize images without a noticeable drop in quality.

COSMO QUIZ

10 **On those crucial first few dates, he should be willing to:**
a. Talk about *anything*, including his most embarrassing moments. How else can you get to know him?
b. Discuss whatever moves him. And if it's the NBA playoffs, well, you're just happy to have a man who'll talk.
c. Tell you a bit about his family, his future plans, and hopes. Anything more would be too much too soon.

11 **You were stuck late at work every night last week. Your mate:**
a. Had you up until midnight cooking dinner—he likes things just so.
b. Took over all the household duties without your even asking.
c. Was thoughtless; he didn't iron and made the most uninspiring meals.

12 Check any of the state-

Dream lover: Is a fantasy your only fate?

number for each item you checked.
a. 3 b. 2 c. 1 d. 2
e. 3 f. 3 g. 1 h. 1

Now count up the number of 1s, 2s, and 3s you've checked—but don't add them together.

Mostly 1s: Beavis and Butt-head Groupie So what if he insists on splitting the check at McDonald's? Since you can't imagine doing any better, you don't bother looking for someone who understands the finer points of romance and intimacy. Unconsciously, you may be trying to re-create an unhappy or deprived childhood, says Alan Entin, a Richmond, Virginia–based psychologist. "People who treat you poorly feel comfortable and familiar," he explains. You may also desperately fear getting hurt, adds psychologist Carl Hindy of Nashua, New Hampshire: "You figure you can't be rejected by someone so pathetic."

So, how to stop reeling in bottom-feeders? Ask your friends and family to help by telling you what they *really* think of the unemployed tattoo artist you've been seeing. "Grill them early in the relationship—when they feel they can be honest," advises Hindy. Should

that fail, consider therapy as a means of figuring out what fuels your loser lust.

Mostly 2s: The Good-Guy Girl You don't demand perfection. If he forgets to put the toilet seat back down, that's okay, as long as he meets more fundamental needs. On the other hand, a man who constantly nags you to lose five pounds won't last long with you—which doesn't mean you'll never compromise for him; if he can't stand your wet panty hose all over the apartment, you'll clean up your act. As for sex, you're realistic enough not to ditch him once the initial thrill is gone. "You understand chemistry counts," says Entin, but also that the key to a long-lasting relationship is friendship."

Mostly 3s: Kennedy Wanna-be Sorry, JFK, Jr., is taken. But given the chance, you'd probably find plenty wrong with *him*. A fear of intimacy may be why you set your sights too high. "You look for a fatal flaw to avoid engaging in a real relationship," says Entin. Or maybe your self-esteem's so low, you subconsciously figure, "If I'm with *him*, people will think I'm worth something." In either case, says Entin, a little self-exploration (alone or with a therapist) may help free you from your quest for the ideal man. In the meantime, advises Hindy, if your head says he's a good guy, give your heart a chance to catch up.

Still Searching

Julia Roberts You need a score-card to follow her string of affairs.

Cindy Crawford has her pick of men but complains she still can't find a decent man.

Liz Taylor Who will be husband number nine?

Drew Barrymore stayed married a month. ■

WARB MARKKOUT

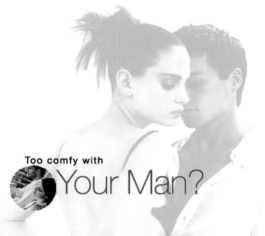

Too comfy with

Your Man?

You're the kind who delights in baring and sharing everything! Could this up-front style be turning him off? Take our quiz -- find out whether the relationship has grown too cozy.

By Carol Weston

Part One
1. You shave your legs:

○ Two or three times a week.
○ Nearly every day.
○ Only during the summer months, when you go bare-legged.

2. Your usual bedtime wardrobe features:

○ Floor-length peignoirs, one or two see-through numbers.
○ Nothing too naughty.
○ Some sweet silks, a few cotton nighties.

3. As for your makeup routine, when he's around, you:

○ Dab some on the minute the alarm clock rings (even wear it to bed on occasion).
○ Makeup? Not you -- you're the original "natural woman."
○ Reserve it for special nights out.

4. He's being his usual passionate, giving self in bed -- but for some reason, orgasm is eluding you. How to finesse?

○ Fake, fake, fake.
○ Admit you may be too tired -- or anxious -- to climax this time around.
○ Joke that you're going to sleep, but he should feel free to continue.

5. The deliveryman arrives with your Chinese take-out. You and your man:

This Week's Tips Your Weekly Astrologer Agony Advice The Cosmo Quiz
Beauty Giveaway Bachelor of the Month Cosmo Asks You In Cosmo This Month

HomeArts **H** Kiss.Net

ANIMATION: Several techniques enhance the overall design of the "Cosmo Quiz" area shown here. The designers created four circular images on the main page that are GIF89a animations. Each animation cycles through four or five images until the user clicks a hyperlink to one of the quizzes.

In order to let viewers quickly recognize where they are, the designers use the same circular images on the secondary pages, in a smaller format.

One nice addition, unavailable in a print magazine, is the CGI scripting on the quiz forms. Once viewers finish taking the quiz, they need only click on the "calculate" button to find out their scores.

COSMO

Pisces

Aquarius

Aries
March 21 - April 19

Taurus
April 20 - May 20

Gemini
May 21 - June 20

Libra
September

Scorpio
October

Sagittarius
November

Capricorn

Your weekly

horoscope

March 17 - March 23

Cancer
June 21 - July 22

Capricorn
December 22 - January 19

Leo
July 23 - August 22

Aquarius
January 20 - February 18

Virgo
August 23 - September 22

Pisces
February 19 - March 20

Sagittarius

Scorpio

Gemini

Cancer

Leo

Libra

Virgo

Cancer
June 21 to July 22

Career

With brilliant Mercury in your job h
you'll slice through challenges like
butter. Expect to accomplish great t
the Moon in your sign on Monday.
natural Cancerian tendencies to try
else's problems rather than focusing
to get done. By Tuesday, the Moon
financial sector and the boss is ama

Horoscope for
Mar. 17 - Mar. 23

WHITE SPACE: Because *Cosmopolitan* magazine is an advertising-supported publication, space is at a premium and departments such as the horoscope section are allotted a specific amount of room, as can be seen from the "Bedside Astrologer" pages shown (below left and bottom). In contrast, one of the larger areas on the *Cosmo* Website is the weekly horoscope (left and above). Each of the twelve zodiac signs has its own page, and models from back issues of *Cosmopolitan* identify each one. The main horoscope page features an image-mapped graphic that links to subsequent pages. Each of the secondary pages then repeats the model image and zodiac illustration. The main images are large, repeating JPEG background graphics that load quickly and take up only 10-16K; the headlines are transparent GIF graphics. Finally, the body copy is HTML text assigned an RGB color that contrasts with the background images, making the text easier to read.

BEDSIDE ASTROLOGER

WHAT THE STARS HAVE IN STORE FOR YOU. BY LYNDA RAY

April

Aries (MARCH 20 – APRIL 19)
CAREER: Midmonth, a major cash craving reawakens your slumbering drive. Work late for lucrative overtime.
LOVE (YOU'RE SINGLE): Playful Sun joins seductive Venus, making you warm and wildly in-demand. *Fill your Filofax.*
LOVE (YOU'RE ATTACHED): Get ready for lusty Mars to ignite passion at month's end.
CONFIDENTIAL TO ARIES: No impulse buys on the 14th—you'll empty your wallet.

Taurus (APRIL 20 – MAY 20)
CAREER: Imaginative concepts win you points with the boss until the 8th.
LOVE (YOU'RE SINGLE): Venus makes many mortal men adore you now. At April's end, your true Adonis will arrive.
LOVE (YOU'RE ATTACHED): From the 16th, he's totally enamored. Start dropping hints for an expensive birthday gift.
CONFIDENTIAL TO TAURUS: Make all important decisions *before* the 15th.

Gemini (MAY 20 – JUNE 20)
CAREER: Hold off on making any major demands from the 19th until May.
LOVE (YOU'RE SINGLE): An affair begun the first week of April is unstable—a more worthy mate turns up on the 29th.
LOVE (YOU'RE ATTACHED): Passions run *very* high around the 15th. Stay indoors.
CONFIDENTIAL TO GEMINI: To smooth over misunderstandings after the 14th, use your clever verbal skills.

Cancer (JUNE 21 – JULY 21)
CAREER: The sun spotlights your accomplishments. Let the lavish praise sink *in*.
LOVE (YOU'RE SINGLE): When Mr. Right enters your social set after the 19th, crack out of your shell and join the group.
LOVE (YOU'RE ATTACHED): He's hooked on you both the first and last week of April. If you must work late, do so midmonth.
CONFIDENTIAL TO CANCER: Carefully check over your tax returns before the 15th.

Leo (JULY 22 – AUGUST 22)
CAREER: You've clever ideas, but have patience: Acclaim is delayed until the 19th.
LOVE (YOU'RE SINGLE): Potential suitors abound on the 2nd and 15th—the perfect days to make your choice.
LOVE (YOU'RE ATTACHED): The 15th, the Moon in Leo turns him into your biggest fan. Get set for total adoration.
CONFIDENTIAL TO LEO: With ruler in sensual Taurus, wear satin under your suit.

Virgo (AUGUST 23 – SEPTEMBER 21)
CAREER: Your ruler Mercury causes technical glitches. In the meantime, check out the techie repairman.
LOVE (YOU'RE SINGLE): A Capricorn may well turn up at month's end.
LOVE (YOU'RE ATTACHED): With Venus in your travel house on the 16th, take off on a lavish, sexy getaway.
CONFIDENTIAL TO VIRGO: On the 19th, think before criticizing at work or the gym.

Libra (SEPTEMBER 22 – OCTOBER 22)
CAREER: On the 21st, your charm makes you highly persuasive. Ask for a raise.
LOVE (YOU'RE SINGLE): As usual, rebels attract you—until the 16th, when Venus enters security-conscious Taurus.
LOVE (YOU'RE ATTACHED): Your house of intimacy is lit up. Sport ultrasensual attire.
CONFIDENTIAL TO LIBRA: Common sense is none too keen on the 22nd: If you must dance on rooftops, wear flats.

Scorpio (OCTOBER 23 – NOVEMBER 21)
CAREER: Take on new challenges until the 19th, when it's back to basics.
LOVE (YOU'RE SINGLE): Best prospects turn up on the 25th: Keep your eyes peeled.
LOVE (YOU'RE ATTACHED): When seductive Venus enters your house of relationships around midnight, let *him* seduce *you.*
CONFIDENTIAL TO SCORPIO: Use magnetism sparingly on the 22nd, unless you want *every* man littering your sidewalk.

Sagittarius (NOVEMBER 22 – DECEMBER 20)
CAREER: Avoid binding agreements until the 27th, when you feel more grounded.
LOVE (YOU'RE SINGLE): Venus makes you a mighty huntress now—a man worth capturing appears on the 28th or 29th.
LOVE (YOU'RE ATTACHED): You're out and about while he's home alone? Hey, spitfire: Invite him to softball practice.
CONFIDENTIAL TO SAGITTARIUS: Book yourself into a day spa at month's end.

Capricorn (DECEMBER 21 – JANUARY 19)
CAREER: Creative ideas reap financial rewards by the end of April.
LOVE (YOU'RE SINGLE): After the 19th, sensible Tauru
Don't comm
LOVE (YOU'RE A
takes over an
to feeding se
CONFIDENTIAL
foreigner tur

Aquari
CAREER: Clear
fore the hor
questionable
21st, wise Ju
LOVE (YOU'RE
sets you up
dling session
CONFIDENTIAL
apologize to

Pisces
CAREER: Moo
you to aspire
and enjoy a *f*
LOVE (YOU'RE
you'll spot M
LOVE (YOU'RE ATTACHED):
don't despai
Prince Char
CONFIDENTIAL
fort to express yourself clearly.

248 For weekly updates of your horoscope, call the **Bedside Astrologer Hot Line** at **1-900-903-7700**. $1.50 per minute. Touch-Tone phone required.

BEDSIDE ASTROLOGER

BY LYNDA RAY

Scoping Him Out
Get inside his head with this cosmic star guide.

Aries CELEBRATE HIS BIRTHDAY. Charming Venus and romantic Sun seduce him into your warm embrace at the beginning of the month. Still, money fights may come up the third week. Prepare for a sexy truce on the 27th. **LOVE DAYS:** 6th, 7th, 28th

Taurus THROW HIM A PARTY. Taurus's birthday celebrations begin on the 19th, when the planetary powers light up his house of personality. He's confident, charming, witty—in other words, totally

Libra BE PLAYFUL. With jovial Jupiter in his house of romance, he's in high spirits. Meanwhile, his ruler Venus in impulsive Aries has him kissing you in very public places. Enjoy the fun while you can; midmonth, Venus moves into security-conscious Taurus. He'd rather seduce you behind closed doors. **LOVE DAYS:** 2nd, 4th, 29th

Scorpio JOIN HIS GYM. No use trying to share in his professional efforts the first half of April: instead, put on some Lycra

MARIAH CAREY: March 27, 1970

BIRTHDAY GIRL

Aries

PUBLIC YOU: Serious Saturn in your sign for the next year attempts to tone down your impulsive nature. Still,

CONTENT: How to deal with large amounts of text and make a page look good has always been a print designer's dilemma, and the Web is no different. Web designers not only need to design around the limited bandwidth of the Internet, but must also deal with viewers not wanting to read large amounts of copy on small monitors that can only display boring, bitmapped text.

Cosmo editors decide on what content to repurpose from the magazine, and what new content needs to be created to be Web-specific. Cosmo.com mitigates viewer fatigue by incorporating only specific departments from the print magazine that can be designed around a small amount of copy without losing their appeal.

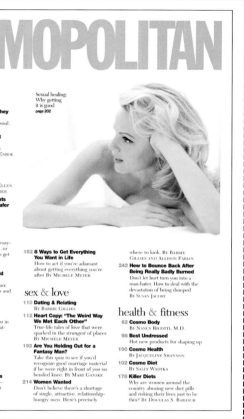

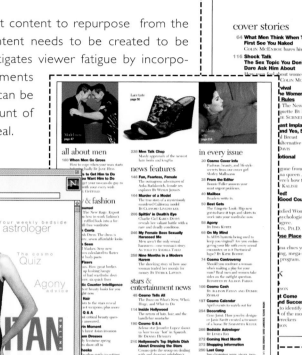

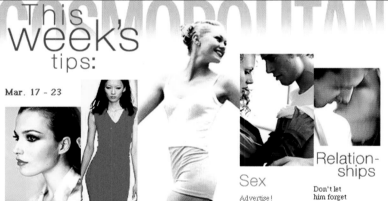

COPY: Short paragraphs in narrow columns, large graphics, and white space make the "Weekly Tips" page (left) a comfortable and quick read for Web viewers.

The minimal text on the home page also allows the design to remain open and uncluttered. In contrast, the print version features a two-page table of contents with tightly leaded text and minimal white space.

A large graphic on the "Cosmo Confessions" page (left inset) and graphic text for the subheads complement the HTML text treatment for the CGI-based forms that Cosmo.com viewers use to submit their confessions to the magazine.

DESIGN: The design of Cosmomag.com was a collaborative process of working with the *Cosmopolitan* editorial staff to determine what would work best online. From the very beginning both Avalanche and *Cosmopolitan* wanted to avoid having a sprawling Website that would be hard to control. "We wanted the branding to be throughout the site," says Peter Seidler, Avalanche Creative Director. "It was really a question of creating an interpretation of the magazine and shifting things in a variety of ways. All of the design elements were created specifically for the Website although *Cosmo* supplied the photos. It's not derived from the magazine; it was designed expressly for the Web, and it was meant to convey and create a new personality for *Cosmo* that was in keeping with their magazine."

How Decadent

Are You?

Find out whether you tilt toward debauchery or self-denial...recklessness or restraint!
By Carol Weston

1. After receiving a gift certificate to an adults-only store for your birthday, you:

○ Cash it in for a garter belt or a box of chocolate-flavored condoms.
○ Send your boyfriend to the shop -- have him pick out a sexy little toy.
○ Bury it in your sock drawer; you like your sex straight up.
○ Spend your next lunch break choosing between a riding crop and velvet handcuffs.

2. How many men have you had sex with?

○ Zero to two
○ Three to five
○ Six to eleven
○ More than a dozen

3. You're glad you have no plans for Saturday; now you can:

○ Curl up with a good book.
○ Curl up with a good man.
○ Invite the girls over for a frittata-and-margarita brunch.
○ Laze in bed reading the paper...maybe head into the office for a little catch-up work.

4. At your engagement party, everybody's watching as you open your presents and unwrap a...vibrator! How to handle?

○ Smirk and move on to the next gift.
○ Pray for the guests to leave soon so you and your man can experiment a little.
○ Laugh and ask if anyone would care to demonstrate.
○ Give a polite thanks.

5. Your boyfriend calls you at the office, suggesting a midday movie. You say:

**This Week's Tips Your Weekly Astrologer Agony Advice The Cosmo Quiz
Beauty Giveaway Bachelor of the Month Cosmo Asks You In Cosmo This Month**

HomeArts Kiss.Net

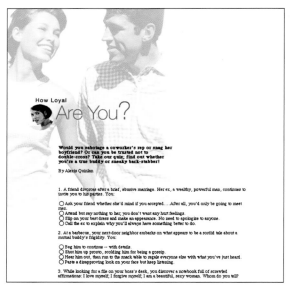

How Loyal

Are You?

Would you sabotage a coworker's rep or snag her boyfriend? Or can you be trusted not to double-cross? Take our quiz; find out whether you're a true buddy or sneaky back-stabber!

By Alexis Quinlan

1. A friend divorces after a brief, abusive marriage. Her ex, a wealthy, powerful man, continues to invite you to his parties:

○ Ask your friend whether she'd mind if you accepted....After all, you'd only be going to meet men.
○ Attend but say nothing to her; you don't want any hurt feelings.
○ Slip on your best dress and make an appearance. No need to apologize to anyone.
○ Call the ex to explain why you'll always have something better to do.

2. At a barbecue, your next-door neighbor embarks on what appears to be a sordid tale about a mutual buddy's frigidity. You:

○ Beg him to continue -- with details
○ Shut him up pronto, scolding him for being a gossip.
○ Hear him out, then run to the snack table to regale everyone else with what you've just heard.
○ Paste a disapproving look on your face but keep listening.

3. While looking for a file on your boss's desk, you discover a notebook full of scrawled affirmations: I love myself; I forgive myself; I am a beautiful, sexy woman. Whom do you tell?

Leo
July 23 to A

🦁 Career

Take it easy o
of emotion and
sector, jealous
cause you to r
raise will be i
brainstorming
your realm of
powerful. Sha
those extra bu
in hypercritica
may lead to ha
trying to help.
room and take
the queenly lio

🦁 Love

You're single.
The Moon in l
tendencies, an
Wednesday. T

Libra
September 23 to

⚖️ Career

Work is invigorating o
coworkers have a lively
Mercury in your house
communications sector
dealings. But as the Su
Thursday, you may fin
plans. Remember, you
calm and don't let then
you'll be glad you did
because the Moon in y
seeds of optimism, and
your vision.

⚖️ Love

You're single.
Your Libran need for s

Horoscope for
Mar. 17 - Mar. 23

**Horoscope for
Mar. 17 - Mar. 23**

Scorpio
October 23 to November 21

 ## Career

You've been thinking about a raise for months, and Monday is the perfect day to ask for it. Supportive Pluto sitting solidly in your house of self-esteem and daring Mercury in your risk-taking realm make you a veritable bulldozer that cannot be denied. Get what you came for, but be careful when it comes to revealing your newfound affluence to coworkers. Sunday's lunar eclipse in your house of secret enemies may make your raise the subject of much discontent.

Love

You're single.
Go to that party on Friday night, but first make a run to the boutique. With three scrutinizing planets in your house of aesthetics, your taste in clothes is exceptional, and whatever you buy will melt hearts at the party. Between the hot dress and your naturally seductive Scorpian powers, any man you meet on Friday will be powerless to resist.

Horoscope for
Mar. 17 - Mar. 23

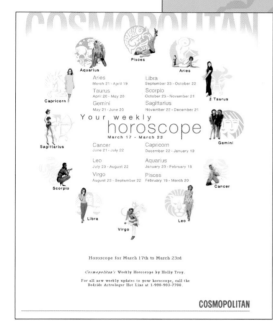

Your weekly
horoscope
March 17 - March 23

Horoscope for March 17th to March 23rd

Cosmopolitan's Weekly Horoscope by Holly Troy.

For all new weekly updates to your horoscope, call the
Bedside Astrologer Hot Line at 1-900-903-7700.

DESIGN: During the design process there was a considerable amount of communication between *Cosmopolitan* and Avalanche. Both teams wanted to make sure the information being placed on the Website would entice viewers to interact with the different areas. "I think the best thing about the Website is that it lets us connect to our readers all that much more," says *Cosmopolitan* Executive Editor Catherine Romano. "There are prompts throughout the Website which give the Web user a chance to give her two cents' worth and ask questions. That's probably the most rewarding part of the whole thing—that it puts us in such close touch with our readers."

Sagittarius
November 22 to December 21

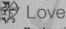 ## Career

Creativity soars when dazzling Mercury, in your creative realm, rouses resourceful Pluto on Monday. Your great ideas will open many new career possibilities. Beware of being duped into doing extra work on Tuesday, when eager Venus and Mars get tangled in your career house. And one last warning: Don't let the Moon in uptight Virgo sour your easygo attitude on Friday. Things are going really well . . . y just don't think they are.

Love

You're single.
With staunch Saturn weighing down your house of lov romance seems impossible lately. But things lighten u on Tuesday, when good-time Mercury in enthusiastic Aries bumps Saturn to the wings. You may be swept o your feet by a Ram man but remember that both you and he are fire signs. The relationship will be passionate beyond belief and have the lifespan of a Roman candle. Enjoy the ride while it lasts - playing

Cancer
June 21 to July 22

Career

With brilliant Mercury in your job house al you'll slice through challenges like a hot k butter. Expect to accomplish great things, the Moon in your sign on Monday. It'll onl natural Cancerian tendencies to try solving else's problems rather than focusing on wh to get done. By Tuesday, the Moon moves financial sector and the boss is amazed by insightful cost-cutting suggestions. But the comes Thursday, when the Sun brings som to your career house. For eight solid hours you touch at the office turns into pure gold

Horoscope for
Mar. 17 - Mar. 23

Love

JCPenney is well-known for catalog shopping. In addition to visiting its stores, customers can browse through the 90,000 items contained in the company's heavy, 2-inch- (5-cm-) thick catalog and fourteen specialty catalogs. Using sophisticated programming, the Web version of the print catalogs offers visitors a creative and dynamic extension of the traditional JCPenney shopping experience. ▪ The site features secure online ordering and several kinds of shopping: shopping from the print catalog; departments, which are the foundation of the site; and collections, which are similar to specialty shops. ▪ "The Website offers viewers a quick and simple way to access JCPenney products online, as well as exposure to special collections," says Senior Art Director Lori Middleton. "Though the Website is a totally different platform than the print catalog, the two mediums complement each other well in their look, feel, and copy."

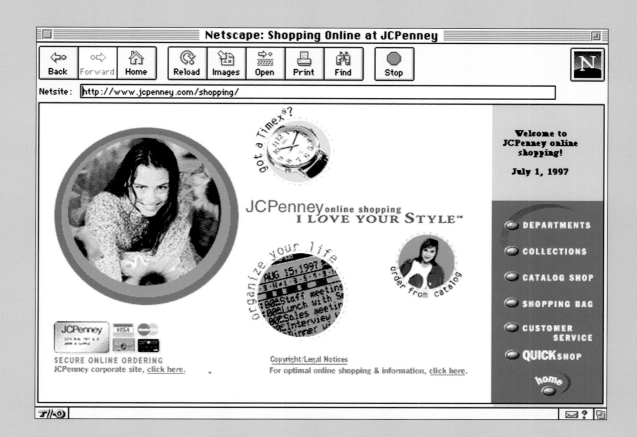

DESIGN FIRM: Modem Media

CREATIVE DIRECTORS: David J. Link, Tom Beeby

SENIOR ART DIRECTOR: Lori Middleton

COPY: Liz Ross

SENIOR PRODUCER: Kate Notman

PRODUCER: Alison Grippo

ACCOUNT DIRECTOR: Craig Lambert

ACCOUNT MANAGER: Michael Lanzi

DATABASE ADMINISTRATOR: Chris Nardone

TECHNICAL ARCHITECT: Brian Campbell

JCPENNEY: Marisha Konkowski, Gwendy Galbraith

TOOLBOX

HARDWARE: Macintosh, Windows PC

SOFTWARE: Photoshop, DeBabelizer, Illustrator, GifBuilder, BBEdit

TYPEFACES: Franklin Gothic, Caslon, Letter Gothic families

SPECIAL FEATURES: GIF89a animation, JavaScript, Electronic ordering

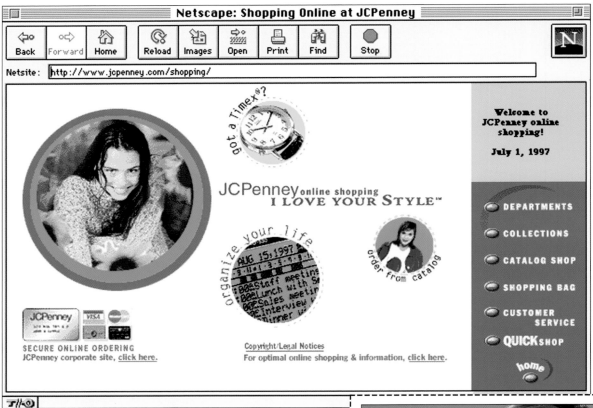

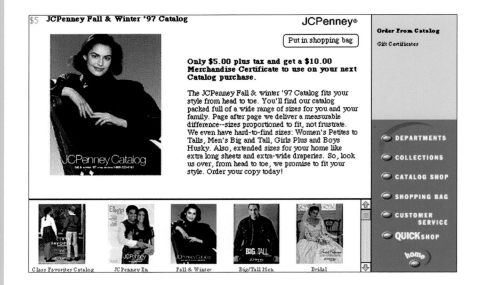

DESIGN: The home page of the JCPenney Website sets the tone for the rest of the site: easy-to-read, easy-to-use, and no waiting. Several elements work together to achieve quick downloads—an artful use of white space; small, highly optimized graphics; and a palette optimized for 8-bit displays. Frames with borders turned off also create a clean design that adds structure to the site without the bulky, gray beveled edges common to the typical page that has a frame.

$35.95 **Timex® Easy Reader® Watch/Mens**

JCPenney®

Men's
Pants
Jeans
Shorts
Tops
Jackets
Swimwear
Sleepwear
Underwear
Dress Shirts/Ties
Accessories/Watches
Gift Certificates

Order From Catalog

[Put in shopping bag]

With Indiglo® night light. Easy-to-read white dials. Water-resistant to 98 feet. Quartz movement. Includes 8-year battery. Gold-tone metal case. Black leather strap. Assembled in the Philippines of parts made in USA and imported from Hong Kong and the Philippines. Movement imported from the Philippines. (1.10 lbs.)

● From our Spring & Summer '97 Catalog, page 278

DEPARTMENTS
COLLECTIONS
CATALOG SHOP
SHOPPING BAG
CUSTOMER SERVICE
QUICKSHOP
home

Timex(R) Easy Pipeline(R)

ANIMATION: GIF89a animations on the home page (middle) profile select products from the catalog. Each animation cycles through three images, while JavaScript rollovers display the promoted price to entice viewers to interact with the site.

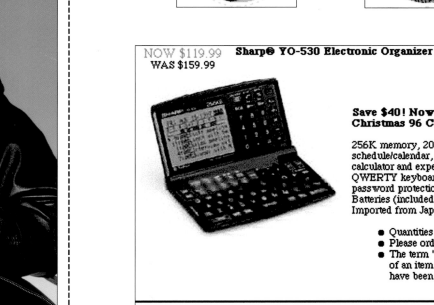

NOW $119.99
WAS $159.99

Sharp® YO-530 Electronic Organizer

JCPenney®

COLLECTIONS
Collectible Toys
Outdoor Living
For Your Home
Graduation
Bridal Apparel
Wedding Gifts
Clearance
Jewelry
 & Watches
Summer Sports
Women's Plus
 & Talls
Gift Registry
Arizona Jean Company

[Put in shopping bag]

Save $40! Now $119.99 (was $159.99 in Christmas 96 Catalog, page 468)

256K memory, 20x8 display. Features schedule/calendar, alarm, memos, phone/address, calculator and expense tracking. Optional PC link. QWERTY keyboard. Confidential data with password protection. Opens flat. Back-lit display. Batteries (included). 5-1/2x3-3/4x3/4 closed. Imported from Japan. (0.75 lbs.)

● Quantities, sizes and colors are limited.
● Please order early to avoid disappointment.
● The term "Was" refers to our first offering of an item. Intermediate markdowns may have been taken.

DEPARTMENTS
COLLECTIONS
CATALOG SHOP
SHOPPING BAG
CUSTOMER SERVICE
QUICKSHOP
home

AT&T Cordless

NASCAR(R) Top

Star Wars

Towncraft(R)

Matchbox

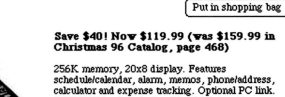

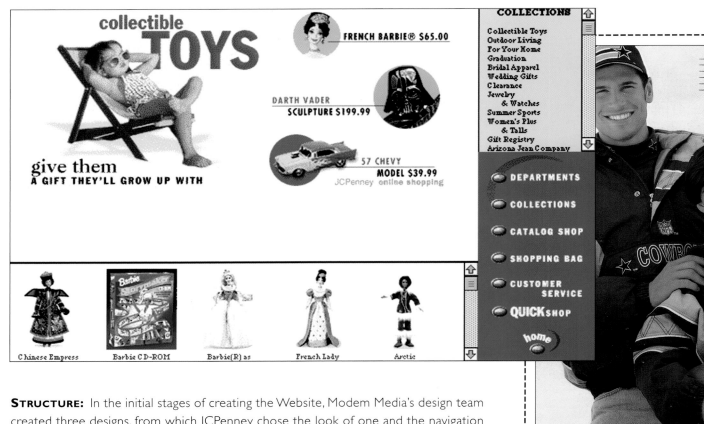

STRUCTURE: In the initial stages of creating the Website, Modem Media's design team created three designs, from which JCPenney chose the look of one and the navigation concept of the other. The navigation structure consists of four main frames, as can be seen in the "Collections" area (shown on these two pages). Each of the main "Collections" pages incorporates a "personality," along with three highlighted products.

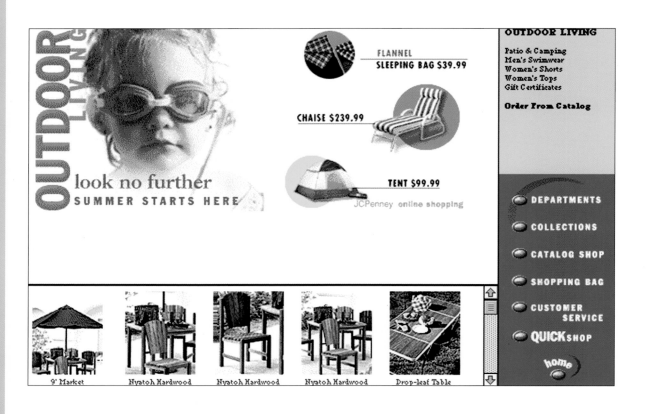

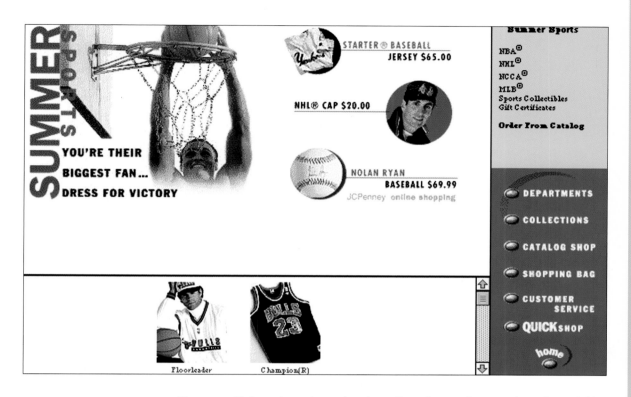

COLOR: Colors throughout the site reflect the products, such as the soft blue of the "Wedding Gifts" header that contrasts well with the couple shown. As the seasons change, the images and colors, as well as products, will be switched out to reflect the current time of year. Each time viewers return to the "Collections" main pages, the three icon images are randomly replaced by three new images. Specific color schemes on the right-hand top and bottom frames allow viewers to keep track of their location.

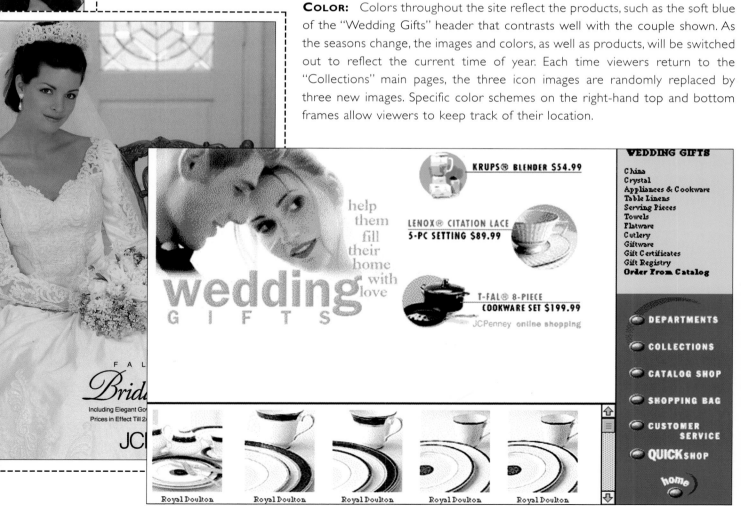

clearance

NASCAR (R) TOP SPEED
JACKET $59.99

HUNT CLUB ®
LEATHER TOTE $49.99

TOWNCRAFT® POLO SHIRT
$12.49 WAS $24.99

JCPenney online shopping

COLLECTIONS

Collectible Toys
Outdoor Living
For Your Home
Graduation
Bridal Apparel
Wedding Gifts
Clearance
Jewelry
 & Watches
Summer Sports
Women's Plus
 & Talls
Gift Registry
Arizona Jean Company

⬤ **DEPARTMENTS**
⬤ **COLLECTIONS**
⬤ **CATALOG SHOP**

G
Also
Husky

Nylon
lining p
easy o
extra i

9.

arm pe
ylon li
elasti

vy;

(18-2

(18-20)

Class Favorites Catalog JC Penney En Fall &

ORDERING: To make searching for products easier, the designers incorporated pop-up menus that let viewers choose from specific departments and items and submit their request. Matching products are then viewed in a horizontal frame (below) that scrolls vertically.

jewelry and **watches**

give a gift
THAT LASTS A LIFETIME

WEDDING SET $185.00

GOLD PINEAPPLE
EARRINGS $239.99

GOLD OVAL HOOP
EARRINGS $239.99

JCPenney online shopping

COLLECTIONS

Collectible Toys
Outdoor Living
For Your Home
Graduation
Bridal Apparel
Wedding Gifts
Clearance
Jewelry
 & Watches
Summer Sports
Women's Plus
 & Talls
Gift Registry

⬤ **DEPARTMENTS**
⬤ **COLLECTIONS**
⬤ **CATALOG SHOP**
⬤ **SHOPPING BAG**
⬤ **CUSTOMER SERVICE**
⬤ **QUICK**SHOP

home

JCPenney®
product search

Every item in the JCPenney internet store is just a click away. Just choose the type of item you're looking for from the 'Items' pull-down menu below. If you want to narrow your search, choose a department from the 'Departments' menu (or leave it on 'NA' if it's not applicable) and then click the submit button. All the items that correspond to your search request will appear on the scrollable item menu to the left. Click on the desired item to display the description, price and ordering information. It's that simple!

Departments: | Mens
Items: | Collectibles

[Submit]

Welcome to JCPenney online shopping!

July 1, 1997

⬤ **DEPARTMENTS**
⬤ **COLLECTIONS**
⬤ **CATALOG SHOP**
⬤ **SHOPPING BAG**
⬤ **CUSTOMER SERVICE**
⬤ **QUICK**SHOP

home

Ken Griffey, Jr Autographed Autographed Famous Player Autographed

Tough nylon shell with fiberfill in sleeves

High front zipper closes to just under the chin

Ken Griffey, Jr
Preschool: 4, 5, 6, 7.
R 414-0448 D...32.99
Boys: S(8), M(10-12), L(14-16), XL(18-20).
State S, M, L or XL.
R 424-1907 D...34.99

boys**4**to**20**
preschool,husky,student

APPARATUS

JCPenney®
product sea[rch]

Every item in the JCPenn[...] [...]y. Just choose the type of
item you're looking for f[...] [...]elow. If you want to
narrow your search, choo[...] [...]nts' menu (or leave it on
'NA' if it's not applicable[...] [...] All the items that
correspond to your searc[...] [...]ble item menu to the left.
Click on the desired item [...] [...]d ordering information.
It's that simple!

Departments:

Items:

[Submit]

N/A - Not Applicable
Boys
Catalogs
Certificates
Electronics
Fitness
Gifts/Jewelry
Girls
Home
Kids
✓ Mens
Sports
Toys
Womens

⬤ **DEPARTMENTS**

⬤ **COLLECTIONS**

⬤ **CATALOG SHOP**

⬤ **SHOPPING BAG**

⬤ **CUSTOMER
SERVICE**

⬤ **QUICK**SHOP

home

Autographed Autographed Famous Player Autographed

PRODUCTS: To create a design framework encompassing the three-thousand–plus products featured on the Website without creating three-thousand–plus pages, Modem Media implemented database technology that dynamically creates and publishes each page on the fly. Modem Media makes all of the changes to the "Collections" areas to keep the design consistent, and its designers created templates for JCPenney staff to use as they remotely update the product areas, adding over two hundred products each month.

shopping bag JCPenney®

If you'd like to come back later and finish shopping, your shopping bag will remain open for another 11 hours and 59 minutes.

Product	Price	Quantity	Size/Color	Total	Remove
JCPenney Fall & Winter '97 Catalog	$ 5.00	1		$ 5.00	☐

[Update] [Empty shopping bag] [Checkout]

To continue shopping online - CLICK HERE.

To buy an item from any current JCPenney catalog - CLICK HERE.

For terms and conditions of service, click here

THE PROCESS

DESIGN: The Web medium challenged the designers to intelligently feature three thousand products chosen to be viewed on the Website, as well as listing the ninety thousand items in JCPenney's nineteen different catalogs. To address this challenge, the designers invoked a concept analogous to a department store.

"The idea behind the online store was to profile the products within the site—that was our number one goal," says David Link, creative director of Modem Media. "We looked at it this way: When you go into a JCPenney store looking for a pair of shoes, you pass by other merchandise on the way and are tempted to purchase other products. We wanted to do the same thing online. Designing the structure of the site with frames, and using the database to offer up accessories, allowed us to entice viewers to browse through other items on their way to purchase that pair of shoes online."

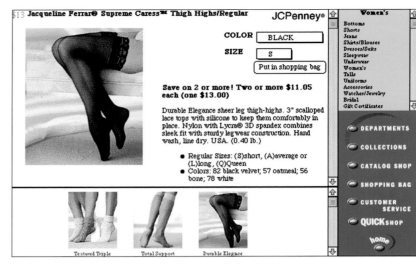

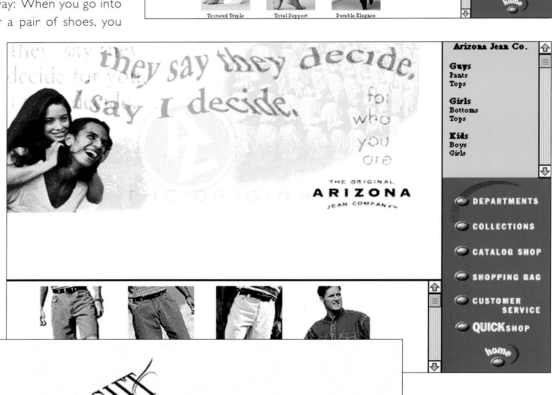

Class Favorites Catalog

JC Penney En
Español Catalog

Fall & Winter
'97 Catalog

Big/Tall Men
Catalog

Bridal
Catalog

Special Needs
Catalog

For Baby
Catalog

Fashion
Influences

Maternity
Collection

Scouts
Catalog

Simply for
Sports Catalog

The Kids Book

Especially for
Talls Catalog

Workwear
Catalog

Uniforms
Catalog

Women 16W & Up
Catalog

Gift Registry
Catalog

J For Style
Catalog

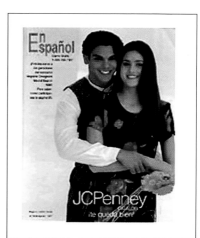

PRODUCTS: Each of the ninety-thousand–plus products within JCPenney's nineteen different catalogs can be ordered through the Website by typing in the product code for the specific item. Software allows viewers to keep track of their selections via the "Shopping Bag" page.

$0 **The Kids Book** JCPenney®

Put in shopping bag

Great apparel for boys, girls, infants, toddlers, and preschool. From dress-up clothes to casual gear, it's all here.

AMERICAN HONDA MOTOR CO.
HTTP://WWW.HONDA.COM

The Honda.com Website shows Rubin Postaer Interactive's clear vision as to what direction Honda's branding should take. This case study of the well-known car company's Website showcases the technology, design, and marketing techniques used to produce the award-winning Website. ▪ Rubin Postaer & Associates has been creating and producing advertising for Honda for more than 20 years; the Honda Website demonstrates the quality the firm puts into its work. "Rubin Postaer has had a relationship with Honda for about twenty years in various forms," says Van Secrist, art director for Rubin Postaer. "I think that is one of our advantages. Unlike a lot of interactive shops, we're not just a bunch of people who got into interactive. We originally came from the advertising side—but we're not solely ad-side. We started with art directors who had a good understanding of the medium and just continued to build on that base. It also helps to have a client who trusts you."

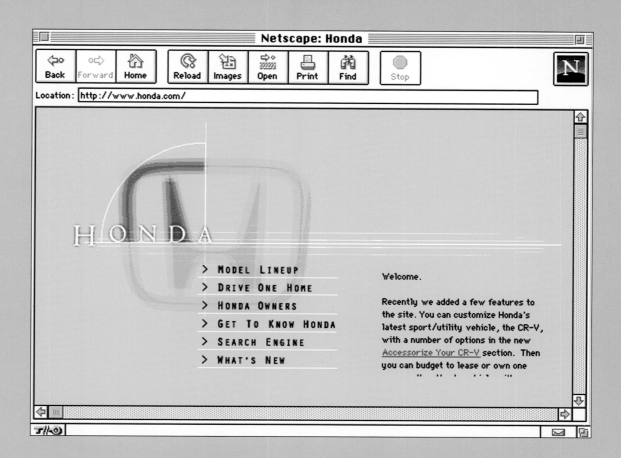

DESIGN FIRM: Rubin Postaer Interactive

CREATIVE DIRECTOR: Tom Roberts

ART DIRECTORS: Brook Boley,

Van Secrist, Luis Ramirez

PRODUCER: Mike Sterner

COPY: Avery Carroll

PROGRAMMER: Andrew Lientz

HONDA: Randy Karahawa

TOOLBOX

HARDWARE: Macintosh, Windows PC

SOFTWARE: Photoshop, Illustrator,

AfterEffects, FreeHand, GifBuilder, BBEdit, PERL5

TYPEFACES: Centaur, Orator

SPECIAL FEATURES: GIF89a animation, JavaScript, Java applets, QTVR

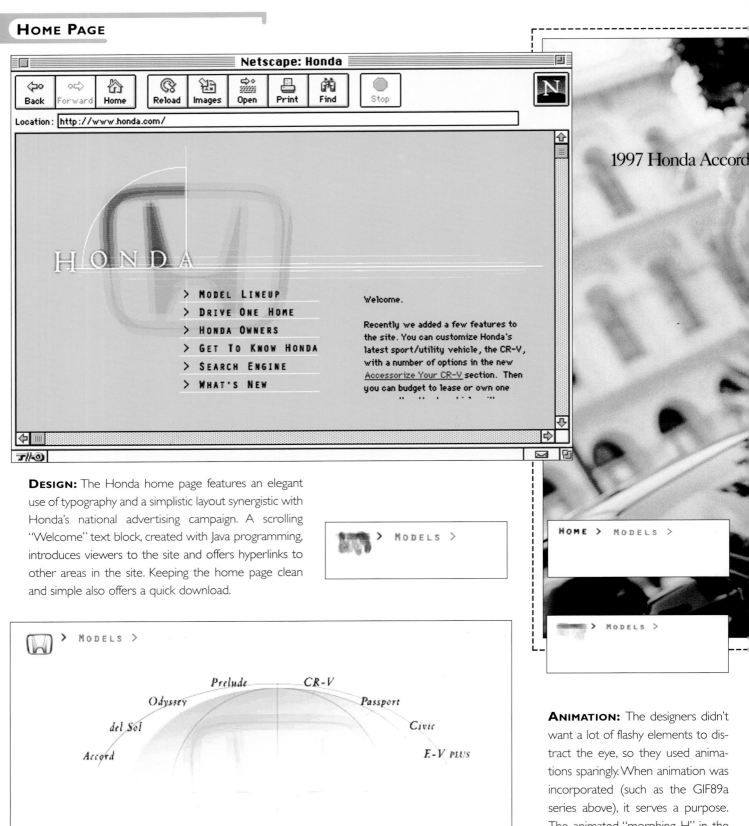

DESIGN: The Honda home page features an elegant use of typography and a simplistic layout synergistic with Honda's national advertising campaign. A scrolling "Welcome" text block, created with Java programming, introduces viewers to the site and offers hyperlinks to other areas in the site. Keeping the home page clean and simple also offers a quick download.

ANIMATION: The designers didn't want a lot of flashy elements to distract the eye, so they used animations sparingly. When animation was incorporated (such as the GIF89a series above), it serves a purpose. The animated "morphing H" in the corner of the pages returns the viewer to the home page and at the same time maintains an onscreen presence for Honda.

PRINT CATALOG: Rubin Postaer's initial design for the Honda Website in 1995 was a strong adaptation of the company's printed catalogs. The design firm liked the first effort but felt the site needed to be more specifically oriented toward the Internet. To make the current site be more of a Honda experience—an inclusive environment—the designers removed all of the scrolling text pages. The majority of the pages were redesigned to fit within a 640 x 480-pixel screen.

To aid viewers in their search for information, the designers implemented pop-up menu bars throughout the site (below). Using pop-up menus also allows the designers to add more white space and work with the overall look of the pages, rather than cluttering them up with scrolling text boxes or multiple navigation bars.

MODEL > ACCORD > CHOOSE A CAR

Accord

Whether it's the roomy and sophisticated sedan, the stylish coupe or the versatile wagon, the Accord stands for how the most advanced engineering and countless

HOME > MODEL > ACCORD >

✓ **CHOOSE A CAR**

Coupe
Sedan
Wagon

Drive One Home
Honda Owners
Get to Know Honda
Dealer Locator
Search Engine

Accord

Whether it's the roomy and sophisticated sedan, the stylish coupe or the versatile wagon, the Accord stands for how the most advanced engineering and countless refinements can result in something that makes your life less complicated.

All information contained herein applies to U.S. vehicles only. Always wear your seat belt.

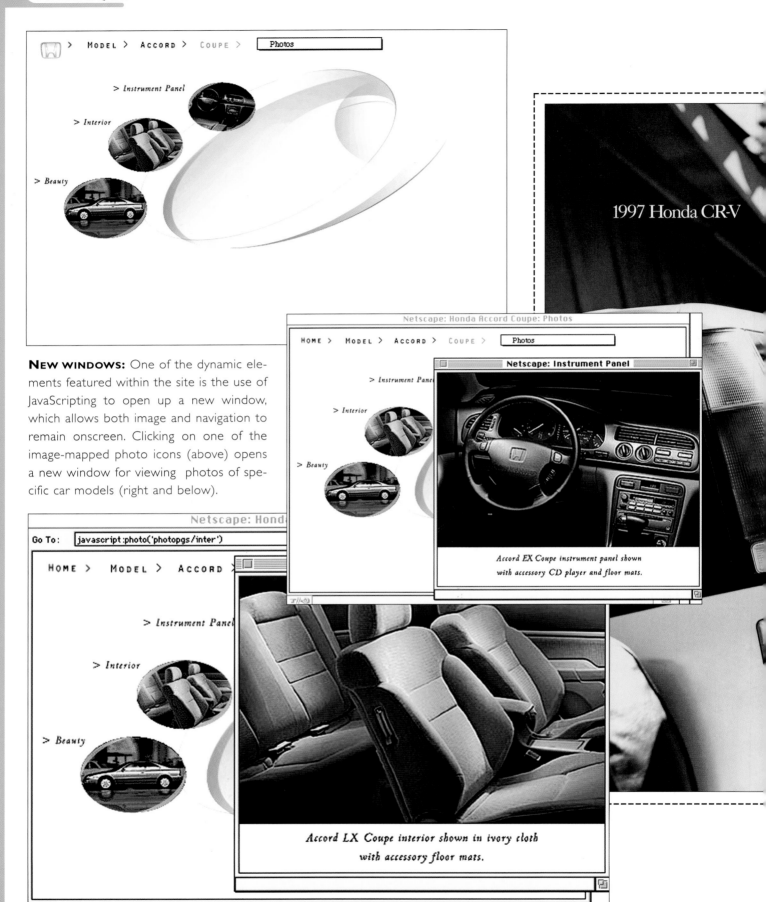

NEW WINDOWS: One of the dynamic elements featured within the site is the use of JavaScripting to open up a new window, which allows both image and navigation to remain onscreen. Clicking on one of the image-mapped photo icons (above) opens a new window for viewing photos of specific car models (right and below).

Accord EX Coupe instrument panel shown with accessory CD player and floor mats.

Accord LX Coupe interior shown in ivory cloth with accessory floor mats.

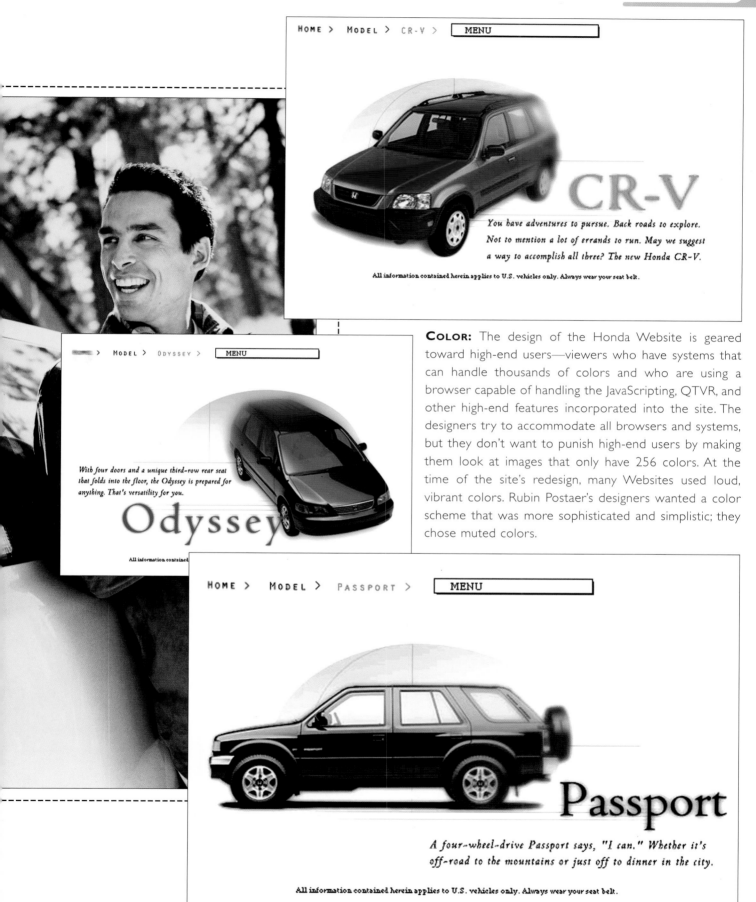

HOME > MODEL > CR-V > MENU

CR-V

*You have adventures to pursue. Back roads to explore.
Not to mention a lot of errands to run. May we suggest
a way to accomplish all three? The new Honda CR-V.*

All information contained herein applies to U.S. vehicles only. Always wear your seat belt.

MODEL > ODYSSEY > MENU

*With four doors and a unique third-row rear seat
that folds into the floor, the Odyssey is prepared for
anything. That's versatility for you.*

Odyssey

All information contained

COLOR: The design of the Honda Website is geared toward high-end users—viewers who have systems that can handle thousands of colors and who are using a browser capable of handling the JavaScripting, QTVR, and other high-end features incorporated into the site. The designers try to accommodate all browsers and systems, but they don't want to punish high-end users by making them look at images that only have 256 colors. At the time of the site's redesign, many Websites used loud, vibrant colors. Rubin Postaer's designers wanted a color scheme that was more sophisticated and simplistic; they chose muted colors.

HOME > MODEL > PASSPORT > MENU

Passport

*A four-wheel-drive Passport says, "I can." Whether it's
off-road to the mountains or just off to dinner in the city.*

All information contained herein applies to U.S. vehicles only. Always wear your seat belt.

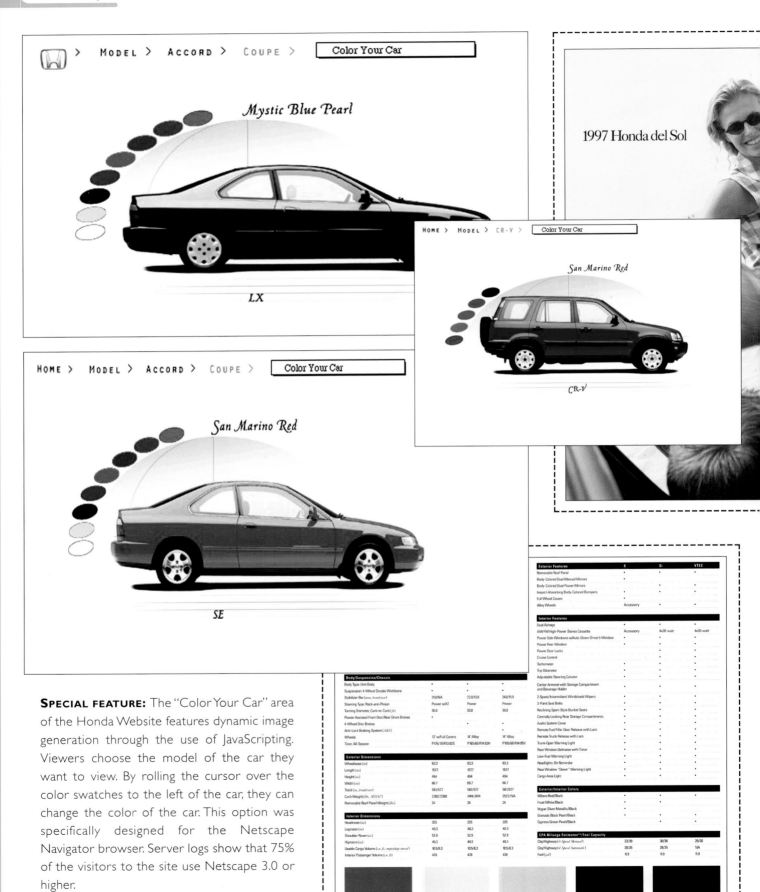

SPECIAL FEATURE: The "Color Your Car" area of the Honda Website features dynamic image generation through the use of JavaScripting. Viewers choose the model of the car they want to view. By rolling the cursor over the color swatches to the left of the car, they can change the color of the car. This option was specifically designed for the Netscape Navigator browser. Server logs show that 75% of the visitors to the site use Netscape 3.0 or higher.

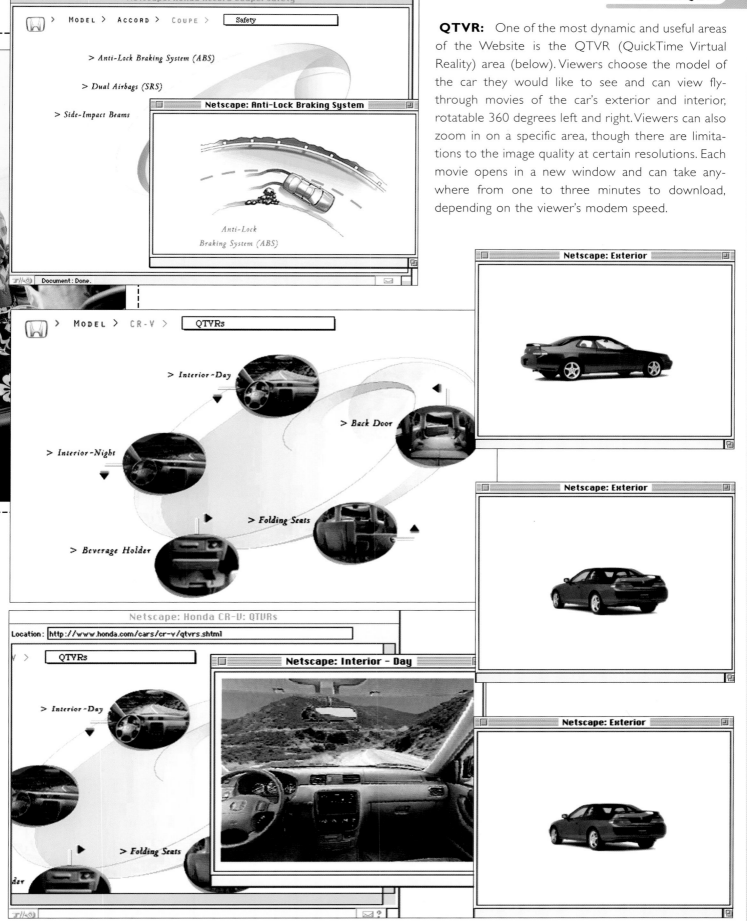

QTVR: One of the most dynamic and useful areas of the Website is the QTVR (QuickTime Virtual Reality) area (below). Viewers choose the model of the car they would like to see and can view fly-through movies of the car's exterior and interior, rotatable 360 degrees left and right. Viewers can also zoom in on a specific area, though there are limitations to the image quality at certain resolutions. Each movie opens in a new window and can take anywhere from one to three minutes to download, depending on the viewer's modem speed.

Netscape: Honda Accord Coupe: Safety

MODEL > ACCORD > COUPE > Safety

> Anti-Lock Braking System (ABS)

> Dual Airbags (SRS)

> Side-Impact Beams

Netscape: Anti-Lock Braking System

Anti-Lock
Braking System (ABS)

Document: Done.

MODEL > CR-V > QTVRs

> Interior - Day

> Back Door

> Interior - Night

> Folding Seats

> Beverage Holder

Netscape: Exterior

Netscape: Honda CR-V: QTVRs

Location: http://www.honda.com/cars/cr-v/qtvrs.shtml

> QTVRs

> Interior - Day

> Folding Seats

Netscape: Interior - Day

Netscape: Exterior

Netscape: Exterior

DESIGN: Before deciding on a new design for Honda.com, the design team used focus groups to assess the existing site—as well as other auto sites—to discover what viewers liked or disliked. The Website is constantly evolving to meet viewer needs.

"We track all of the choices, so we can tell what people like, or what Internet users who visit the site would like to accessorize their CR-V with," says producer Mike Sterner. "It's pretty interesting, because we're getting to the point where we can compare the online data with what people are really buying to get a good assessment of where people are coming from."

> GET TO KNOW HONDA >

> *Honda Racing*
> *Honda Classic*
> *Los Angeles Marathon*
> *Little League*
> *Honda Awards Program*
> *Honda Scholar Athlete Program*
> *Made In America*
> *Acura*

See legal terms and conditions.

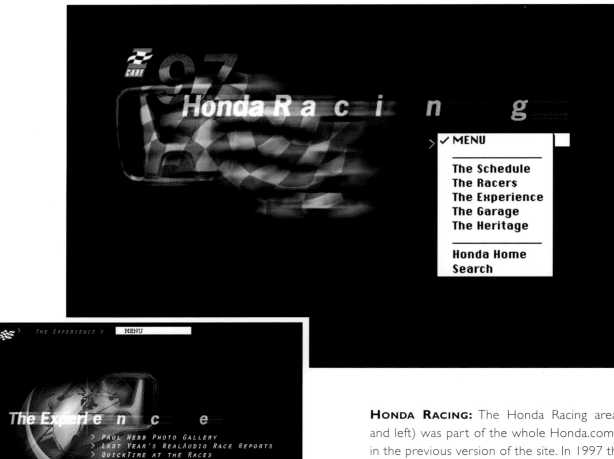

HONDA RACING: The Honda Racing area (above and left) was part of the whole Honda.com Website in the previous version of the site. In 1997 the design firm broke it off into its own site. Modeled after the main Honda site, the Honda Racing area features a darker look with the classic white layout of Honda.com replaced with black backgrounds.

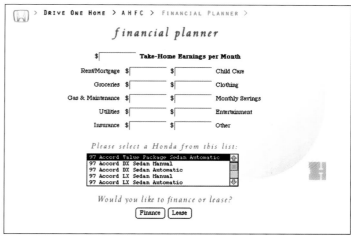

Accord V-6 Sedan

Powerful. Luxurious. The V-6 Sedan is a truly different class of Accord. A solid 170-horsepower V-6 engine provides the power. While an incredibly refined 4-wheel double wishbone suspension system makes the ride extremely smooth. And amenities are everywhere to ensure that one of the smoothest-performing, quietest-riding automobiles in its class is irresistible.

V-6 Power

DESIGN: Throughout the site, pop-up menus serve as the primary navigation tool on the site map (top left and right). For viewers interested in finding out more information about purchasing a Honda vehicle, the designers implemented a "Financial Planner" area (above).

SEBASTIAN INTERNATIONAL

HTTP://WWW.SEBASTIAN-INTL.COM

This case study shows how Blind Visual Propaganda's designers overcame the obstacles involved with creating and maintaining an online catalog and Web experience. ▪ Blind is well-known for its commercial video and movie title designs, and from the look of the Sebastian International Website—the design firm's first full Web project—it won't be long before the name is also synonymous with high-quality Web design. ▪ During the site's initial design stage Sebastian International gave the designers "a ton of literature and brochures" to use for the site, says Christopher Do, creative director. "Sebastian was so new to the Web and the whole concept behind the Web that they just dumped a big box in front of us and said 'Okay, go ahead.' So we spent weeks, maybe even months, going through the stuff with their marketing guys." Finally, the design firm developed a site map that addressed most, if not all, of Sebastian's issues and concerns.

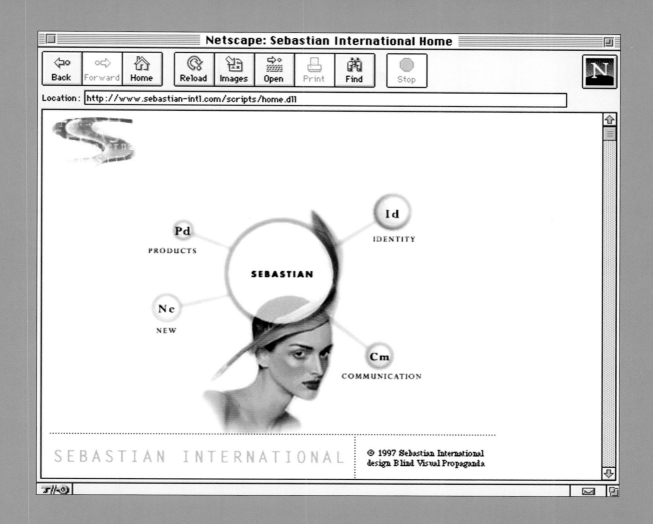

DESIGN FIRM: Blind Visual Propaganda

CREATIVE DIRECTOR: Christopher Do

DESIGNERS: Michelle Dougherty, Jessie Huang

PRODUCER: Rachele Troffer

COPY: Sebastian International

PROGRAMMER: Arthur Do

SEBASTIAN INTERNATIONAL: Jefferey Roy, Steven Muro

TOOLBOX

HARDWARE: Macintosh

SOFTWARE: Photoshop, DeBabelizer, AfterEffects, GifBuilder, Fusion

TYPEFACES: Bell Gothic, M-Bembo, OCR-B, Futura

SPECIAL FEATURES: GIF89a animation, JavaScript

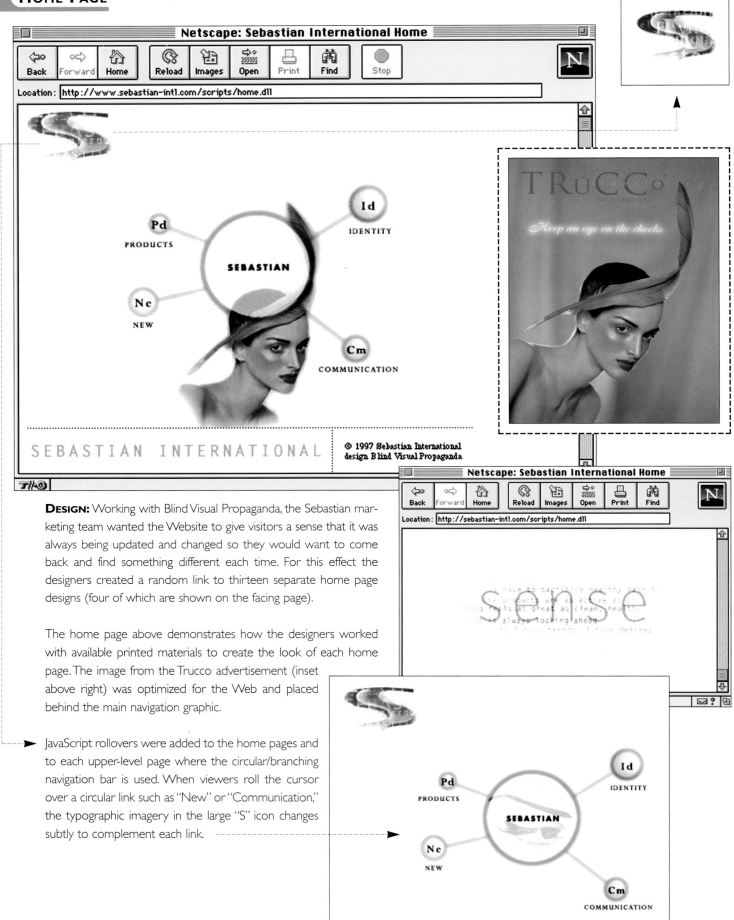

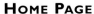

DESIGN: Working with Blind Visual Propaganda, the Sebastian marketing team wanted the Website to give visitors a sense that it was always being updated and changed so they would want to come back and find something different each time. For this effect the designers created a random link to thirteen separate home page designs (four of which are shown on the facing page).

The home page above demonstrates how the designers worked with available printed materials to create the look of each home page. The image from the Trucco advertisement (inset above right) was optimized for the Web and placed behind the main navigation graphic.

JavaScript rollovers were added to the home pages and to each upper-level page where the circular/branching navigation bar is used. When viewers roll the cursor over a circular link such as "New" or "Communication," the typographic imagery in the large "S" icon changes subtly to complement each link.

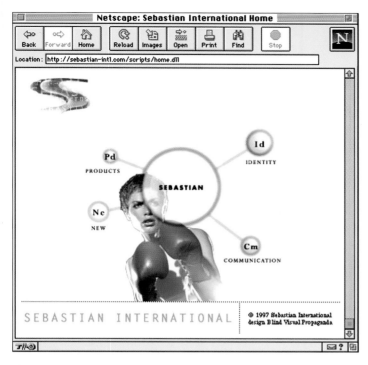

SPLASH PAGE: Blind Visual Propaganda created three separate splash page animations with AfterEffects, taken into GifBuilder, and programmed to randomly load with each new entrance into the Sebastian Website. The animated phrase "Sense the difference" (right and facing page) uses Photoshop's Spherize filter to move the three words in and out consecutively, looping until the viewer clicks to enter the home page.

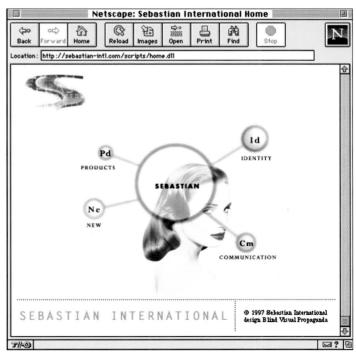

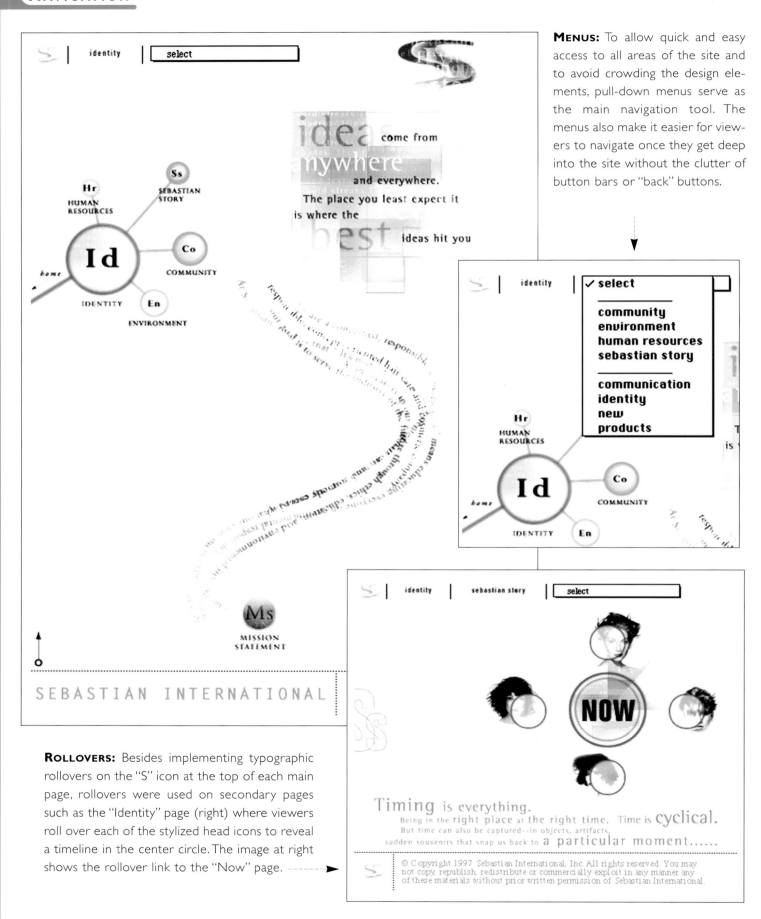

MENUS: To allow quick and easy access to all areas of the site and to avoid crowding the design elements, pull-down menus serve as the main navigation tool. The menus also make it easier for viewers to navigate once they get deep into the site without the clutter of button bars or "back" buttons.

ROLLOVERS: Besides implementing typographic rollovers on the "S" icon at the top of each main page, rollovers were used on secondary pages such as the "Identity" page (right) where viewers roll over each of the stylized head icons to reveal a timeline in the center circle. The image at right shows the rollover link to the "Now" page.

communication | directory | select

To find your closest Sebastian Salon,
fill in the field of your choice below.

(You can make your search
as broad or narrow as you like.)

Zip
Code

Area Code

BEGIN

State Abbr.

cafe society

BROWN

asymmetrical

disconnected cu

RANDO

SHEE

floatatious

solid

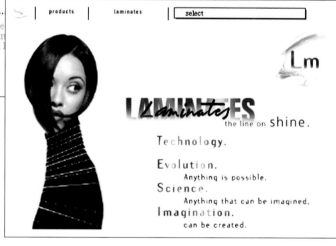

products | laminates | select

LAMINATES *Laminates*
the line on shine.

Technology.

Evolution.
Anything is possible.
Science.
Anything that can be imagined,
Imagination.
can be created.

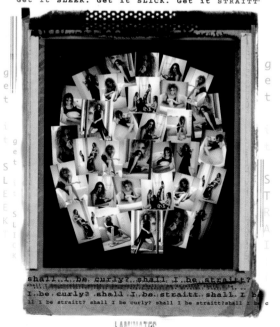

SEBASTIAN

Get it SLEEK. Get it SLICK. Get it STRAITT

shall I be curly? shall I be straitt?
I be curly? shall I be straitt. shall I b
ll I be straitt? shall I be curly? shall I be straitt?shall I b c

Laminates

TYPEFACES: Sebastian International's marketing team
stressed the fact that the look of its printed materials
had to transfer to the Website. To keep consistent with
each campaign, the Web designers researched which
typefaces the marketing team used for the seven dif-
ferent product lines. The typography in each online area
complements the typography in the printed materials.
For example, the "Laminates" printed material features
Template Gothic and Bodega (left), which creates a
technical, modern feel. Accordingly, the designers used
Template Gothic on the Website area (above) to com-
plement the product brochures.

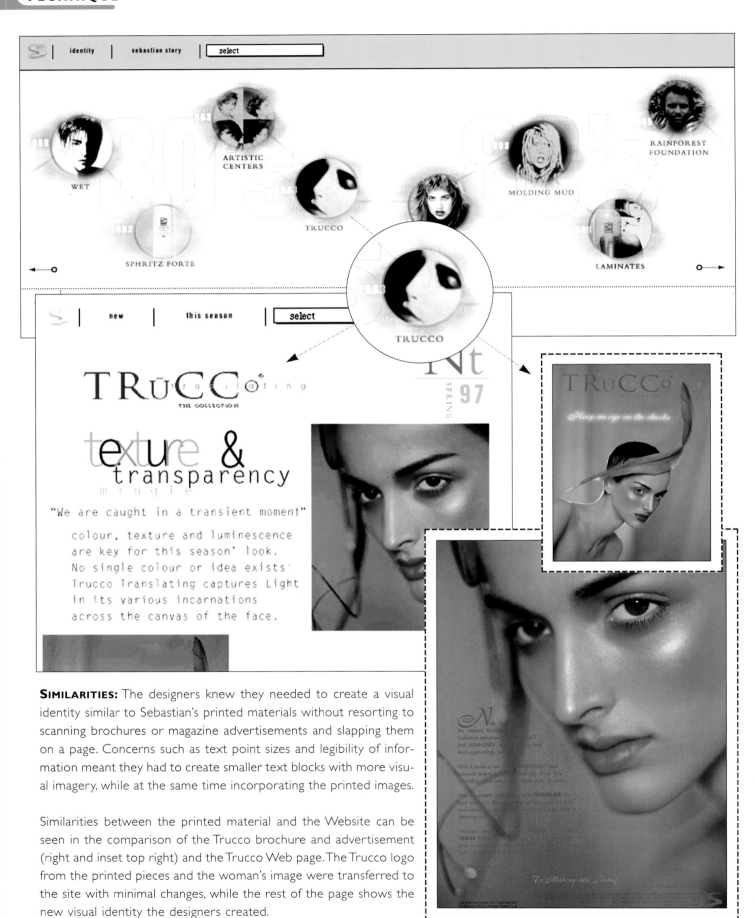

SIMILARITIES: The designers knew they needed to create a visual identity similar to Sebastian's printed materials without resorting to scanning brochures or magazine advertisements and slapping them on a page. Concerns such as text point sizes and legibility of information meant they had to create smaller text blocks with more visual imagery, while at the same time incorporating the printed images.

Similarities between the printed material and the Website can be seen in the comparison of the Trucco brochure and advertisement (right and inset top right) and the Trucco Web page. The Trucco logo from the printed pieces and the woman's image were transferred to the site with minimal changes, while the rest of the page shows the new visual identity the designers created.

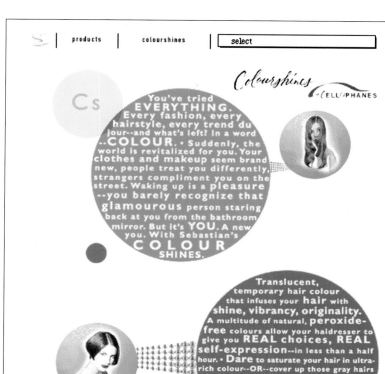

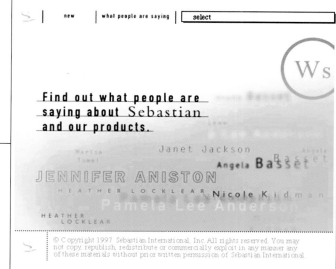

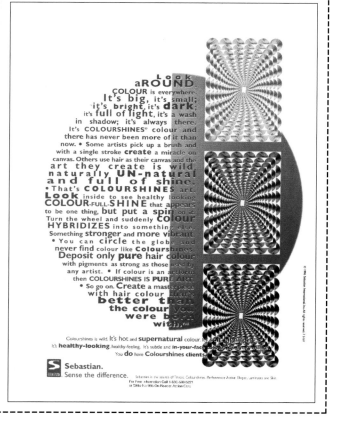

COLOR: As with the typography of the site, the color also needed to match and complement Sebastian's printed materials. "The marketing people," Do says, "kept re-emphasizing that they have a look—they don't even have to put their logo on the page and people will recognize their products through their images." How well the printed look translated to the Website can be seen by comparing the "Colourshines" 5-inch (13-cm) square, three-fold brochure (top right), with the "Colourshines" main Web page (top left). Color, images, and the circular motif of the brochure are echoed in the design of the Web page.

THE PROCESS

DESIGN: Coming from a traditional commercial animation and video background—and having to translate their ideas to the limitations of the Web—required some adjustment for the Blind Visual Propaganda designers. Once the designers realized they were playing by different rules, things fell into place quickly.

"It's a hard thing for us to think in terms of animations being only ten frames," Do says. "Usually, for a commercial, we're doing thirty frames a second and it's thirty seconds. I think there was a little stumbling there. We did it, and everybody was looking at the animation—and of course when they looked at it with Movie Player, it was playing back at light speed. It took a bit of adjustment. We're used to doing full-frame, high-end animations that bleed off the edges and that have tons of color and gray levels. On the Web you can't do full-frame, you can't have images bleeding off the edges, and images need to be ghosted away so they don't leave hard edges in the middle of the screen. I don't think it was terribly difficult, it was just remembering three things: the animation has to loop, it should be quick in how many frames it resolves in, and file size has to be kept small."

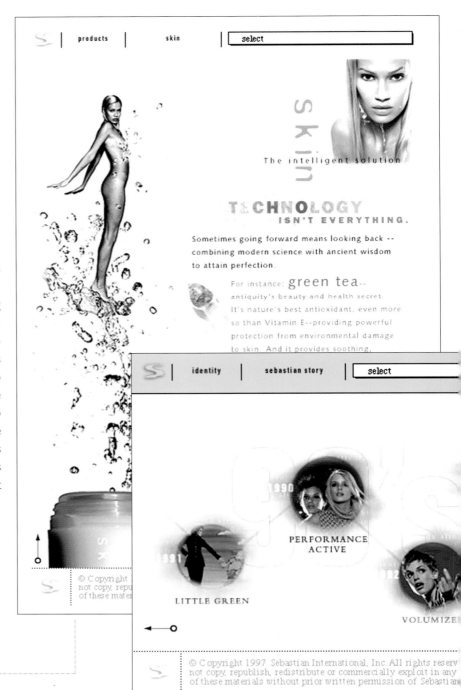

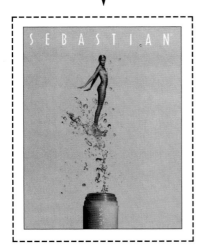

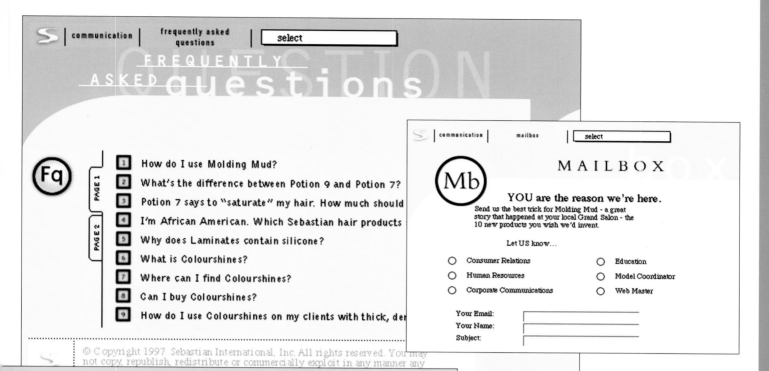

FREQUENTLY ASKED questions

Fq

PAGE 1

1. How do I use Molding Mud?
2. What's the difference between Potion 9 and Potion 7?
3. Potion 7 says to "saturate" my hair. How much should

PAGE 2

4. I'm African American. Which Sebastian hair products
5. Why does Laminates contain silicone?
6. What is Colourshines?
7. Where can I find Colourshines?
8. Can I buy Colourshines?
9. How do I use Colourshines on my clients with thick, de

MAILBOX

Mb

YOU are the reason we're here.

Send us the best trick for Molding Mud - a great story that happened at your local Grand Salon - the 10 new products you wish we'd invent.

Let US know...

○ Consumer Relations ○ Education
○ Human Resources ○ Model Coordinator
○ Corporate Communications ○ Web Master

Your Email: _____
Your Name: _____
Subject: _____

TEXTURIZER

COLOURSHINES

Hs SPRING 97

Random
Disconnected cuts
A-symmetrical
20's Bobs
On the Slant

SEBASTIAN

1997 PROMO GUIDE

To enhance Landrover.com, members of the Adjacency design team went on a six-day, back-country, off-road adventure in the Colorado Rockies to shoot original video and photography for the site, and also to get a feel for the product. This project demonstrates Adjacency's expertise in marketing a well-known brand while offering visitors to the site a dynamic and useful Web experience. ▪ The Website features leading-edge programming and design that takes a departure from the elegant Land Rover North America brochures and explores the more rugged aspects of the brand. "What we were trying to do with the Website, with Land Rover's encouragement, was explore different aspects of the brand," says Andrew Sather, Adjacency's creative director. "We wanted to go with something that looked as durable and gutsy as the vehicles themselves." ▪ To create the site, Adjacency designers explored all aspects of Land Rover's marketing and branding, giving viewers an in-depth look at the vehicle manufacturer's products.

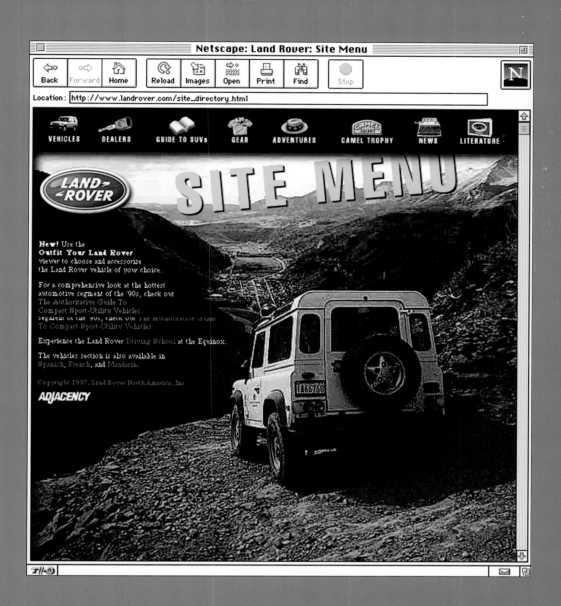

TOOLBOX

HARDWARE: Macintosh, Windows PC,
Canon Hi-8 video camera, Agfa Arcus II scanner

SOFTWARE: BBEdit, Photoshop, Illustrator

TYPEFACES: Helvetica Family

SPECIAL FEATURES: GIF89a animation, JavaScript, Java applets, Screensavers

DESIGN FIRM: Adjacency

CREATIVE DIRECTOR: Andrew Sather

DESIGNERS: Bernie DeChant,
Andrew Sather, Pascal

PRODUCER: Bernie DeChant

COPY: Chris Marchand (Land Rover North America),
Coyne Communications, Andrew Sather

PHOTOGRAPHY: Coyne Communications,
Corey Radlund ("Outfit Your Land Rover")

SALES LITERATURE DESIGN: Coyne Communications

ADVERTISEMENTS: Grace & Rothschild Advertising

PROGRAMMERS: Anton Prastowo,
Matt Kirchstein, Carlo Calica

LAND ROVER CONTACT: Chris Marchand

TECHNOLOGY: The philosophy at Adjacency is "Technology must serve design and communication." Knowing that technology for technology's sake can be counterproductive, Adjacency designers chose not to include animation on the home page of the Land Rover site. The designers instead implemented a large background image of a Land Rover vehicle to capture and hold the viewer's attention. This large background image is a design technique that is repeated throughout the upper-level pages of the site.

A splash page greets visitors to the site offering "enhanced" and "lite" versions of the Website, and letting viewers know the best system configuration for viewing the site.

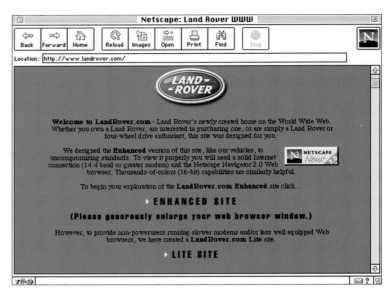

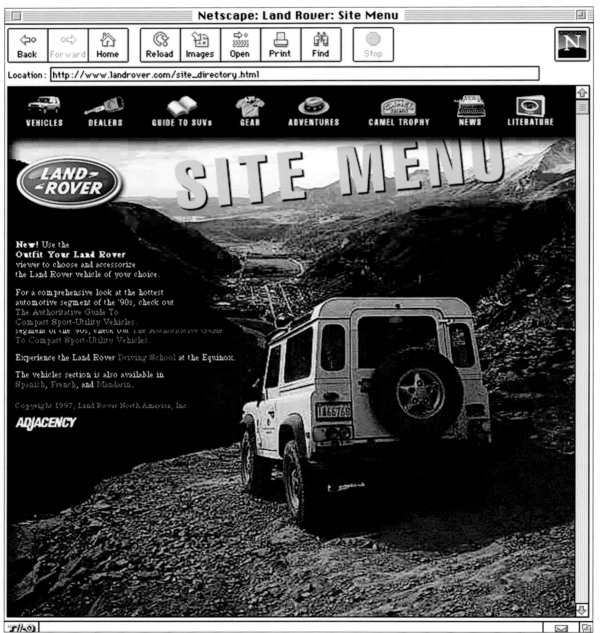

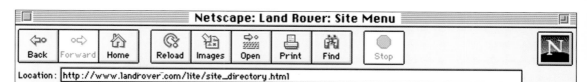

Netscape: Land Rover: Site Menu

Back | Forward | Home | Reload | Images | Open | Print | Find | Stop | N

Location: http://www.landrover.com/lite/site_directory.html

SITE MENU

LandRover.com is your source for updates from the 18th annual Camel Trophy Adventure, taking place from May 13-31, 1997.

For a comprehensive look at the hottest automotive segment of the '90s, check out The Authoritative Guide To Compact Sport-Utility Vehicles.

Experience the Land Rover Driving School at the Equinox.

New Screen Savers!
The Camel Trophy '96 screen saver highlights what many consider the most challenging off-road event in the world, and the Great Divide Expedition screen saver features images from one of three Land Rover Adventure Outfitters trips in Colorado's Rocky Mountains.

Lease a Discovery for $395 a month!*

The vehicles section is also available in Spanish, French, and Mandarin.

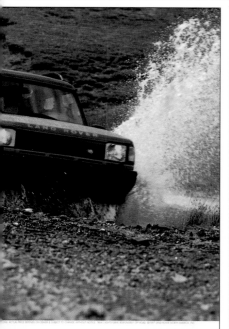

Site Menu // Vehicles // Dealers // Guide to SUVs // Camel Trophy // Gear // Adventures // News // Literature

Copyright 1997, Land Rover North America, Inc.

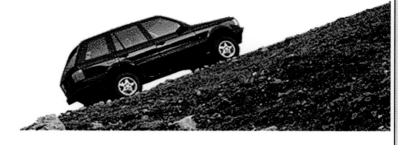

VEHICLES

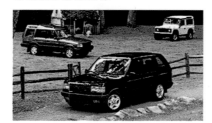

All Land Rover vehicles - the refined **Range Rover**, the adventurous **Discovery**, and the rugged **Defender 90 Station Wagon** - are designed to provide the best balance of off- and on-road handling.

New! Limited-edition Land Rover vehicles are now available. Discovery XD, Range Rover 4.6 HSE with The Kensington Interior, and Range Rover 4.6 HSE Vitesse.

A letter to all dual airbag Land Rover owners.

LITE VERSION: The "lite" version of the Land Rover Website (right) offers viewers with slower connections a chance to get to the information without waiting for long downloads. In this version the large background images are removed. Visitor traffic to the site shows that, in the course of a year, use of the "lite" site has dropped and there has been a corresponding increase in use of the "enhanced" version.

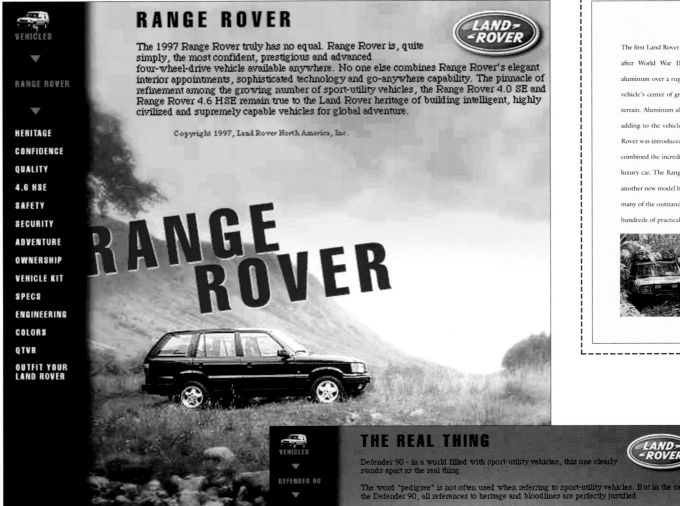

RANGE ROVER

The 1997 Range Rover truly has no equal. Range Rover is, quite simply, the most confident, prestigious and advanced four-wheel-drive vehicle available anywhere. No one else combines Range Rover's elegant interior appointments, sophisticated technology and go-anywhere capability. The pinnacle of refinement among the growing number of sport-utility vehicles, the Range Rover 4.0 SE and Range Rover 4.6 HSE remain true to the Land Rover heritage of building intelligent, highly civilized and supremely capable vehicles for global adventure.

Copyright 1997, Land Rover North America, Inc.

VEHICLES

RANGE ROVER

HERITAGE
CONFIDENCE
QUALITY
4.6 HSE
SAFETY
SECURITY
ADVENTURE
OWNERSHIP
VEHICLE KIT
SPECS
ENGINEERING
COLORS
QTVR
OUTFIT YOUR
LAND ROVER

The first Land Rover vehicle was introduced
after World War II. Its lightweight bod
aluminum over a rugged steel frame, a feat
vehicle's center of gravity and improved its
terrain. Aluminum also proved to be very re
adding to the vehicle's growing reputation
Rover was introduced to rave reviews of aut
combined the incredible off-road prowess of
luxury car. The Range Rover opened a new
another new model began to take shape on
many of the outstanding rugged features of
hundreds of practical features that had been
 losing any of
 become the
 adventure tr
 commitment
 of a Land R
 anticipate alr

COLOR: The initial designs Adjacency created for the Land Rover site complemented the existing print brochures. Land Rover liked the look, but wanted the design firm to explore the more adventurous aspects of the brand. The final version of the design features some of the rugged, off-road safari-ish color themes and elements of the brand's heritage—exemplified by the use of earth tones throughout the site.

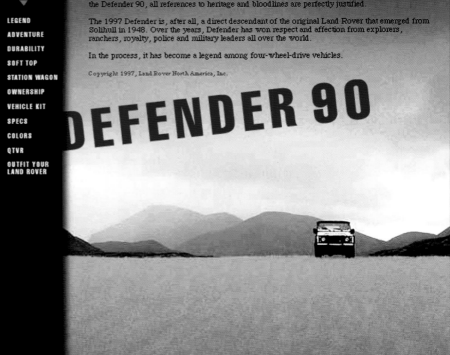

THE REAL THING

Defender 90 - in a world filled with sport-utility vehicles, this one clearly stands apart as the real thing.

The word "pedigree" is not often used when referring to sport-utility vehicles. But in the case of the Defender 90, all references to heritage and bloodlines are perfectly justified.

The 1997 Defender is, after all, a direct descendant of the original Land Rover that emerged from Solihull in 1948. Over the years, Defender has won respect and affection from explorers, ranchers, royalty, police and military leaders all over the world.

In the process, it has become a legend among four-wheel-drive vehicles.

Copyright 1997, Land Rover North America, Inc.

VEHICLES

DEFENDER 90

LEGEND
ADVENTURE
DURABILITY
SOFT TOP
STATION WAGON
OWNERSHIP
VEHICLE KIT
SPECS
COLORS
QTVR
OUTFIT YOUR
LAND ROVER

HERITAGE

The name Land Rover conjures up romantic images of African safaris and global expeditions. Indeed, these tough and versatile vehicles have long been the choice for explorers, farmers, royalty, police and military organizations worldwide. When it is important to get through, the task invariably has been given to a Land Rover. Assuring that Land Rover products meet their unique expectations requires more than superior design, technology and testing. It demands a clear dedication to a set of guiding principles we call the Land Rover Marque Values: Individualism... Authenticity... Freedom... Adventure... Guts... Supremacy.

...st ...m ...he ...gh ...n,

...n 1970, the sophisticated and elegant Range ...s and global explorers. Here was a vehicle that ...h the traditional refinement of a conventional ...d that continues today. ✤ By the mid-1980s, ...wing boards. It was the Discovery. It retained ...inal Land Rover, but broke new ground with ... four decades of global exploration. Without ...mble Land Rover heritage, the Discovery has ...cle in the world for relaxed and comfortable ...d Rover is built with an uncompromising ...sign and manufacturing quality. Every system ...re-tested during the development process to ...er's needs.

TYPOGRAPHY: Land Rover's print material tends to use serif faces, serif headlines, and script initial caps, but Adjacency designers wanted to use a more durable-looking and readable typeface for the Website. Helvetica Compressed Bold is the main typeface used throughout the Website; headlines are set at an angle on each of the main intro pages, and the angles are used on subsequent pages for continuity. "Something like a headline can and should be as expressive as you need it to be," Sather says.

HTML TEXT: Knowing that legibility and ease-of-use are essential to a Website, the designers tried to keep HTML text clean and formatted within tables. The Range Rover "craftsmanship" page (right) shows Adjacency's use of text blocks in table cells for large areas of HTML text.

VEHICLES
▼
RANGE ROVER
▼
HERITAGE
CONFIDENCE
QUALITY
4.6 HSE
SAFETY
SECURITY
ADVENTURE
OWNERSHIP
VEHICLE KIT
SPECS
ENGINEERING
COLORS
QTVR
OUTFIT YOUR
LAND ROVER

CRAFTSMANSHIP

Drivers are especially well catered to in a Range Rover. The steering wheel offers tilt and telescopic adjustments to fit your individual posture. The instruments are large and easy to read at a glance, and are supplemented by a Message Center that can display up to 150 different messages. Driver visibility is enhanced by electrically heated front and rear windshields as well as heated external mirrors. To assist in parking, the outside mirrors also tilt downward when Reverse gear is selected. High-pressure headlamp washers and individual wipers are provided for good night time visibility, even when the weather turns bad.

RANGE ROVER

Range Rover is an extraordinarily comfortable method of global travel. Supremely supportive leather-clad seats offer convenient power adjustments, plus two-person memory for driver *and* front-seat passenger. The remote entry system can be pre-programmed to adjust the driver's seat and outside mirrors to your selected settings when the door is unlocked. And to take the chill off cold winter mornings, the front seats -- both cushion and backrest -- are electrically heated.

For occupant comfort and a proper fit, the front and rear seatbelt anchorages are easily adjustable for height, and all head restraints are adjustable (those in front are power adjustable). Leg room is abundant, and the cargo area behind the rear seats is spacious and, of course, practical. The cargo area can be further expanded by folding the 60/40 split rear seat. The full-size spare tire doesn't interfere with Range Rover's load capacity, as it is out of the way in its own well under the cargo area.

R ange Rover interiors possess an ambience that is both comfortable and functional. Leather-trimmed seats provide proper support for driving down the interstate or across a mountain ridge. The heated front seats offer ten-way power adjustment and two-person memory. More than simple style, Range Rover's quality and craftsmanship will endure through years of ownership.

A center console box offers easy access to stored sundries and provides a patented tray capable of holding up to four beverages. Range Rover's climate control system includes automatic temperature control and individual settings for the driver and front passenger. A refreshing 10° F difference can be accommodated side-to-side. A special pollen filter reduces the likelihood of dust particles, pollen and odors reaching the interior. All four power windows offer one-touch open operation. The front windows and power sunroof feature one-touch open and close. And for added safety with children, an anti-trap function is incorporated into all of these power conveniences.

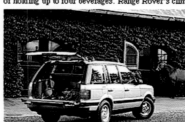

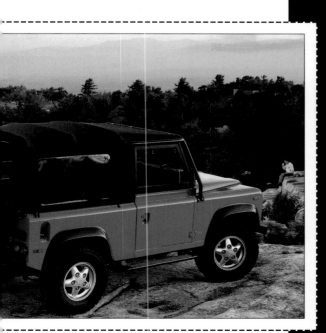

SIMILARITIES: One of the most dynamic areas of the Land Rover site is the "Outfit Your Land Rover" area, where viewers can choose from three Land Rover models and outfit them with various accessories.

To create an illusion of depth and distance within the "Vehicles" main page (below), the designers featured three models on a white background, at different angles and sizes. To add additional depth, the image of the model closest to the viewer bleeds off the right side of the page.

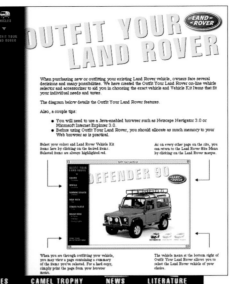

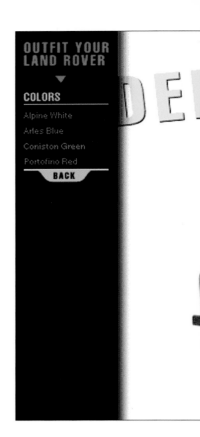

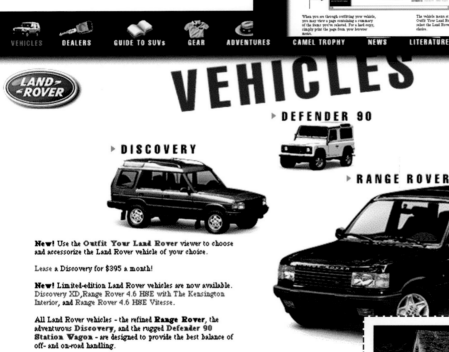

IMAGES: Repurposing images from print to the Web can be time-consuming and complicated. The three images on the main "Vehicles" page (above) were manipulated and edited out of a group photo taken in a grassy pasture. To ready the images for the Web, the designers first had to open the group image in Photoshop and remove the grass obscuring the tires, clean up reflections on the windshields, and remove other incidental reflections that showed the natural setting.

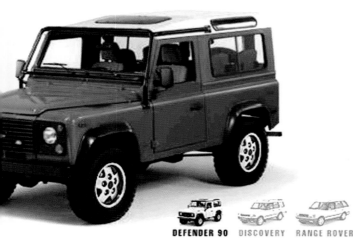

DEFENDER 90 DISCOVERY RANGE ROVER

JAVA APPLET: To create the "Outfit Your Land Rover" area, Adjacency shot each of the models with and without each accessory. Because they had only one color of each model, they colorized the vehicles in Photoshop (to allow viewers to choose their preferred color while exploring this area). The vehicle images were saved as JPEG background images, and all of the accessories (which had to be transparently overlaid on the backgrounds) were saved as transparent GIFs. When viewers choose a specific color and accessorize their vehicle, the images are compressed and joined into a new JPEG image that is shown to them without ever revealing what is happening in the background.

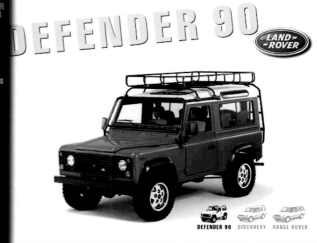

OUTFIT YOUR
LAND ROVER

COLORS
Arles

WHEELS
Diamond

RUNNING BOARDS
None

ROOF RACK
Safari Roof Rack

FENDER PLATES
None

BRUSH BARS
None

PRINT YOUR
SELECTED OPTIONS

DEFENDER 90 DISCOVERY RANGE ROVER

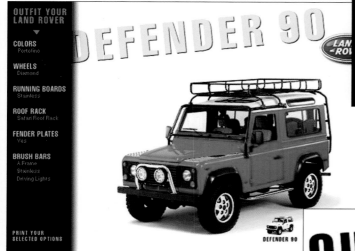

OUTFIT YOUR
LAND ROVER

COLORS
Portofino

WHEELS
Diamond

RUNNING BOARDS
Stainless

ROOF RACK
Safari Roof Rack

FENDER PLATES
Yes

BRUSH BARS
A Frame
Stainless
Driving Lights

PRINT YOUR
SELECTED OPTIONS

DEFENDER 90

MARKET INFO: Once viewers choose a Land Rover model, color, and accessories, they have the option of printing an image of the selected model (right). Tracking software allows Adjacency to follow which items were clicked, and how many people actually print their selected model (reports show an average of 250 printouts from this section per day).

OUTFIT YOUR LAND ROVER

DEFENDER 90 STATION WAGON

Portofino Red

SELECTED VEHICLE KIT ITEMS

- Diamond Wheels
- Stainless Running Boards
- Safari Roof Rack
- Fender Plates
- Stainless A Frame Brush Bar *
- Driving Lights **

THE PROCESS

DESIGN: Because the Land Rover Website was something of a departure from the car company's traditional print materials, the designers always felt as if they were treading on thin ice. "We had to be careful, and we had to do it right," says Adjacency's Andrew Sather. "Any time you deal with print and adapt content to a Website, you need to take a close look at the differences between the two media and how people use them. The whole idea with Land Rover was to create a unified, impressive look. We've done that in several ways: using color where possible as a background to unify the pages, big type, and we tried to create the illusion of space and depth with the bleeding background images."

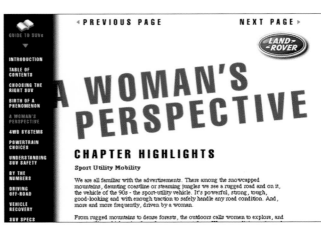

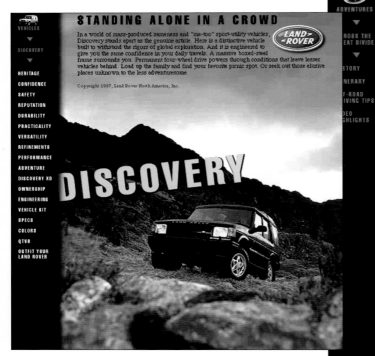

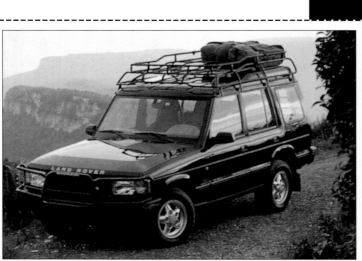

GUIDE TO SUVs GEAR ADVENTURES

ADVENT

k out
...ation on
...Off-Road Driving Tips.

...S THE GREAT DIVIDE

...RS OF ASPEN

...BAL

...GE RACE

...OVER TRёK '96

...LIGHTLY!

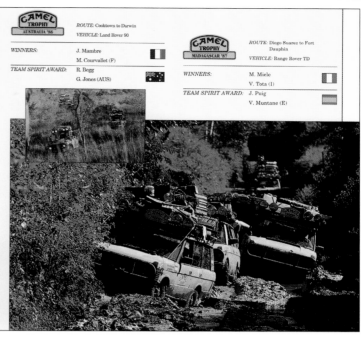

CAMEL TROPHY BRAZIL '84	ROUTE: Transamazonica Highway
	VEHICLE: Land Rover 110
WINNERS:	M. Lavi
	A. Redaelli (I)
CAMEL TROPHY BORNEO '85	ROUTE: Samarinda to Balikpapan
	VEHICLE: Land Rover 90
WINNERS:	H. Kallin
	B. Strohdach (D)
TEAM SPIRIT AWARD:	T. Rosenberg
	C. Probst (BR)

CAMEL TROPHY AUSTRALIA '86	ROUTE: Cooktown to Darwin
	VEHICLE: Land Rover 90
WINNERS:	J. Mambre
	M. Courvallet (F)
TEAM SPIRIT AWARD:	R. Begg
	G. Jones (AUS)

CAMEL TROPHY MADAGASCAR '87	ROUTE: Diego Suarez to Fort Dauphin
	VEHICLE: Range Rover TD
WINNERS:	M. Miele
	V. Tota (I)
TEAM SPIRIT AWARD:	J. Puig
	V. Muntane (E)

RANGE ROVER

VEHICLE KIT
SPECS
ENGINEERING
COLORS
QTVR
OUTFIT YOUR
LAND ROVER

Standard Profile

Few people may ever encounter conditions that truly test the mettle of a Range Rover, but few vehicles can inspire such confidence in every driving situation. One key to this remarkable ability is the Electronic Air Suspension system (EAS), with

An aluminum-alloy V-8 powers both Range Rover models. This advanced powerplant has been the beneficiary of significant improvements for durability, smooth operation, low maintenance and low emissions. For example, the cast aluminum block features cross-bolted main bearings and steel cylinder liners for reduced vibration and increased durability. Stainless steel exhaust manifolds resist rust and lower exhaust emissions. And a distributorless ignition system uses four coils and a sophisticated computer to determine the precise instant to fire each spark plug. With 190 horsepower and 236 pound-feet of torque, both at relatively low rpm, the Range Rover 4.0 SE's 4.0-liter V-8 offers superb flexibility and responsiveness for on-road travel and off-road adventure.

The exclusive Range Rover 4.6 HSE is even more

RANGE ROVER

VEHICLE KIT
SPECS
ENGINEERING
COLORS
QTVR
OUTFIT YOUR
LAND ROVER

Access Mode

Few people may ever encounter conditions that truly test the mettle of a Range Rover, but few vehicles can inspire such confidence in every driving situation. One key to this remarkable ability is the Electronic Air Suspension system (EAS), with

An aluminum-alloy V-8 powers both Range Rover models. This advanced powerplant has been the beneficiary of significant improvements for durability, smooth operation, low maintenance and low emissions. For example, the cast aluminum block features cross-bolted main bearings and steel cylinder liners for reduced vibration and increased durability. Stainless steel exhaust manifolds resist rust and lower exhaust emissions. And a distributorless ignition system uses four coils and a sophisticated computer to determine the precise instant to fire each spark plug. With 190 horsepower and 236 pound-feet of torque, both at relatively low rpm, the Range Rover 4.0 SE's 4.0-liter V-8 offers superb flexibility and responsiveness for on-road travel and off-road adventure.

The exclusive Range Rover 4.6 HSE is even more

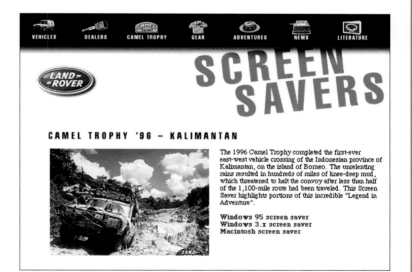

VEHICLES DEALERS CAMEL TROPHY GEAR ADVENTURES NEWS LITERATURE

LAND-ROVER

SCREEN SAVERS

CAMEL TROPHY '96 – KALIMANTAN

The 1996 Camel Trophy completed the first-ever east-west vehicle crossing of the Indonesian province of Kalimantan, on the island of Borneo. The unrelenting rains resulted in hundreds of miles of knee-deep mud, which threatened to halt the convoy after less than half of the 1,100-mile route had been traveled. This Screen Saver highlights portions of this incredible "Legend in Adventure".

Windows 95 screen saver
Windows 3.x screen saver
Macintosh screen saver

DESIGN ELEMENTS: Several elements added to the Land Rover site give the site movement and offer viewers more than a flat, one-dimensional experience. GIF89a animations were used when they could be woven into the functionality of the site, such as the animation showing the "electronic air suspension" (middle two photos left). QuickTime VR showcases specific models of Land Rover (left), and downloadable screensavers (above) are offered to viewers.

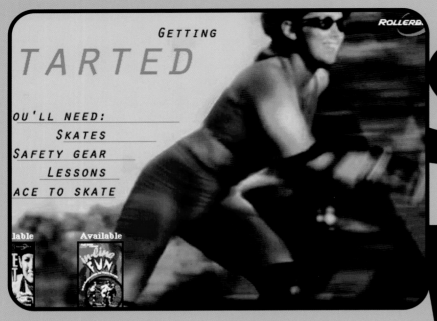

ROLLERBLADE

SMA

SMA

WE

WE

FAO SCHWARZ

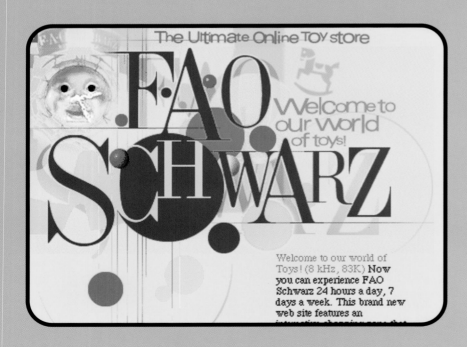

TREK BICYC

ALL

ER WEBSITES

BSITES

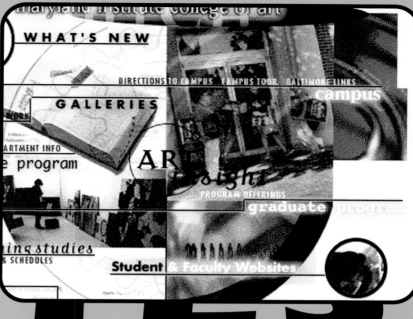

S

MARYLAND INSTITUTE, COLLEGE OF ART

TIME WARNER

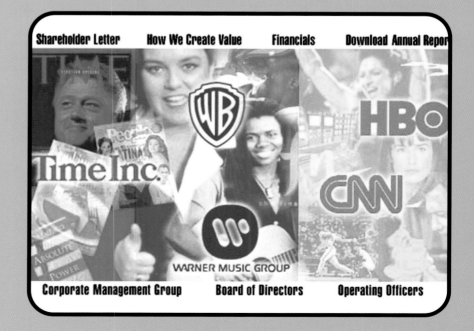

This project by CO2 Media presents a look at the technique and methodology used to translate the Maryland Institute, College of Art (MICA) print catalogs into a beautiful Website promotion for the College. Like most art and design schools, MICA publishes catalogs that showcase its best features as well as its curriculum, faculty, and admissions information. Max McNeil, president and creative director of CO2 Media, and Jeff Wilt, vice-president and art director, worked on several of the college's catalogs while employed at a previous design firm. After starting CO2 Media, they acquired MICA as a client and created its current Website. ▪ The print versions of the catalogs are beautiful, full-color, artfully designed pieces that showcase the school's graduate and undergraduate programs. The catalog's unique design features include a large format, perfect binding, and slipcases. ▪ CO2's challenge was to transfer the high-quality design and production values of the printed materials to the Website.

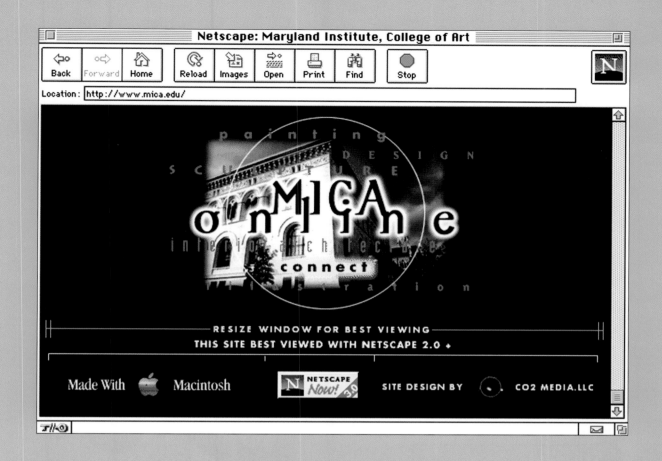

Location: http://www.mica.edu/

RESIZE WINDOW FOR BEST VIEWING
THIS SITE BEST VIEWED WITH NETSCAPE 2.0 +

Made With Macintosh NETSCAPE Now! SITE DESIGN BY CO2 MEDIA.LLC

DESIGN FIRM: CO2 Media
CREATIVE DIRECTOR: Max McNeil
DESIGNERS: Max McNeil, Jeff Wilt, Dan Bennderly
PRODUCERS: Max McNeil, Debra Rubino
COPY: Debra Rubino
PROGRAMMER: Mark Lundquist
MICA CONTACT: Debra Rubino

MICA CATALOG DESIGN
DESIGN FIRM: Franek Design Associates Inc.
CREATIVE DIRECTORS: David Franek, Max McNeil, Jeff Wilt
DESIGNERS: Max McNeil, Jeff Wilt
COPYWRITER: Debra Rubino
PHOTOGRAPHERS: Stephen John Phillips, Joe Rubino

TOOLBOX

HARDWARE: Macintosh, Windows PC

SOFTWARE: Photoshop, DeBabelizer, Illustrator, GifBuilder, Alpha, Web Weaver

TYPEFACES: Dead History, Blur, Filet, Futura Family, Garamond

SPECIAL FEATURES: GIF89a animation, JavaScript

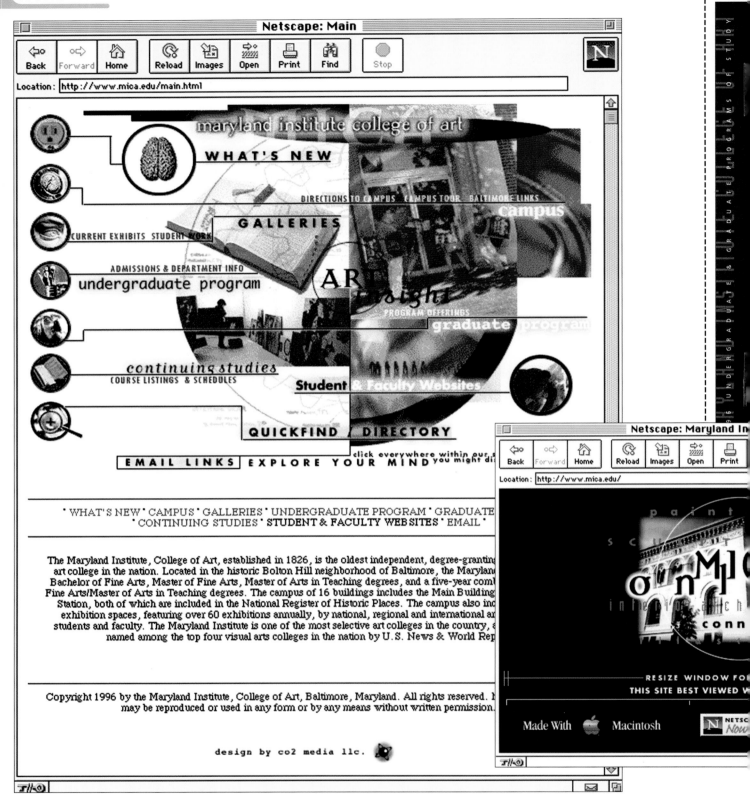

HOME PAGE: Like many design firms creating Websites, CO2 chooses to work within a safe area of 640×480 pixels. The home page (above) features the main information and illustrated area at the top of the page, so viewers can access the navigation areas without scrolling.

The design firm had plans to add animation and other "bells and whistles" to the Website, but because the site was so large (more than 400 pages) and graphically intense, they decided not to eat into the page size and download time by adding unnecessary animation.

PRINT CATALOGS: To attract art students and designers to MICA, the Institute produces high-quality, full-color brochures with elements that work well in print but are too complicated—or impossible—to replicate on a Website, such as the oversize design of one catalog (center), or the slipcase-and-side-stitched design of another (top and below).

To complement MICA's luxurious print production values, CO2 developed online design elements that would continue the Institute's high standards. Large collage illustrations—such as the one shown on the home page (facing page)—are one kind of element CO2 employed to define the style of the online catalog.

selections, registration, major or academic program, student mobility programs, study abroad...Call the director of academic advising at (410) 225-2243.

Financing programs or financial aid...Call the financial aid office at (410) 225-2285.

Careers and job internships...Call the Joseph Meyerhoff Center for Career Development at (410) 225-2420.

Housing at The Commons at the Maryland Institute...Call the housing office at (410) 225-2398.

Student activities and services, personal counseling services, health services...Call the student affairs office at (410) 225-2422.

The undergraduate admissions office can answer general questions about all of the above as well as questions about admissions to undergraduate programs, merit scholarship programs, and how to plan your transfer from another institution. Call the undergraduate admissions office at (410) 225-2222.

SPLASH PAGE: The splash page for MICA greets visitors and offers suggestions for the best viewing of the Website, with a link to the recommended browser.

THE MARYLAND INSTITUTE, COLLEGE OF ART

what's **New** at **MICA**

Featured News

- Maryland Institute Sees Substantial Increase in Applications *(March 24, 1997)*
- MICA's Popularity Leads to Record Numbers of Incoming Students

Campus News

- New Graduate Program: Master of Arts in the Digital Arts *(February 5, 1997)*
- MICA to Begin Offering Classes on the World Wide Web *(January 10, 1997)*
- Summer Pre-College Studio Residency Program Offers Unique Visual Arts High School Students *(January 3, 1997)*
- 1997 Spring Mixed Media: A Series of Lectures and Performances *(January 3, 1997)*
- New Building Opens: Phase I Includes New Home for Visual Communicat[ions] Departments

Exhibits and Events

- Artist and Critic Deborah Bright to Lecture *(March 27, 1997)*
- Melina Nicolaides and Jason Swift to Exhibit New Work *(March 25, 1997)*
- Gregg Emery and Paulo Machado Exhibit New Works *(March 21, 1997)*
- Annual Juried Undergraduate Exhibition Opens *(March 19, 1997)*
- Spring Semester Calendar of Exhibitions and Lectures *(January 3, 1997)*

Office of Communications and Public Affairs

Comments, questions, and suggestions about these pages

UPDATES: Updates to the graphics of the MICA Website happen about once a year. CO2 handles major updates and created templates for the "Gallery" and "What's New" areas so that MICA staff can update these areas as needed.

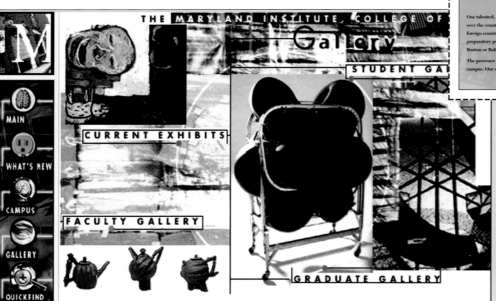

THE MARYLAND INSTITUTE, COLLEGE OF [ART]

Gallery

STUDENT GA[LLERY]

CURRENT EXHIBITS

FACULTY GALLERY

GRADUATE GALLERY

Each year over 90 public exhibitions are featured in MICA galleries--a stimulating component of the educational program. Innovative exhibitions have garnered national and international attention and have featured a diverse group of major artists from various art disciplines. Programming also includes exhibits of work by graduate and undergraduate faculty and visiting artists. Two major gallery spaces, the Decker Gallery in the Mount Royal Station and the Meyerhoff Gallery in the Fox Building, as well

CLICK ON PHOTO FOR A LARGER

Take a visual tour of the MICA and discover the unique campus settings that make [it] a place to be.

BACK TO THUMBNAILS

Inside the ceramics studio, a student creates on the wheel.

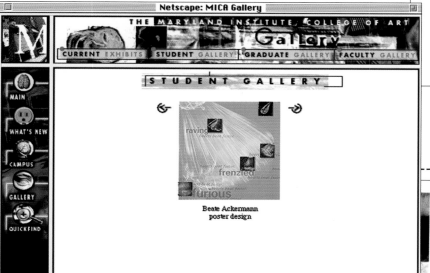

Netscape: MICA Gallery

THE MARYLAND INSTITUTE, COLLEGE OF ART
Gallery

CURRENT EXHIBITS · STUDENT GALLERY · GRADUATE GALLERY · FACULTY GALLERY

MAIN

WHAT'S NEW

CAMPUS

GALLERY

QUICKFIND

STUDENT GALLERY

raving
frenzied
furious

Beate Ackermann
poster design

GALLERY: The "Student Gallery" area of the Website (above and lower left) features elements that make the online version responsive to the Institute's changing student body and allows freedom to showcase current and past student works. This area also features faculty work, which lets students and potential students view an instructor's work before taking his or her class.

Lucy Peaker
senior general fine arts major
drawing

John Franey
senior general fine arts major
sculpture

Jennifer Samuelson
junior photography major
color photography

THE MARYLAND INSTITUTE, COLLEGE OF ART

DIRECTIONS

| CAMPUS MAP | DIRECTIONS TO CAMPUS | BALTIMORE |

MAIN
WHAT'S NEW
CAMPUS
GALLERY
QUICKFIND

From the New Jersey Turnpike and points north: Take Interstate 95 south to exit 64B, Interstate 695 west, Towson. Do not bear left to Baltimore via I-95. Continue on 695 west to exit 23, Interstate 83 south, Baltimore. Take 83 to exit 6, North Avenue. The exit ramp becomes Mount Royal Avenue. Continue to 1300 Mount Royal Avenue, the Main Building, a large white Italianate marble building on your right.

From Washington, DC and points south: Approach Baltimore on Interstate 95 north, follow Baltimore Downtown signs to exit 395. Do not take tunnel exit. Take 395 north and follow for about one mile to Inner Harbor/Conway Street exit. Continue on Conway Street to Charles Street. Turn left on Charles Street and for about two miles to Mount Royal Avenue. Turn left on Mount Royal and proceed to the Main Building, a large white Italiante marble building on your left, 1300 Mount Royal Avenue.

From Pennsylvania and points west: Take Interstate 70 east to Interstate 695 west, Towson to Interstate 83 south, Baltimore. Take 83 to exit 6, North Avenue. The exit ramp becomes Mount Royal Avenue. Continue to 1300 Mount Royal Avenue, the Main Building, a large white Italianate marble building on your right.

GO TO
MAP

TYPEFACES: The CO2 design team wanted to capture the essence of the school, its students, and the campus to portray what it felt was a "funky yet sophisticated" attitude throughout the site. To accomplish this, it used a mélange of about twenty different typefaces, mixing some cool and funky typefaces with more traditional typefaces. More importantly, the designers wanted to make the Website easily readable and navigable without viewers having to strain to figure out what area they were in— or where they wanted to go next.

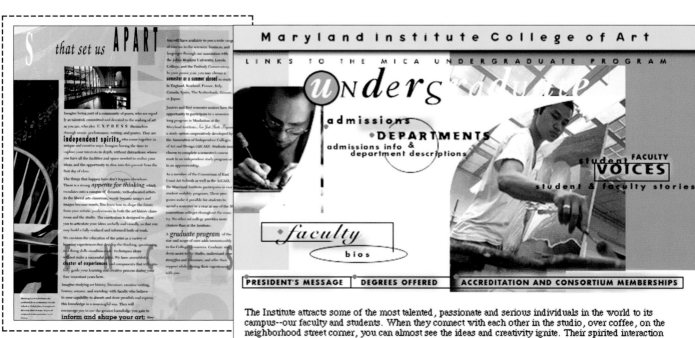

COLOR: A rich, vibrant color palette played an important role in the creation of the MICA site. The designers used color to represent the diversity of attitudes and offerings within the school, as well as the uniqueness of the campus. Beyond the aesthetic use of color, the basic palette helps keep download times short.

Colorizing photos with primary colors, such as in the "Voices" area (below), is another color technique the designers developed to keep download times to a minimum.

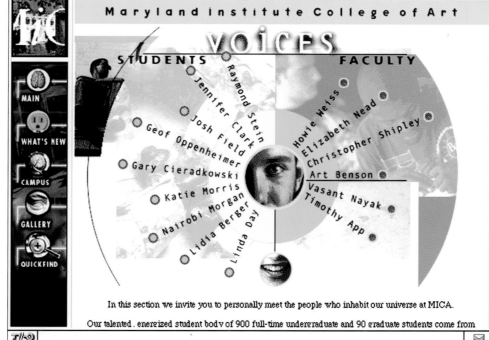

ANIMATION: The single GIF89a animation featured on the Website is a scrolling MICA logo in the upper left corner of each page. CO2's original concept for the animation was to offer viewers different artwork created by a student or faculty member on each page. The pieces would link to a byline or bio of each artist. The idea was shelved in favor of putting more content on the site.

DESIGN: CO2 has been designing online media for MICA for several years. With the previous catalogs the partners designed while at another firm, they now feel that they are quite familiar with the audience. CO2 created the initial MICA site in 1995 and finished the second version of the site in the first half of 1996.

The Website aims to attract potential art students and transfer candidates from other art schools. Through tracking of the site's visitors, MICA has determined that quite a number of applicants are influenced by the site. "We know that last year the Website helped contribute to an enrollment increase," says CO2 Creative Director Max McNeil. "The biggest problem was to make the site look fresh. It's always a challenge to design something new for a client that you've done work for in the past, to design something better. A lot of expectations were placed on it to be something that was new and fresh, not only for MICA but for the Web itself."

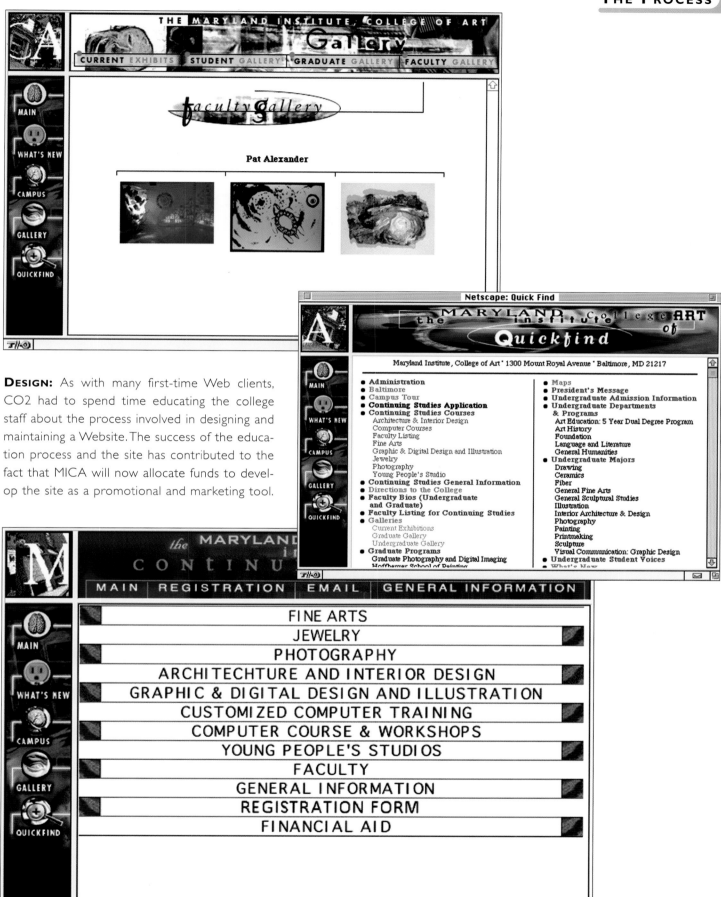

DESIGN: As with many first-time Web clients, CO2 had to spend time educating the college staff about the process involved in designing and maintaining a Website. The success of the education process and the site has contributed to the fact that MICA will now allocate funds to develop the site as a promotional and marketing tool.

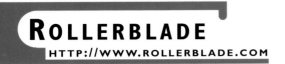

The Rollerblade project exemplifies Adjacency's ability to connect a print-based brand identity to the Internet, in this case that of a premier in-line skate manufacturer. Having designed Rollerblade's original Website, Adjacency was in an ideal position to redesign the Website and incorporate evolving browser technology. ▪ Rollerblade wanted to redirect the site's visual identity toward a more aggressive in-line skating audience. To this end, Adjacency implemented new design elements such as bold images and typography, as well as chat rooms. ▪ Adjacency's designers focused on the sport of in-line skating as much as on the Rollerblade product. ▪ "We wanted to focus on the sport while branding Rollerblade—to glorify the action and the use of the product, and let that sell Rollerblade's products," says Andrew Sather, Adjacency's creative director.

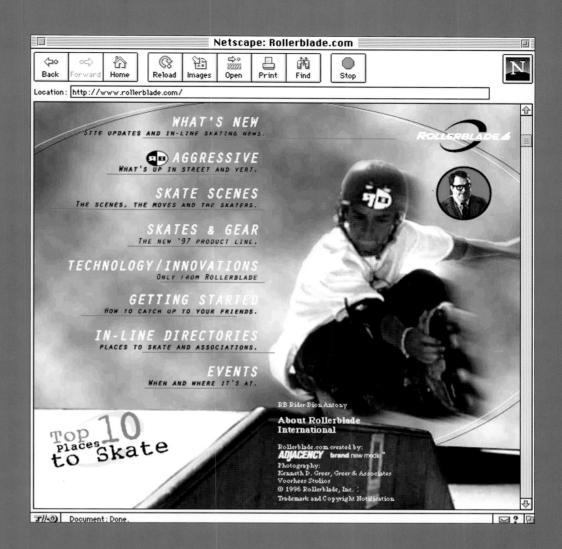

Design Firm: Adjacency

Creative Director: Andrew Sather

Designers: Matia Wagabaza, Bernie DeChant, Andrew Sather

Producers: Bernie DeChant, Jen Pagnini

Copywriters: Rollerblade, Greer & Associates, Adjacency

Programmers: Pascal, Matt Kirchstein, Matia Wagabaza, Carlo Calica

Rollerblade: Colleen Cribbins, Maureen O'Neill

TOOLBOX

Hardware: Macintosh

Software: Photoshop, DeBabelizer, Illustrator, BBEdit, GifBuilder

Typefaces: Orator, Angivetti

Special Features: GIF89a animation, JavaScript

HOME PAGE: The first Website Adjacency designed for Rollerblade (home page shown at right) featured many large background images, with image-mapped headlines placed on a curve serving as the main typographic theme throughout. The new home page (below) still uses much of the same type of imagery throughout the site, but the designers have switched from a curved-type theme to a more organized layout for headlines.

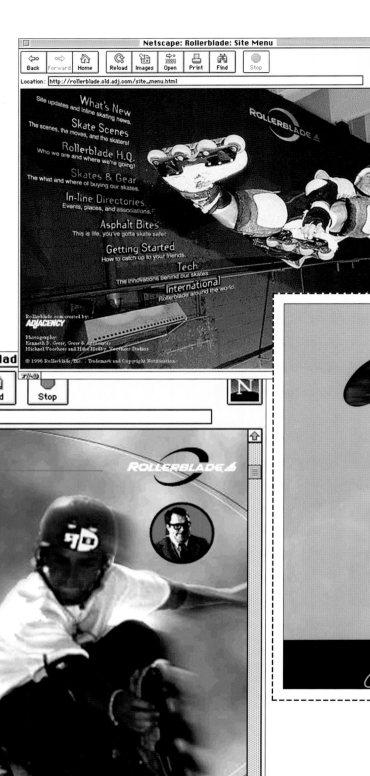

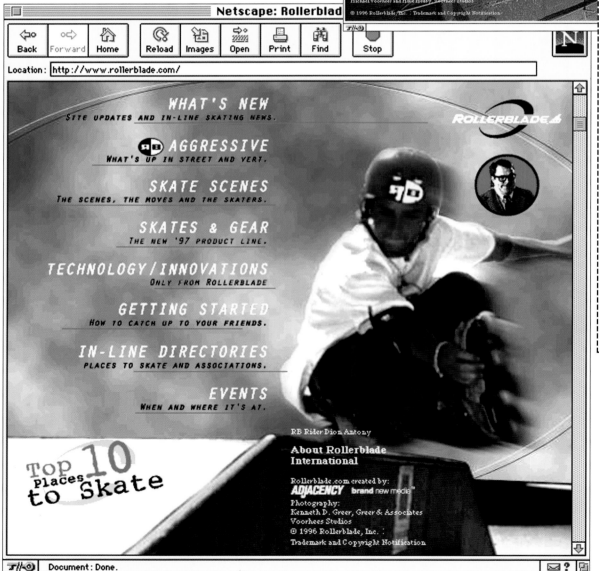

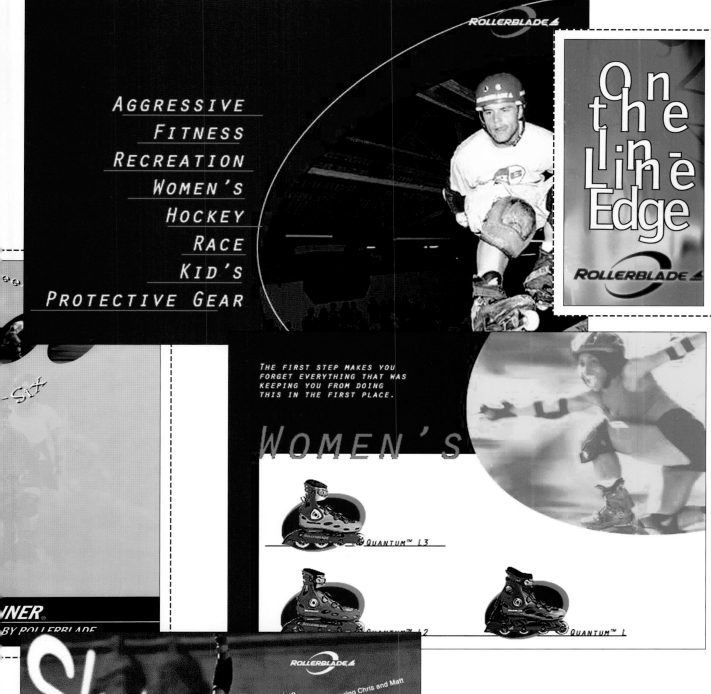

AGGRESSIVE
FITNESS
RECREATION
WOMEN'S
HOCKEY
RACE
KID'S
PROTECTIVE GEAR

On
the
Line
Edge
ROLLERBLADE

THE FIRST STEP MAKES YOU
FORGET EVERYTHING THAT WAS
KEEPING YOU FROM DOING
THIS IN THE FIRST PLACE.

WOMEN'S

QUANTUM™ L3

QUANTUM™ L2

QUANTUM™ L

NER®
BY ROLLERBLADE

Skate Scenes

ROLLERBLADE

Aggressive
Aggressive in-line skating featuring Chris and Matt

The Arena
The where, when, and how of in-line hockey

Racing
Featuring the Geo Rollerblade Racing Team®

Kids' Club
Featuring Team Bladerunner™

Work It!
Skating for fun and fitness

site menu ◀

email us

LAYOUT: The "Skate Scene" page shows the difference in layout from the original site (bottom) and the current site (middle and top). Large images are still used on most pages, but rather than always making the photo the main image, with superimposed type, images on the current site are used as a more balanced and less dominant element on the pages, which now also use background colors.

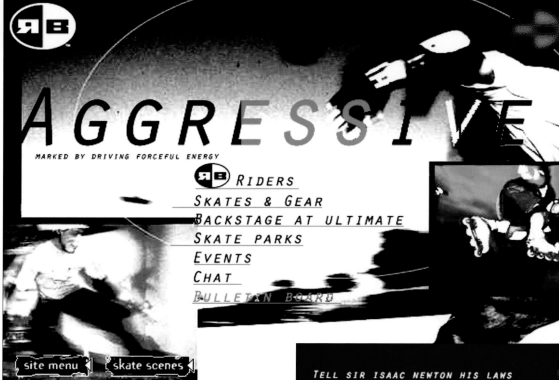

TRANSPARENT GIFs: Transparent GIFs appear in the foreground whenever a large background JPEG occurs on a page. The "Aggressive" area of the Rollerblade site (above) shows how transparent GIFs are used when the page loads. The top image (this page) shows how the main "Aggressive" headline and subheads load before the large background image. These two sequences show how to make specific colors transparent in order for the type to "sit" correctly on the background. The white and red text is set on the same blue as the background; choosing the blue as the transparent color allows the white and red color to be knocked out of the blue.

TYPEFACES: One of the main areas of redesign for the new Rollerblade site was its typography. The designers executed comps using many different typefaces before settling on Orator to replace the old Template Gothic. Angivetti was used in areas that required a more radical look.

The "What's New" section shows the differences between the old headline set in Template Gothic (below left) and Orator (below).

WHAT'S NEW

ROLLERBLADE

PRODUCTS

Aggressive: Dirk™, RB's new "hang out" street skate.

High Performance Fitness: Quantum L3 -Have fun and burn calories.

Recreation/Fitness:
Synergy™ -Learn about Rollerblade's new Cross-Molded Technology.
Nitroblade™ -an all new state-of-the-art recreational skate.

In-Line Hockey:
Evo™, Evo Max™ -Designed with the ultimate hockey componentry for the serious league player.

Kids - Xtenblade -Popular Science editors name Xtenblade™ to their list of Th... Achievements in Science & Te...

PROGRAMS

Top 10 Places to Skate

Rollerblade, Inc. announces the locations of its inaugural list of top places to skate.

It's official...
The jury has left the asphalt -but not before carving out the names of the 1997 RB Riders (street/vert) and the Rollerblade Racing Team.

Blade Jam™ only from Rollerblade, the world's largest interactive in-line ...touring the United

...GRAMS

e-mail us

Aggressive Menu

AGGRESSIVE
FITNESS
RECREATION
WOMEN'S
HOCKEY
RACE
KID'S
PROTECTIVE GEAR

What's New

ROLLERBLADE

Check out Rollerblade's holiday gift guide and take advantage of our great holiday rebates.

Best of What's New
Popular Science editors name Xtenblade™ to their list of
The Years 100 Greatest Achievements in Science & Technology.

International

For in-line skating information in countries other than the United States, contact our international distributor nearest you.

Select a region and click 'Continue'.

The Mark Of
A Leader,
Not A Sport.

ROLLERBLADE

TODAY, IN-LINE SKATING IS A WORLDWIDE PHENOMENON PRIMARILY AS A RESULT OF ROLLERBLADE'S PIONEERING EFFORTS. AND, AS SUCH, THE ROLLERBLADE NAME AND MARK ARE SOMETIMES MISUSED. IN ORDER TO PROTECT THE BRAND, ITS PRODUCTS, TRADEMARKS AND COPYRIGHTS, THE COMPANY IS VIGILANT ABOUT THEIR PROPER USAGE IN ADVERTISING AND PROMOTIONAL MATERIALS. WHEN YOU DO BUSINESS WITH ROLLERBLADE, PLEASE AS... FOR A COMPLETE GUIDE TO TRADEMARK AND COPYRIGHT USAGE.

Forward Motion

SIMILARITIES: To keep the home page image fresh and in line with Rollerblade's print materials, designers at Adjacency change the image several times over the course of a year. Many of the images used to create the Website's visual identity are chosen from a "ton" of slides and photos taken by photographers contracted by Rollerblade. Often members of the design team attend in-line skating events and shoot their own photos using digital cameras. This year Adjacency designers attended the X-Games, an extreme sporting event.

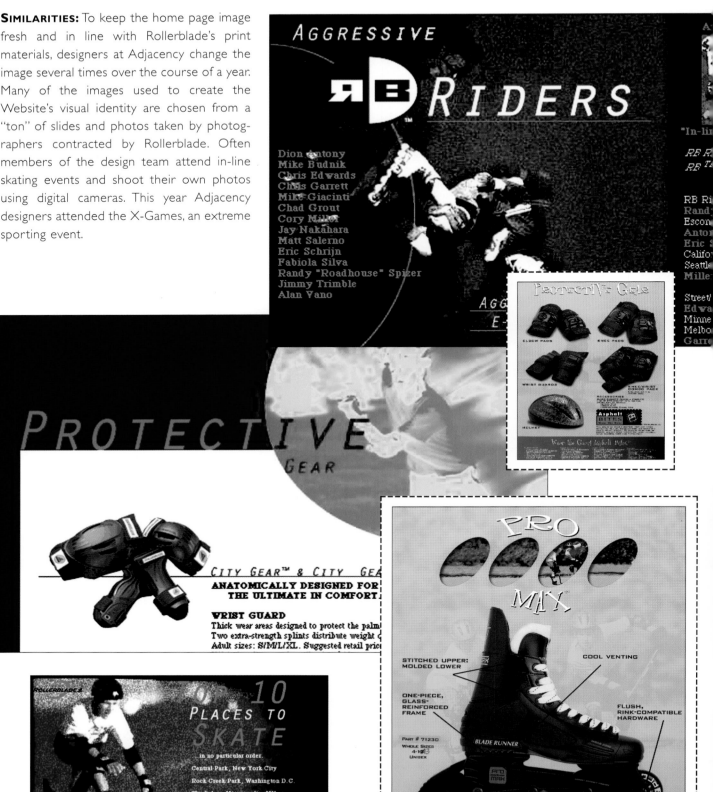

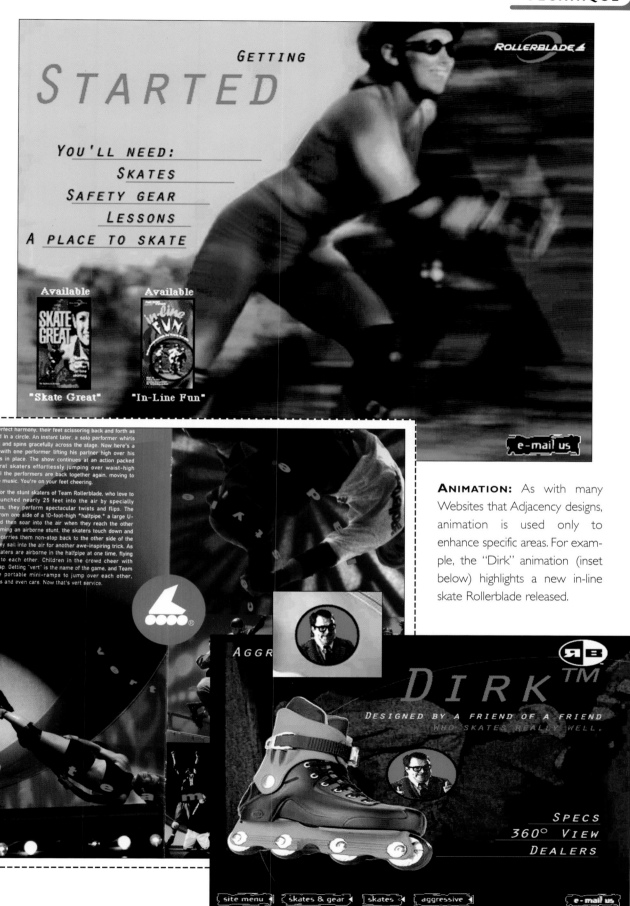

ANIMATION: As with many Websites that Adjacency designs, animation is used only to enhance specific areas. For example, the "Dirk" animation (inset below) highlights a new in-line skate Rollerblade released.

DESIGN: Rollerblade's marketing direction focuses on its lightning rod consumer group—younger males who inhabit the aggressive, cutting-edge area of in-line skating. When Adjacency first began work on the original Website, they were challenged because there was no set direction to initiate the design process.

"At the time we began creating Rollerblade's first site," Sather says, "their print collateral didn't really say much about who they were at the moment. Their marketing materials had been created by different firms, so it wasn't unified. Rollerblade realized this, and at the time we were working with them they were also working with a firm in London to re-focus the brand. We had no idea how they were going to be reinvented, so we decided to focus on the sport as much as the product. The Website definitely provided a cohesive, unified look at a time when Rollerblade wanted one."

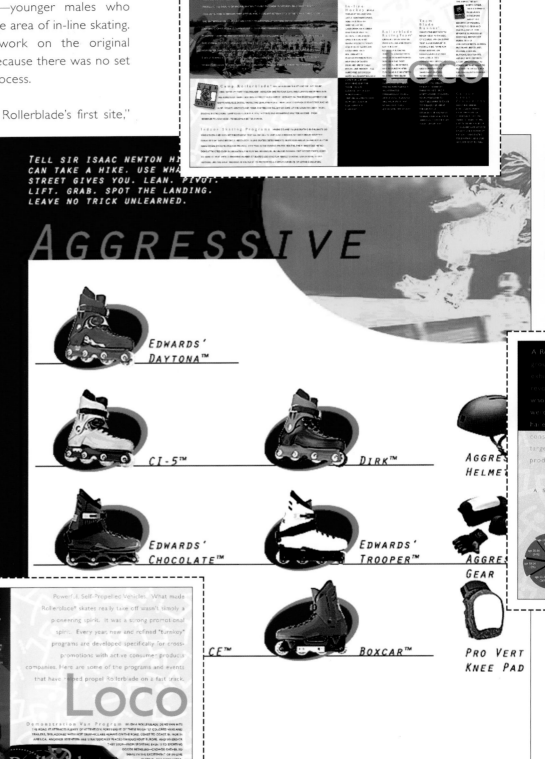

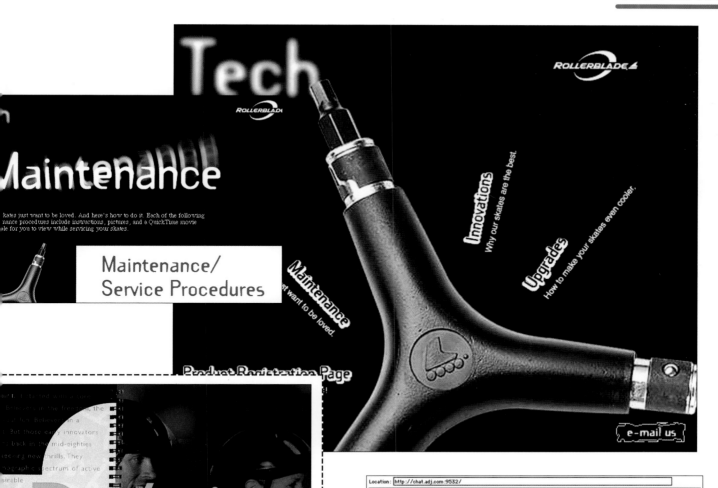

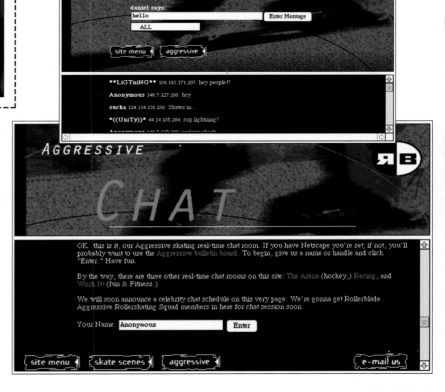

DESIGN ELEMENTS: Because the Rollerblade site features so many large images, the designers incorporate imagery that adds movement and interest to the site rather than rely on animation. The "Tech Maintenance" image at top is an example of using typographic effects to give added interest to a page.

Another element that keeps viewer interest is the "Chat" area of the site (right).

The name FAO Schwarz is synonymous with toys. This project demonstrates how the Avalanche Systems designers took a well-known brand to the Internet, structuring traditional catalog sales information into a dynamic and entertaining Website. With this as its goal, the Avalanche design team, working with FAO marketing executives, created a Website for the toy company that showcases the store's name and shopping environment, as well as the many brands sold in the store. The designers also wanted to ensure that visitors to the site focused on the site's primary goal: online purchasing. ▪ To make viewing the site a comfortable and rewarding experience, the design paralleled the in-store shopping experience closely. "There definitely is an interesting relationship between the site and the actual physical store," says Peter Seidler, Avalanche creative director. "You can go into an area in the store that's all Barbies—a sort of 'Barbie-world.' The same is true on the Website."

Location: http://www.faoschwarz.com/

The Ultimate Online TOY store

ABOUT FAO SHOPPING

Welcome to
our world
of toys!

Welcome to our world of Toys! (8 kHz, 83K) **Now you can experience FAO Schwarz 24 hours a day, 7 days a week. This brand new web site features an interactive shopping zone that is fun, easy and a secure place to shop. To begin your FAO journey just click on "Shopping" or "About FAO" and enjoy the experience!**

DESIGN FIRM: Avalanche Systems

CREATIVE DIRECTOR: Peter Seidler

DESIGNER: Bryant Wilms

PRODUCER: Lucy Lieberman

DEVELOPER: Elisha Sessions

FAO SCHWARZ: Brooke Adkins

TOOLBOX

HARDWARE: Macintosh

SOFTWARE: Photoshop, DeBabelizer, GifBuilder

TYPEFACES: Univers family

SPECIAL FEATURES: GIF89a animation, Transaction/purchasing

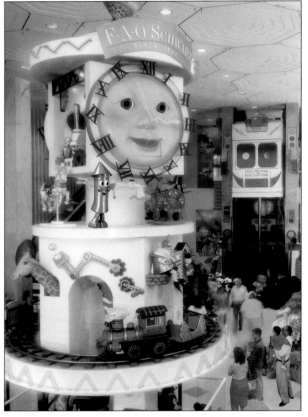

REDESIGN: The original FAO Schwarz home page (middle left, also created by Avalanche), was modified dramatically to create the current home page design (left). Avalanche discarded the first design's sparing use of color and typography in favor of a more dynamic, typographically pleasing, and colorful home page design. To make the opening page more active, the designers implemented GIF89a animations in the form of a rocking horse and colorful spheres that jump around and pulsate to the rocking sound of the toy horse image.

SOUND: One design element that carries over from the previous design of the home page is the "Welcome to our World of Toys!" sound clip that utilizes a Netscape pop-up audio player (left). Once the 8 kHz WAV file loads, viewers can play the sound using the small control box, which allows the sound to be rewound and played again.

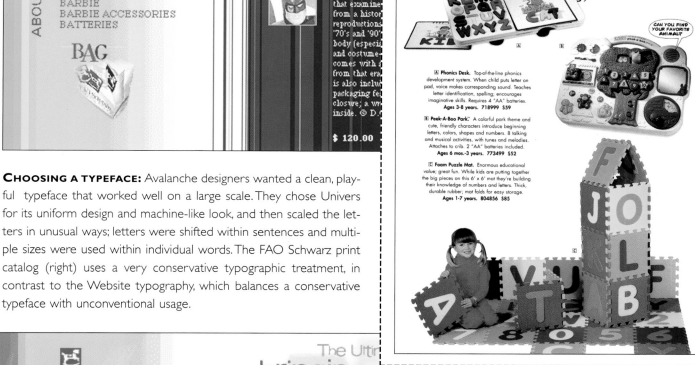

CHOOSING A TYPEFACE: Avalanche designers wanted a clean, playful typeface that worked well on a large scale. They chose Univers for its uniform design and machine-like look, and then scaled the letters in unusual ways; letters were shifted within sentences and multiple sizes were used within individual words. The FAO Schwarz print catalog (right) uses a very conservative typographic treatment, in contrast to the Website typography, which balances a conservative typeface with unconventional usage.

The Ultimate Online TOY store

World of dolls

SHOPPING

ABOUT FAO · SHOPPING

BRINGING UP BABY
PRESCHOOL AT PLAY
HUGGABLE FRIENDS
WORLD OF DOLLS
BOOKS
ACTION FIGURES
ARTS AND CRAFTS
SCIENCE AND
DISCOVERY
MUSIC AND GAMES
VEHICLES
COLLECTIBLES
BARBIE
BARBIE ACCESSORIES
BATTERIES

BAG

Doll Carriage
Elegant Doll Accessories. Crafted for us with European design in mind, these accessories will be used by many generations of dolls. (Dolls sold separately.) Metal frame, collapsible hood. 25"h.

$159.00 ADD TO BAG

Child's Ballet Slipper Sleeping Bag
Slip into our dreamy child-size sleeping bag. Removable inner lining. Fully washable. Comes with satin appliqué carry sack.

$199.00 ADD TO BAG

Adult Ballet Slipper Sleeping Bag
Slip into our dreamy adult-size sleeping bag. Removable inner lining. Fully washable. Comes with satin appliqué carry sack.

$275.00 ADD TO BAG

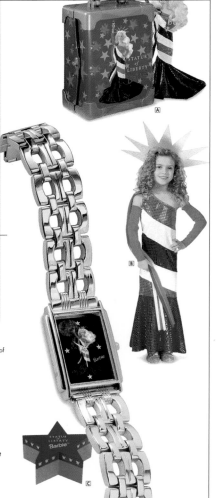

Barbie

AT FAO SCHWARZ

For over 37 years Barbie has been charming and delighting millions of fans of all ages. Since the beginning, you have been able to find all things Barbie at FAO Schwarz, and now we offer every Barbie item in existence, including fabulous exclusives, at our 26 Barbie Boutiques across the country.

1959

Two years ago this very popular nostalgic Barbie was reintroduced—to the delight of Barbie collectors everywhere. (Barbie trivia: Did you know that 2 Barbie dolls are sold every second?)

Only at FAO
Ⓐ **Statue of Liberty Barbie® Case.** Carry Liberty throughout the land! Holds 2 Barbie dolls and loads of clothes and accessories (not included). With 2 drawers. **Ages 5 and up.** 748749 **$25**

Only at FAO
Ⓑ **Statue of Liberty Barbie® Costume.** Dress up like dazzling Statue of Liberty Barbie! Sequin spangled satin, with crown. Sizes S(4-6x), M(6-8), L(10-12). 805507 **$56**

Only at FAO
Ⓒ **Statue of Liberty Barbie® Watch by Fossil.** Limited edition timepiece with sophisticated goldtone bracelet band. Quartz movement, 1-yr. limited warranty. Individually numbered. In a stellar star-shaped box. **Ages 9 to adult.** 745851 **$75**

26

COLOR: The design team spent a lot of time in different FAO Schwarz stores studying their color schemes and layouts. As with their typography, they tried to use a color palette consisting of bright, primary colors to evoke a sense of playfulness. To help give the site movement and to direct the viewer's line of sight, vertical lines of color were used within the frames that separate the two sides of the main pages. These vertical lines are also reminiscent of the elevator robot, a memorable feature located in the flagship store.

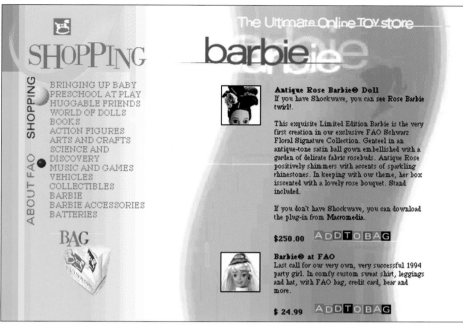

ANIMATION: GIF89a animations add a bit of fun on the home page and on each of the upper-level pages in the shopping area located in the left-hand frame of the Website. As on the home page, colored spheres jump and pulsate in each frame, while additional animations are featured sparingly in the catalog areas of the right frames.

The "Antique Rose Barbie Doll" (above) is showcased within the site by a small GIF89a animation on the intro page (top image and sequenced images left) and as a Macromedia Shockwave animation (above and inset).

DIFFERENCES: The three printed catalogs and the Website catalog share some similarities, such as the sectioning of the various areas (Action Figures, Collectibles, Barbies), but one major difference is one that can't be seen by site visitors: The printed catalogs are updated and released only every three months, while the Webmasters at FAO Schwarz can update the Website on a weekly basis. To accomplish this, the Avalanche designers created a template that allows FAO Schwarz to easily pull old products and add new ones.

FULFILLMENT: Avalanche worked with FAO Schwarz and its catalog order fulfillment service to link online orders to the existing infrastructure. When an online order is placed, it gets sent directly to the fulfillment service, which also handles phone orders. Avalanche helped develop a method of transferring information in a way that was easy for the service to use.

FULFILLMENT: Avalanche implemented SSL (Secure Socket Layer) technology to create a secure ordering environment for viewers to purchase merchandise online. A virtual "shopping cart" allows viewers to select items, which are then added to their shopping cart. When customers are ready to pay for the items, the site software adds up the prices, asks whether they want the items wrapped, and calculates shipping costs. Customers can then pay through the Website with a credit card or call a toll-free number to order.

DESIGN: To present viewers with the most useful site possible, Avalanche monitored the site traffic and studied the areas that were hit most often. Areas that had lower visitation rates were adjusted over time.

"There are a lot of details that relate to the time we spent in the FAO Schwarz stores," says Avalanche Creative Director Peter Seidler. "We spent days just hanging out in different stores, trying to get a feel for how they were organized. We wanted the whole shopping experience to be fluid and friendly."

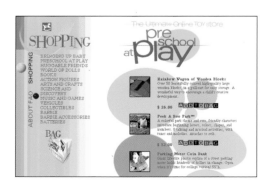

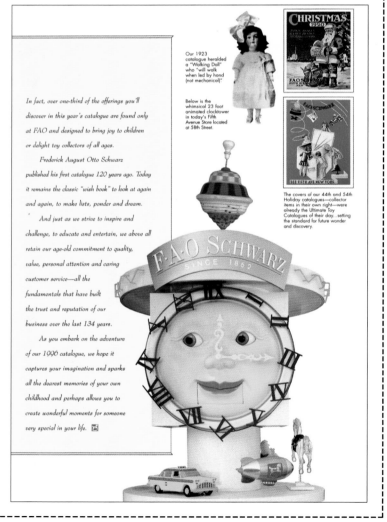

DESIGN: Avalanche presented FAO Schwarz with three final designs from which to choose, the field having been narrowed from six internally by the Avalanche staff. "We wanted to create the world's greatest online toy store," Seidler says. "That meant we scrapped multiple designs before we moved forward. We were really demanding—it wasn't the client so much as what we felt we needed to do for the site."

Trek Online showcases the Cedro Group's ability to incorporate leading-edge technology into a dynamic user experience. QuickTime VR, Java rollovers, and electronic postcards are just a few of the elements the designers have incorporated into the Website. ▪ The Cedro Group has designed more than ninety Websites for both large and small companies. The Trek Website was originally created by Trek's advertising agency, but it was taken over by the Cedro Group and redesigned in 1995. "When we designed the site, we focused on the technology to help people find bikes faster," says Andrew Chen, Cedro Group's creative director. "We also added interactive technologies and capabilities that would allow Trek to do a lot of the maintenance themselves." ▪ The designers streamlined the process of updating the Website to be quicker and more convenient, allowing Trek to eliminate a three-day lag between its requests and online implementation.

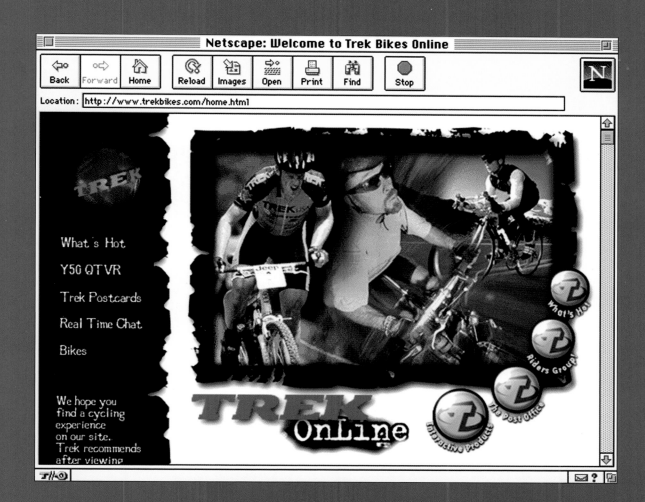

DESIGN FIRM: Cedro Group

CREATIVE DIRECTORS: Andrew Chen, Kim McElhinney

DESIGNERS: Sharon Buck, Jeffrey Willis, Tara Cottrell

PRODUCERS: Andrew Chen, Kim McElhinney

COPY: Trek Bicycle

PROGRAMMERS: Jim Morris, Amir Taghinia,

Sameer Sham Suddin, Hsufeng Ko,

Robert Chea, Andrew Chen

ADVERTISING EXECUTIVE: Tara Cottrell

TREK: Mike Mayers, Connie Mundth

TOOLBOX

HARDWARE: Macintosh

SOFTWARE: Photoshop, DeBabelizer, Strata 3D

TYPEFACES: Trixie, Funky Fresh, Trek Base family, Rockwell

SPECIAL FEATURES: GIF89a animation, JavaScript

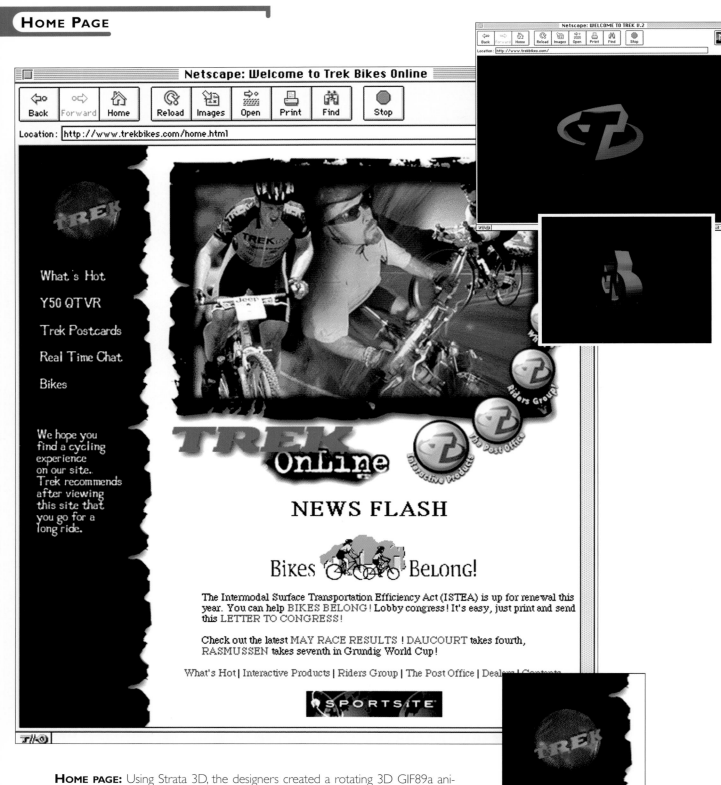

HOME PAGE: Using Strata 3D, the designers created a rotating 3D GIF89a animation of the Trek logo for the splash page (inset above right). The designers felt that the Website was already graphically intensive and decided not to incorporate too many dynamic elements outside of the home page.

The home page incorporates both JavaScripting—for navigation button rollovers—and GIF89a animation in the form of a spinning 3D Earth with the Trek name rotating around it (above and right).

IMAGES: GIF files, rather than JPEGs, were used throughout the Website because the designers liked the consistent quality that GIFs offer. Also, when the site was built, America Online's browser would not support more than 256 colors, which causes JPEG images to band badly.

Get it while it's fresh: the latest news of Trek innovations and Trek riders around the world. We'll continually update this portion of our web site with news and views of cycling. From leading technology to some of racing's most interesting personalities.

Trek Race Results
Updates on Trek Racing Teams' most current races.

Wrench Force
Service wherever the Riders are.

Trek Credit Card
Apply for the Trek Credit Card now!

Travis Brown's Journal
Check in with Trek's Notorious Rocket Boy.

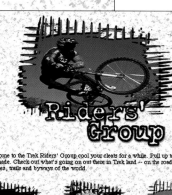

Welcome to the Trek Riders' Group: cool your cleats for a while. Pull up to a place in the shade. Check out what's going on out there in Trek land -- on the roads, race courses, trails and byways of the world.

TREK RIDES
Get the scoop on the rides happening near you.

TREK Q&A
Your most frequently asked questions end here.

TREK RACING
Catch up with the latest from Trek's racing teams.

TREK RACE RESULTS
Updates on Trek Racing Teams' most current races.

WRENCH FORCE
Service wherever the Riders are.

HAND-BUILT CRAFTSMANSHIP

HOME | BIKES | WHAT'S HOT | RIDER'S GROUP | POST OFFICE
CONTENTS | CATALOG | INTERACTIVE PRODUCTS | DEALERS | FEEDBACK

HOME | BIKES | WHAT'S HOT | RIDER'S GROUP | POST OFFICE

CONTENTS | CATALOG | INTERACTIVE PRODUCTS | DEALERS | FEEDBACK

TYPEFACES: The two main typefaces featured on the Website are Trek Base (see black "Wrench Force," above), a font designed specifically for Trek's promotional materials, and Trixie, more of a grunge font (see "Race Results," "News Flash," "OffRoad"). Trek's print materials are geared toward the hard-core rider, and its materials represent this rider's attitude (see below). Cedro Group's designers wanted to complement this attitude by designing the site with a cutting-edge typographic look.

Our durable legacy of USA hand crafted steel.

Twenty years ago, Trek USA began its practice of meticulously constructing custom steel road bikes that quickly earned a reputation for superior craftsmanship and performance. Today, as America's leading manufacturer of custom-quality bicycles, we dedicate more of our energies than ever to the design and production of outstanding steel bikes. Over the years, we've developed advanced technology and expanded our operations to meet worldwide demand for our high-quality bikes. Still, producing outstanding steel frames requires more than advanced equipment. It takes a pair of skilled human hands, a partnership between technology and craftsmanship. Trek employs both to the fullest.

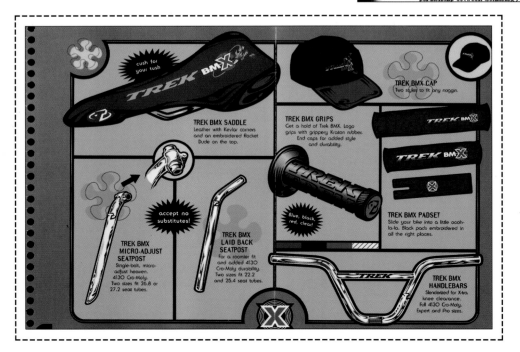

HIGH PERFORMANCE

$1200–$900

Y3

Race Results

NEWS FLASH

April 1997

OffRoad

through the world of Trek. Check out all our latest technology, meet the Trek race teams and ask us any questions you may have. Come and visit us at http://www.trekbikes.com. We'll be waiting for you!

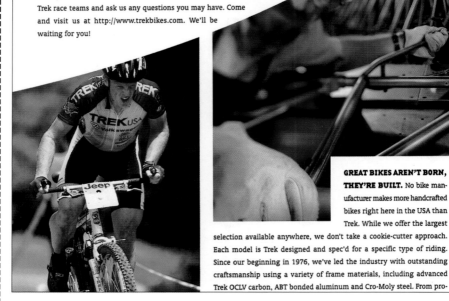

GREAT BIKES AREN'T BORN, THEY'RE BUILT. No bike manufacturer makes more handcrafted bikes right here in the USA than Trek. While we offer the largest selection available anywhere, we don't take a cookie-cutter approach. Each model is Trek designed and spec'd for a specific type of riding. Since our beginning in 1976, we've led the industry with outstanding craftsmanship using a variety of frame materials, including advanced Trek OCLV carbon, ABT bonded aluminum and Cro-Moly steel. From pro-

WELCOME TO THE...
TREK LIVE CHAT

TREK
BICYCLES

TREK HOMEPAGE
RIDERS' GROUP
POST OFFICE
TREK DEALERS
INTERACTIVE PROD.

Color: black Size: 3 (standard) Style: Plain
Comments:
Your signature: daniel

SUBMIT CLEAR RELOAD

But 8500 is much better.
- Toshyc said at 01:29 PM on Sat Jul 05, 1997 :
 Aluminum/bonded/team color or no painted
- Churchill said at 01:28 PM on Sat Jul 05, 1997 :
 Anybody know anything about the 97 Trek 8000?
- Toshyc said at 01:27 PM on Sat Jul 05, 1997 :
 Look at me
- Churchill said at 01:27 PM on Sat Jul 05, 1997 :
- Mr. Y said at 02:17 PM on Tue Jul 22, 1997 :
 the north face of one of our ski resorts was the extreme ski championship location
- Toshyc said at 01:26 PM on Sat Jul 05, 1997 :
 Hallo
- Churchill said at 01:26 PM on Sat Jul 05, 1997 :
 Hello???

TREK.MOV

SPECIAL FEATURES: Several elements built into the Trek Website make it a useful and fun experience. The "Trek Live Chat" area (above) allows viewers to communicate with each other from all over the world.

The Trek QTVR area lets viewers with a QuickTime VR player download a 1,724K movie (left and below) that can be rotated 360 degrees.

Tracking activity at the Trek Website shows that in summer months, the site averages 90,000 visitors per month, and each viewer visits about twelve pages. One area that receives a significant number of hits is the "Postcard Gallery" section (facing page), where viewers can create an electronic postcard and e-mail it to someone on the Internet.

TREK.MOV

TREK.MOV

Postcard Gallery

BLUES

JETTA TREK　　　　**Y FIVE-O**

RD

FRAME Freestyle full Cro-Moly COLOR Matte Dark Plum FORK Cro-Moly freestyle HANDLEBARS Trek Cro-Moly freestyle STEM Alloy 4-bolt AheadSet PEDALS Wellgo alloy platform ROTOR Fishbone UFO GRIPS Trek logo Kraton rubber w/replaceable end caps BRAKES DiaCompe 990 (W)

FRAME Freestyle 3-tube Cro-Moly COLOR Matte Metallic Green FORK Cro-Moly freestyle HANDLE-BARS Trek freestyle BRAKES Dia-Compe 990 rear, Bulldog front BRAKE LEVERS Tektro alloy

SEND POSTCARD

CHANGE CARD

PREVIEW CARD

CARD GALLERY

Send a postcard to a friend! Simply fill in the addressing info, type your message, choose your text color and send. It's that easy. If you'd like to preview the postcard, click preview card. Want to change the postcard, just click change card. Have fun!

Message:

32 USA

Recipient name:

Recipient e-mail address(es):

(Send to multiple recipients by separating e-mails with commas)

Sender name:

Sender e-mail address:

☒ **Include Today's Date**

Font Size:　　　**Font Color:**
○ **LG.**　　　◉ **Black**
○ **MD.**　　　○ Trek Red
◉ **SM.**　　　○ Ocean

DESIGN: Maintenance of the Trek site requires ongoing communication between the Cedro Group and Trek account executives. Almost a year passed between the first version of the site and the current one. During this time, the two companies worked together to evaluate what the Trek Webmasters could realistically manage in terms of providing new content. "The challenges were more planning problems than technical problems," says Andrew Chen, Cedro Group's creative director. "It's a huge site with a lot of different features. We had built a lot of features that were really neat but required too much maintenance. So we took some of them out, simply because no one had the time to monitor the site so closely. Trek did a good job of treading the line between great design with a lot of content and not letting it grow stale."

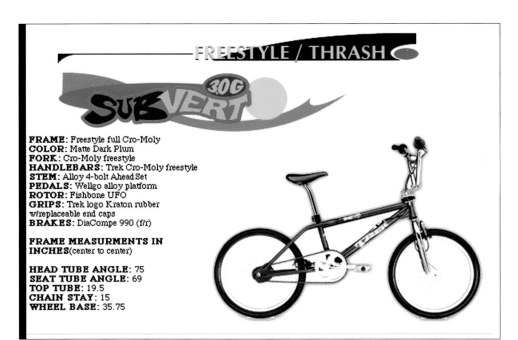

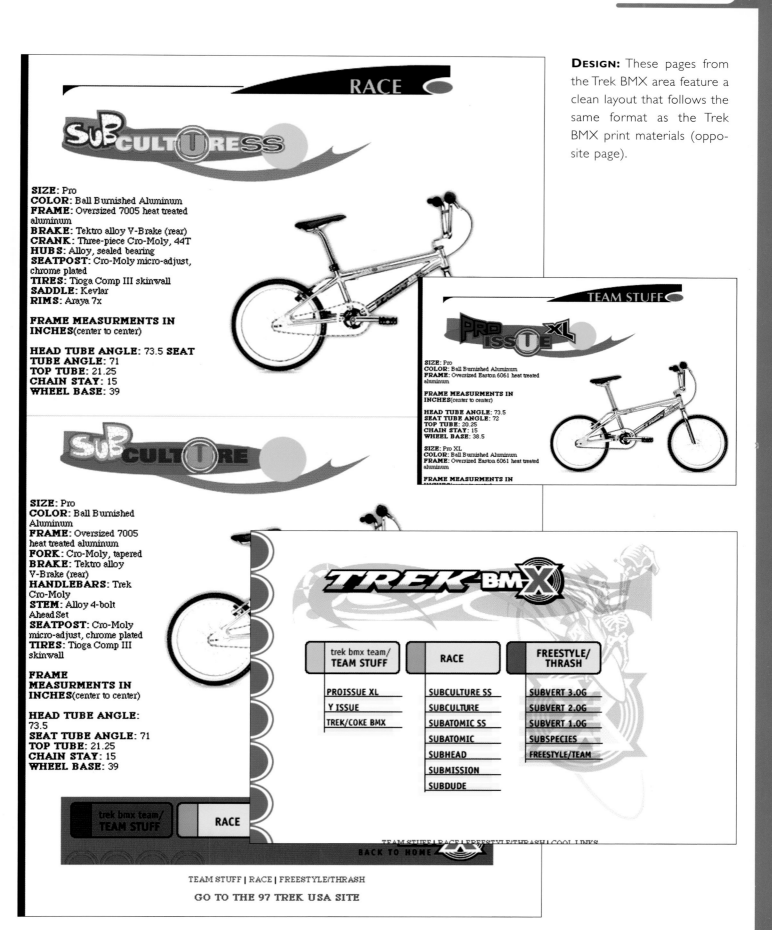

DESIGN: These pages from the Trek BMX area feature a clean layout that follows the same format as the Trek BMX print materials (opposite page).

RACE

SUBCULTURESS

SIZE: Pro
COLOR: Ball Burnished Aluminum
FRAME: Oversized 7005 heat treated aluminum
BRAKE: Tektro alloy V-Brake (rear)
CRANK: Three-piece Cro-Moly, 44T
HUBS: Alloy, sealed bearing
SEATPOST: Cro-Moly micro-adjust, chrome plated
TIRES: Tioga Comp III skinwall
SADDLE: Kevlar
RIMS: Araya 7x

FRAME MEASURMENTS IN INCHES(center to center)

HEAD TUBE ANGLE: 73.5 **SEAT TUBE ANGLE:** 71
TOP TUBE: 21.25
CHAIN STAY: 15
WHEEL BASE: 39

SUBCULTURE

SIZE: Pro
COLOR: Ball Burnished Aluminum
FRAME: Oversized 7005 heat treated aluminum
FORK: Cro-Moly, tapered
BRAKE: Tektro alloy V-Brake (rear)
HANDLEBARS: Trek Cro-Moly
STEM: Alloy 4-bolt Ahead Set
SEATPOST: Cro-Moly micro-adjust, chrome plated
TIRES: Tioga Comp III skinwall

FRAME MEASUREMENTS IN INCHES(center to center)

HEAD TUBE ANGLE: 73.5
SEAT TUBE ANGLE: 71
TOP TUBE: 21.25
CHAIN STAY: 15
WHEEL BASE: 39

TEAM STUFF

PRO ISSUE XL

SIZE: Pro
COLOR: Ball Burnished Aluminum
FRAME: Oversized Easton 6061 heat treated aluminum

FRAME MEASURMENTS IN INCHES(center to center)

HEAD TUBE ANGLE: 73.5
SEAT TUBE ANGLE: 72
TOP TUBE: 20.25
CHAIN STAY: 15
WHEEL BASE: 38.5

SIZE: Pro XL
COLOR: Ball Burnished Aluminum
FRAME: Oversized Easton 6061 heat treated aluminum

FRAME MEASUREMENTS IN INCHES(center to center)

TREK BMX

trek bmx team/ TEAM STUFF	RACE	FREESTYLE/ THRASH
PROISSUE XL	SUBCULTURE SS	SUBVERT 3.0G
Y ISSUE	SUBCULTURE	SUBVERT 2.0G
TREK/COKE BMX	SUBATOMIC SS	SUBVERT 1.0G
	SUBATOMIC	SUBSPECIES
	SUBHEAD	FREESTYLE/TEAM
	SUBMISSION	
	SUBDUDE	

TEAM STUFF | RACE | FREESTYLE/THRASH | COOL LINKS
BACK TO HOME

TEAM STUFF | RACE | FREESTYLE/THRASH
GO TO THE 97 TREK USA SITE

VSA Partners designed both the print and Web versions of the 1996 Time Warner Annual Report. This project shows how VSA Partners transformed the print piece into a Website that gives Time Warner shareholders clear and easy access to important information. ▪ "We feel that the annual report Website, though it has to embody the brand and character of Time Warner, is not necessarily an entertainment site," says Jeff Walker, VSA Partners' content director. "A lot of people are going there specifically because they don't have access to the print annual report and want to get data quickly, or they want to get a brief overview of how one of the operating divisions of Time Warner performed that year." ▪ Because the designers of the annual report Website were also the designers of the print version, they had an intimate understanding of the challenges that arose in translating the information from print to the Web.

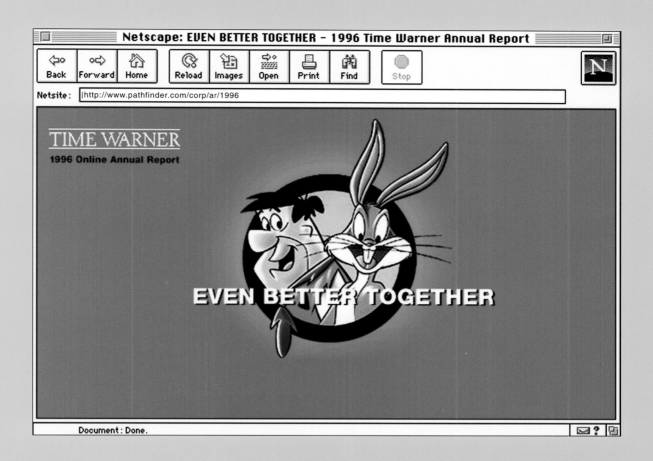

DESIGN FIRM: VSA Partners

CREATIVE DIRECTORS: Dana Arnett, Curt Schreiber

DESIGNERS: Ken Fox, Fletcher Martin, Jason Eplany, Geoff Mark

PRODUCER: Geoff Mark

COPY: Time Warner

PROGRAMMERS: Derik Noonan, Geoff Mark, Jason Eplany

CONTENT DIRECTOR: Jeff Walker

TIME WARNER: Sussanne Arden, Brian Wilson, Cheryl Blech

(See page 160 for full credit listings)

TOOLBOX

HARDWARE: Macintosh

SOFTWARE: Photoshop, Director, SoundEdit 16, BBEdit

TYPEFACES: Helvetica Extra Compressed

SPECIAL FEATURES: Shockwave, JavaScript

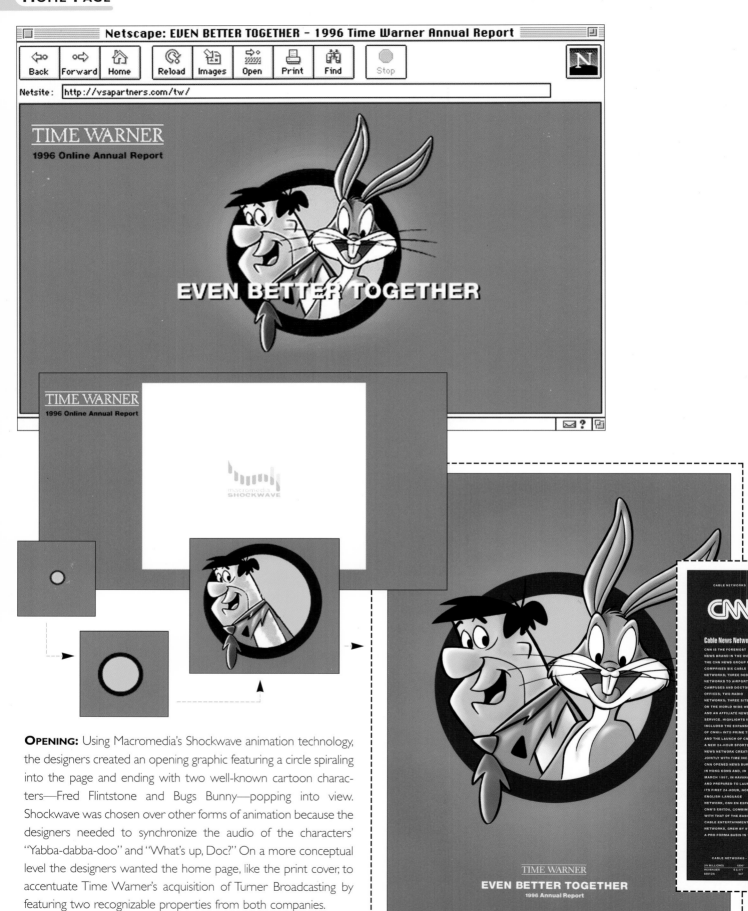

OPENING: Using Macromedia's Shockwave animation technology, the designers created an opening graphic featuring a circle spiraling into the page and ending with two well-known cartoon characters—Fred Flintstone and Bugs Bunny—popping into view. Shockwave was chosen over other forms of animation because the designers needed to synchronize the audio of the characters' "Yabba-dabba-doo" and "What's up, Doc?" On a more conceptual level the designers wanted the home page, like the print cover, to accentuate Time Warner's acquisition of Turner Broadcasting by featuring two recognizable properties from both companies.

Dear shareholders:

On behalf of Time Warner, I want to welcome the shareholders and employees of Turner Broadcasting. Separately, our two companies helped shape the global media and entertainment industry. By joining our uniquely complementary assets, talents and cultures, we have created an enterprise without peer. The words on the cover of this report

CONTENT: Though the designers had some leeway in designing the look of the online version, the content of the print annual report was transferred in its entirety to the Website. Once Time Warner's lawyers approved the printed piece, no changes to the content could be made. Rather than try and add additional features for entertainment value, the designers focused on finding the best way to navigate the information. Some areas, such as the "Dear Shareholders" opening text (left) were reset and transferred to the Web with very little change. Other areas, like the CEO's letter (below), had to be redesigned from a horizontal format to a vertical scrolling format.

The overriding objective of our investments and acquisitions -- the most significant being Turner Broadcasting -- has been to build the finest array of creative and journalistic franchises in combination with unmatched global distribution networks, so that our shareholders can reap the benefits.

This goal has required a sizable outlay of corporate resources. At the same time, the period of regulatory approval necessary for the Turner merger and the equity issued to close it kept our stock price depressed. We appreciate your patience and understand your frustration. Equally, we understand that your overwhelming vote in favor of the merger was a mandate for us to do what must be done to make our share price reflect the real value of what we have created.

Gerald M. Levin
Chairman and Chief Executive Officer

ACCELERATING RETURN ON CAPITAL

Our focus is on both deleveraging our company and generating faster growth in order to accelerate our return on capital. By increasing free cash flow -- cash from operations, minus capital expenditures -- we will be able to fuel our growth, reduce our debt and, over time, buy back stock. As part of these initiatives, we are committed to reducing our exposure to cable. At the same time, we will continue to seek ways to simplify our structure. We will also put a lid on capital spending, thus improving our overall return by driving growth off less capital employed.

We have begun a cost-management program to find better, more efficient, ways to do business that will have a permanent impact on what we spend. Simultaneously, as we control capital outlays and costs, we will exploit the many opportunities that Turner gives us to cross-promote our brands and spur their growth.

STRATEGICALLY COMPLETE

With the addition of Turner Broadcasting, Time Warner is strategically complete. The rapid progress we have made in consolidating our companies is proof both of the compatibility of our operations and the commitment to teamwork throughout our divisions.

All our cable networks are now gathered in the Cable Networks Group, which is led by Ted Turner -- one of the formative geniuses of the programming industry -- who also serves as Time Warner vice chairman. The Group has already launched two new networks: CNNfn and CNN/SI. Soon it will add CNN En Español to this list. Warner Bros. is bringing the infrastructure of our film libraries, animation, syndication, consumer products and home video operations under one roof.

Cartoon Network, the fastest-growing basic cable channel, which is already in over 40 million U.S. homes, brings [expo]sure to our Hanna-Barbera and Looney Tunes collections and is a valuable promotion outlet for our [prod]ucts. Internationally, Cartoon Network is in over 85 markets, and we believe it has the potential to [be] the most significant entertainment assets in the world.

[ov]erriding objective of our investments [and a]cquisitions—the most significant being [Turne]r—has been to build the finest array of [creati]ve and journalistic franchises in com-[m]on with unmatched global distribution [netwo]rks, so that our shareholders can [reap t]he benefits."

STRONG PERFORMANCE

[Our re]sults indicate, our operating performance has never been stronger. Each division continued to be a [cat]egory. Publishing, Filmed Entertainment, Cable Networks, and Cable all set new records.

[...] its third record year in a row. *People*, *Sports Illustrated* and *Time* were listed by the Publisher's [Bu]reau as the year's top three consumer magazines. *Entertainment Weekly*, the company's fourth and [...] -- no other company has more than one -- had its first year of profitability, well in advance of our

[...]ce of our Cable Networks division was outstanding. TNT passed a new milestone as it became the No.1-rated basic cable network in prime time. TNT, CNN and TBS are now each in over 70 million homes. A tenth straight record year for HBO and Cinemax reflected a 2.7 million increase in subscriptions, bringing the total to 32.4 million.

CNN News Group
630
million viewers worldwide

and acquisitions—the most finest array of creative and unmatched global distribution the benefits."

DESIGN: "The Value Creation Process" also uses Shockwave to entice the viewer into reading and interacting with the information. Since this area encompasses one of the key elements of the report (explaining how the company builds value and brand recognition through its network and distribution channels), the designers wanted to portray this clearly and quickly. The printed report features a single illustration to demonstrate the concept. The interactive animation on the Website allowed the designers to walk the viewer through information to help educate and explain how Time Warner builds shareholder value through its network assets, branded properties, and distribution channels.

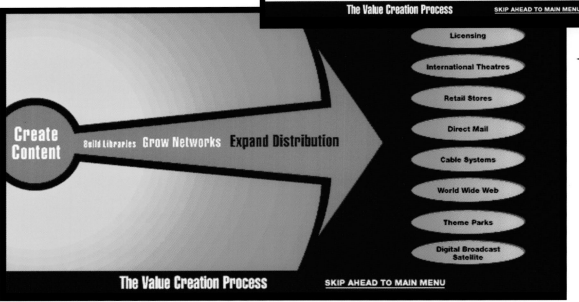

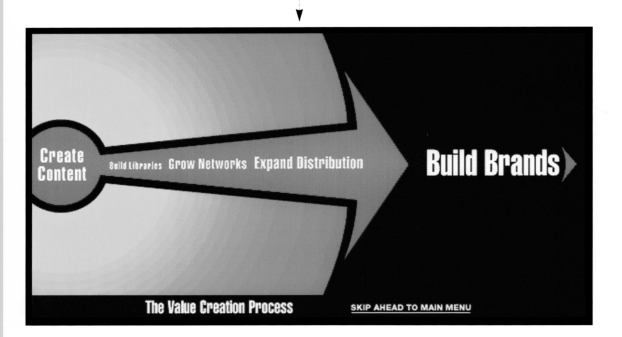

Building the Batman Brand

FILM MERCHANDISE THEME PARKS SOUNDTRACK

CNN LOONEY TUNES HOW TIME WARNER CREATES VALUE MAIN MENU

DESIGN: The main navigation graphic (below) consists of an image-mapped graphic that links to the rest of the annual report. JavaScript rollovers were implemented on each of the top and bottom headers, such as the "How We Create Value" header (inset below).

Shareholder Letter How We Create Value Financials

Corporate Management Group Board of Directors Operating Officers Investor Information

value.

half-hour of ght libraries,

CNN
HBO
CINEMAX
TNT
TBS SUPERSTATION

Licensing
International Theatres
Retail Stores
Direct Mail

Grow Networks Expand Distribution

CARTOON NETWORK
Headline NEWS
TCM
WB

Cable Systems
World Wide Web
Theme Parks
Digital Broadcast Satellite

Build Brands

CNN International CNN CNNfn Interactive CNN Airport Headline News

Theme Parks Broadcast TV Film Merchandise Cable Networks Video

DESIGN: Time Warner had seen the work the VSA team had done on the Harley-Davidson Website and asked the firm to produce both the printed and online versions of the annual report. "Converting the annual report was great because we knew we had content that was well-defined and pre-approved," says VSA Partners Director of New Media Geoff Mark. "We knew all of the images that we had available, so the only challenge was coming up with an effective navigation format and an engaging interface that still retained the feel of the book. The site doesn't look like boilerplate HTML hypertext. I think we definitely gave it an impact graphically."

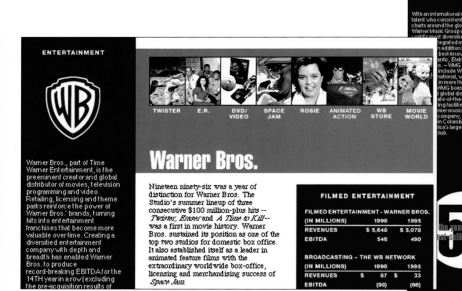

SIMILARITIES: The design team followed the look of the printed annual by keeping many of the design elements from the printed piece, such as the blue sidebars, and the appropriate background colors used behind operating division pages, such as the CNN photographic images (below).

PUBLISHING

Time Inc.

| TIME MAGAZINE | ENTER-TAINMENT WEEKLY | PEOPLE EN ESPAÑOL | COOKING LIGHT | ABSOLUTE POWER | CENTURY OF WARFARE |

Time Inc. is the world's foremost creator of publishing and information brands, including America's most successful magazines, best-selling books, favorite book clubs and popular Internet sites. It is also a leading direct marketer of books, music and video.

Time Inc. is synonymous with journalistic excellence and innovation. It pioneered the concept of specialized magazines. At its core are 28 titles that continue to set standards in their categories — powerful brands whose evolution into new products extends their franchises. They made 1996 a year of record EBITDA, with 12% growth.

Time Inc.

Despite vigorous competition in 1996, Time Inc. once again outperformed the industry. Time Inc. magazines boosted both circulation and advertising revenues, increasing their already sizable portion of ad-revenue market share. Three Time Inc. titles -- *People, Sports Illustrated* and *Time* -- were the top consumer magazines in advertising revenues for 1996. These three titles, along with two other Time Inc. magazines also among the top ten overall in ad-revenu

GROWTH THROUGH BRAND EX

No one has magazine brands like Time Inc growth by developing popular new produc For example, the Olympics inspired *Spor* produced on-site at the Games for 18 cons special; *SI Presents'* first Olympic commemorative issue (published 72 hours after closing ceremonies); and the first *SI* Olympic Website. Collaboration with CNN led to the launch of CNN/SI, a 24-hour sports-news cable network. A sports magazine for women and a weekly TV series on CBS based on *SI For Kids* will debut in 1997.

No one has publishing brands l
Time Inc., and no one is more a
developing popular new produ

CABLE NETWORKS

| CNNfn | NEW VENUES | INTERNATIONAL | CNN/SI | INTERACTIVE | HEADLINE NEWS |

Cable News Network

CNN is the foremost news brand in the world. The CNN News Group now comprises six cable networks; three dedicated networks to airports, campuses and doctors' offices; two radio networks; three sites on the World Wide Web; and an affiliate news service. Highlights in 1996 included the expansion of CNNfn into prime time and the launch of CNN/SI, a new 24-hour sports news network created jointly with Time Inc. CNN opened news bureaus in Hong Kong and, in March 1997, in Havana; and prepared to launch its first non-English-language network, CNN en Español. CNN's EBITDA, combined with

The CNN News Group's many brand extensions rely on the continued strength of the core domestic network. CNN is the largest cable service in the U.S., with cable and satellite distribution to more than 71 million households. In a newly competitive environment, CNN maintained its leadership in television journalism with unmatched breaking news coverage of events such as the U.S. presidential campaign, the TWA Flight 800 explosion and the hostage crisis in Peru. New programming included *Burden of Proof*, which evolved into a daytime legal series; a quarterly magazine, *American*

CABLE NETWORKS - TBS		
(IN MILLIONS)	1996*	1995*
REVENUES	$ 2,477	2,106
EBITDA	547	502

* Pro forma

CNN INTERACTIVE

CNN Interactive operates the World Wide Web's top general-news (CNN.com), business (CNNfn.com) and political (AllPolitics.com) sites, generating 16 million page views a week and proving that cyberspace can be profitable – with revenue increasing 451% to $10 million in 1996.

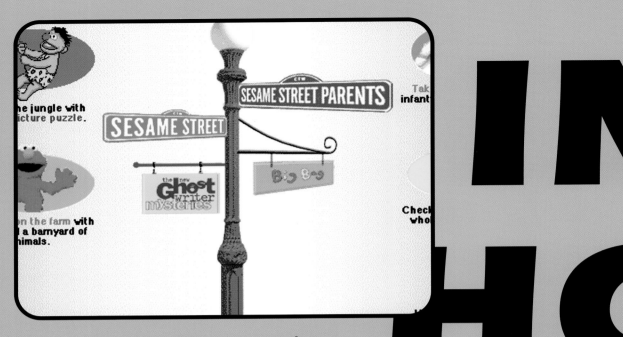

CHILDREN'S
TELEVISION
WORKSHOP

PUBLISHERS
DEPOT

Welcome to Publishers Depot!

the BEST FIRST STOP for STOCK

Publishers Depot is the creative professional's best first stop for **stock photography, fonts, illustrations, maps** and much more. Membership to Publishers Depot is **free!** So take a look around -- you will find that all the digital media you need is right here.

Already a member? Enter here.

If not...

Try a sample [SEARCH] in the Stock Photos Store...

Take a look at "Using Publishers Depot - A Visual Demo"...

SE WEBSITES

USE
BSITES

PRIMO ANGELI

PAPERMAG

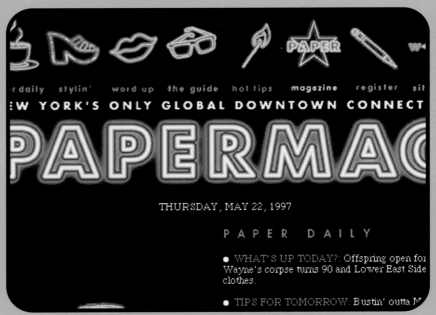

Paper magazine is a leading New York cultural magazine for Generation X'ers. Its Website follows in the footsteps of the print magazine, but takes the concept to another level, using technology and design elements not available in the print medium. ▪ "The thing is, don't take print where print doesn't belong," says the site's creator, Bridget deSocio. "It's an environment that is driven by light, so change the rules. Don't make edges. It's an edgeless, horizonless space. I didn't want to design a Website that looked anything like Paper; it's not about Paper anymore. It's not paper, it's a monitor, it's RGB—so start with what it already is, don't bury it or force it." ▪ Papermag.com focuses on New York City nightlife but is directed toward a wider audience by incorporating film, music, and fashion sections that offer a global viewpoint. The neon icons used throughout the site are a familiar, universal motif recognizable by young urbanites worldwide.

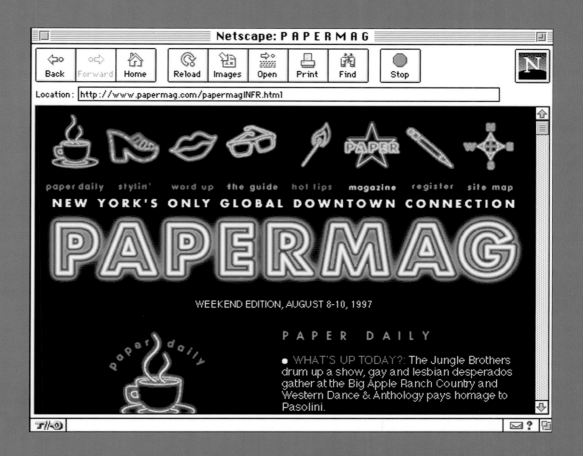

DESIGN FIRM: Socio X

EDITORS AND PUBLISHERS: Kim Hastreiter, David Hershkovits

CREATIVE DIRECTOR: Bridget deSocio

DESIGNERS: Lara Harris,

Mayra Morrison, Greg Smith

PRODUCER: Noah Koff

COPY: Angela Tribelli, Shana Liebman

PROGRAMMERS: Michael Rais, Larry Yudelson

ADVERTISING EXECUTIVE: Jonathan Landau

TOOLBOX

HARDWARE: Macintosh

SOFTWARE: Photoshop, Premiere, Illustrator, BBEdit, SoundEdit 16

TYPEFACE: Futura Bold

SPECIAL FEATURES: GIF89a animation, JavaScript, QuickTime video, WAV audio

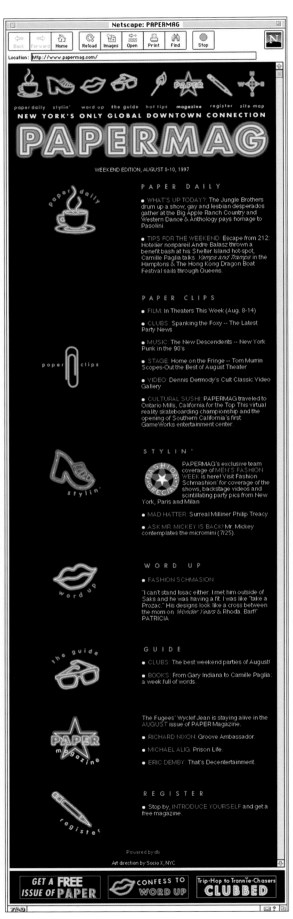

HOME PAGE: Frames within the *Papermag* Website make it easier for the viewer to navigate through each page. The main header icons are placed at the top of the page to further aid the viewer. The main frame area is the home page (which can be compared to the print contents page, right), which gives the viewer current information on the daily and weekly updates to the site. The long vertical page (left) shows the entire length of the scrolling home page, designed to fit within a window 640 pixels wide.

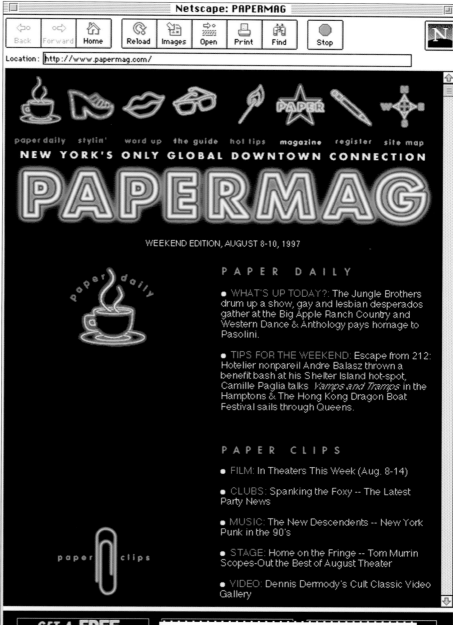

ANIMATION: Two of the most frequently updated, and most visited departments are "Paper Daily" and "Paper Clips" (right).

To add movement to the home page and direct the viewer's eye to specific departments, the designers implemented dynamic GIF89a animations—the neon match and the coffee cup for (below and left).

TYPEFACES: Neon headlines and artwork (such as "ask mr. mickey," right) are created using Photoshop, the PhotoGIF plug-in, and DeBabelizer for batch-processing large groups of images. The Netscape browser—the main browser viewers use to visit the site—allows users to change the default typeface for HTML copy, but because few users actually change their defaults, the designers incorporated the "Fontface" HTML tag to temporarily change the viewer's default font in some areas from the usual Times. Initially, the designers used Futura, but have since switched to Helvetica for Macintosh users and Arial for PC users. While viewers are in the site, their browsers use the specified font in areas such as "Ask Mr. Mickey" and "Videoclips" (right).

To deal with the large amount of content updated weekly, editorial staff who work specifically for the Website plug copy into a proprietary publishing tool that automatically generates templated HTML pages.

VIDEO: Dennis Dermody's Cult Classic Video Gallery

[Videoclip: Primitive Love] 2.17 MB, (Something Weird Video)

This rare 1964 Jayne Mansfield film directed by Luigi Scattini features *Mondo Cane*-like footage two goofy Italian comics named Franchi and Cic and Jayne herself as an anthropologist! In one unbelievable fantasy sequence, Jayne does a w Hawaiian dance to an Annette Funicello song w wearing a black wig and sarong, only to be carri off by muscleman husband Mickey Hargitay. Transferred from the original 35mm negative, *Primitive Love* has to be seen to be believed.

HOT TIPS / clubs

MONDAY ● TUESDAY ● WEDNESDAY ● THURSDAY
FRIDAY ● SATURDAY ● SUNDAY ● CLUB INDEX

Gone are the days of anything goes. Mayor Giuliani's strangle-hold on life after dark created an unnecessary police pressure on the scene. Club czar Peter Gatien had his Limelight and Tunnel repeatedly shut down and Junior Vasquez's Saturday night at Tunnel was moved to Palladium's Arena. Last year's club circuit drama culminated when Michael Alig was arrested after Angel Melendez's body floated down the Harlem River.

On the positive side, Twilo, System and Vinyl continue to draw crowds while new venues Opera, 2i's, Plush and Chaos kicked open their doors. Also, meatpacking fixtures Johnny Dynell and Chi Chi Valenti gave their perennial party, Jackie 60, a home and renamed it Mother, and the Sound Factory's may have found a permanent home in midtown.

paper clips

cultural sushi

DAILY

last week's paper clips tips for tomorrow what's up today

stylin' register magazine word up site map the guide hot tips home

paperclips | cultural sushi | last week's paper clips | tips for tomorrow | what's up today |

stylin | register | magazine | word up | site map | the guide | hot tips | home

e to our demented weekly
hion advice column. Mr. Mickey will
u to high style status with tips on sex,
, style and grooming - so send him
estions and look here for his answers!

r. Mickey,
you think of this micromini -- make
mini -- they're showing? Will anyone
ght mind wear it?
ver

ini,
over of exposed pussy, Mr. Mickey
r skirt can never be too short -- just
e man's tighty whiteys can never be
. But we can't all be as demonstrative
ly assaulting as Mr. Mickey -- too bad
y as a whole but all the better for Mr.
popularity among the press. (When
oking for overdressed, paunchy

M. 'Til Dawn
Where to get a life.
CAVAL, JUNE JOSEPH AND WILLIAM VAN METER

Blowin' up the spot at Blow Pop

ounds great, the
and the beat goes
.
d E-Man set the
orm fun. The best

the free buffet)
ht is Scot-Free's
ack room. E-Man
k, house, etc. No

SDAY
scintillating sirens
rias and Raven-O,

grace the stage of this long-running
downtown lounge. Saturdays and
Sundays, too. $5, Bar d'O.
Beige Come to Erich Conrad and
Edwige's carefully cultivated event
that's strictly for campy and cool
downtown types. No cover, B Bar.
Camouflage 50/50 Productions
brings a necessary night of jungle to
the L.E.S. with resident DJs Beau,
On-E and Christian Bruna spinning
for the devoted regulars. Highly rec-
ommended. $3/$5, 205 Club.
Groove School Classic soul and

raunchy rock rub shoulders courtesy
of DJ Seth K. No cover, Sapphire.
In Like Flint Martini- and cos-
mopolitan-slugging hipsters lounge
around at this swank retro party,
held every other Tuesday. Come
and meet the swingin' folks of the
lounge dynasty, where bee-
hives and skinny ties are the
norm. Free cocktail with
admission. $10, Void.
Jackie 60 With the Mother of
all parties, Chi Chi Valenti and
Johnny Dynell keep the true
spirit of the club scene alive.
Call 929-6060 for weekly info,
themes and dress codes.
$10, Mother.
Latin Roots Rene Lopez hosts an
evening full of *sabor*. DJ Frankie
Inglese rocks the party old-school
Latin style while you perfect your
salsa moves. $5, Belmont Lounge.
Original Flava This one's from the
people who brought you the long-
running Giant Step party, so you
know it won't be half-stepping.
Guest DJs express a more experi-
mental side of the Groove
Academy. For venue details, call
the hot line at 714-8001. $10.
Studio Filthy Whore Mario Diaz
and DJ Adam take Z Bar hostage
for the night with two floors of fun.
DJ Joe Joe spins deep house
downstairs in the cool, cavernous
basement where anything can hap-
pen...and usually does. $7, Z Bar.
Sweet Thang Big Frank and
Everton move on up to the West
Side, where Spark Ronson sparks
your interest with the hip
hop/R&B stylee that the ladies
love. $5/$10, Rebar.
Voices Like stepping into Natalie's
New York Undercover's fictitious
'bourgie' hangout, right down to
the surprise celebrity performers.
DJ Cadet spins urban-friendly
tracks downstairs. $10 cover/two-
drink minimum at tables, Nell's.

WEDNESDAY
Cream They might have taken
Cake away, but they can't stop
pied piper Mario Diaz from bring-
ing this creamy affair to a new
spot. Rotating DJs like Lily of the
Valley and Misstress Formika spin
rock 'n' roll while the boys dance

(Continued on following page)

CLUBS

BY ALICE ARNOLD PAPER Guide ★ 9

Published: WEEKEND EDITION, AUGUST 8-10

CLUBS : Spanking the Foxy -- The Latest Party News

"Shooting ping-pong balls out of your ass," now
that's **Foxy**. Mario Diaz and Adam's new party
Saturday night party at Velvet (167 Ave. A,
475-2172) dares you to perform your most
outrageous stunt for the chance to win $100. **Foxy**
is the spawn of the East Village's beloved **Cream**
party, formerly Wednesday nights at Velvet (and
Cake before that).

Published: TUESDAY, AUGUST 5, 1997

VIDEO: Dennis Dermody's Cult Classic Video Gallery

[Videoclip: Primitive Love] 2.17 MB, (Something Weird Video)
This rare 1964 Jayne Mansfield film directed by Luigi Scattini features *Mondo Cane*-like footage, two goofy Italian comics named Franchi and Ciccio, and Jayne herself as an anthropologist! In one unbelievable fantasy sequence, Jayne does a wild Hawaiian dance to an Annette Funicello song while wearing a black wig and sarong, only to be carried off by muscleman husband Mickey Hargitay. Transferred from the original 35mm negative, *Primitive Love* has to be seen to be believed.

SPECIAL FEATURES: Two dynamic features implemented on the Website are located in the "PaperClips" area. Streaming QuickTime video clips are offered in the film reviews section (below), and audio clips supplied as WAV files can be heard using the Netscape audio player (right). A GIF89a animation of a neon speaker with sound waves coming out of it (right and above) is an immediate visual cue that a music clip is available for listening.

PAPERCLIPS

Published: THURSDAY, AUGUST 7, 1997

MUSIC : The New Descendents -- New York Punk in the 90's

In my last column, I recommended a few local post-punk groups. But what of classic punk, still flourishing here so many years later, in the shadow of hit California bands like Green Day, Offspring and Rancid?

Anyone who uses the word "revival" is hideously misinformed. You don't have to read *Maximum Rock 'n' Roll* to know that battalions of bands in every big burg have fa... formula for twenty year... CBGB's, Max's Kansas... Mabuhay and The Mas... the New York hardcore... unchanged from the ea... *York Thrash*- era.

The Playgirls and The Vampire

RETURN TO
PAPER CLIPS

stylin' home magazine word up register the guide hot tips paper daily

stylin | home | magazine | word up | register | the guide | hot tips | paper daily

Cybermania is only going to get bigger. In the three years since the advent of the Web, 11 percent of homes went on-line. With next year's $200 WebTV start-up kits that allow you to access the Web through your TV, the net in 1997 is going to get really crowded. Last year, Silicon Alley received large cash infusions from media and ad agencies while many companies -- America Online, for example -- experienced growing pains. N.Y.C. finally launched its first silicon alley firm, Flatiron Partners, and many new ones are on the way. The cyberscene spread from cafes to clubs with cyberparties for new Web sites and digital music shows like Orbital and Chemical Brothers. For every site that dies in 1997, 50 more will be put up as new media struggles to find its Orson Welles. The information superhighway ended in 1996; now if only cable modems were ready and somebody would win the browser wars... J.C.

A gourmet is nothing but a glutton with brains, and this years gargantuan food roundup does have a soupcon of intelligence behind it. Some of the best brains in the business are Stephen Lyle, who brought us Odeon, Bodega and Independent, and Katy Sparks of Quilty's.

A boom of zesty nuevo Latino restaurants, which used to be found only in shabby storefronts, as well as a boom of good places to eat in Williamsburg, are breaking culinary (and geographic) boundaries. Also, New Yorkers have become fascinated with soups, raw bars and the newest addition to sandwich cuisine: the wrap. And let's not overlook the rebirth of the diner, offering comfort food with an ethnic twist at popular prices -- enough to make New York feel a little more like home. J.B.

by Julie Besonen, Christine Muhlke, Jason Oliver Nixon and Jonathan Hayes

stylin' register **magazine** word up site map the guide hot tips paper daily

Print to Web: Only three articles from the print magazine are repurposed for the *Papermag* Website each month. These articles are used in the "Magazine" section to promote the print magazine. All other content (including the in-depth "Guide" to New York, above and right) is written and edited specifically for *Papermag* by the Web magazine's two copywriters and *Papermag* interns.

DESIGN: In creating the *Papermag* Website the designers had to go beyond what they refer to as the "print paradigm." As designers with print backgrounds, they faced a real challenge to figure out what to offer Web viewers. "From a design standpoint, we try to design the site for people who only spend a very small amount of time visiting the site and who just want to check into their community, whether it's the 'Word Up' forum, chatting, or reading 'Paper Daily,'" says Noah Koff, *Papermag* producer. "We designed the site to be super-functional for people who have very little time to spend at the site. We're constantly defining the site, based on feedback from users."

PAPER DAILY

FOURTH OF JULY WEEKEND EDITION, JULY 3-6, 1997

- What's Up Today
- Tips For Tomorrow

what's up today

THURSDAY

Tell us something about yourself and
what brings you to our neck of the hood.

Your Name:

Have a hot tip? Share it with Managing
Editor Angela Tribelli. If we use your tip,
we'll send you a copy of the latest issue of
our hard copy magazine, PAPER.

read it

...and don't weep.
inted matter still matters.

Your Name:

We recently checked in with our brilliant friend Manolo Blahnik, who continues to invent the most genius shoes in the world. His humor, openness and impeccable taste make him the king in our book. With his high energy, which sometimes borders on fun hysteria, the dramatic Blahnik met us for cocktails at the St. Regis, where he hyperventilated about the dramaramas of what it's like trying to be an artist while remaining commercial (or, as he calls it, prostitution). ★ Kim Hastreiter

"Animals are much more refined than human beings!"

The

CHILDREN'S TELEVISION WORKSHOP

HTTP://WWW.SESAMESTREET.COM

Children's Television Workshop (CTW) is an icon in the world of children's programming. Sesamestreet.com follows on the heels of the company's traditional marketing venues—television and print publications—and is quickly becoming another powerful format for developing the Sesame Street brand. ▪ The current version of the Website is the third redesign since the site went live in March 1996. The first information featured on the Website was mainly Sesame Street preschool activities and content from Sesame Street Parents magazine. "We worked on creating templates for porting printed content to the Web, and didn't pay much attention to the design," says Karen Kane, director of online product development. "Then about a year later, we spent some time on just the look and feel and creating more sophisticated graphics for the front end. In May of 1997 we went live with what is currently on the Website." ▪ Though its designers are always looking to make the site better, this latest version offers children and their parents a wealth of information and enjoyment.

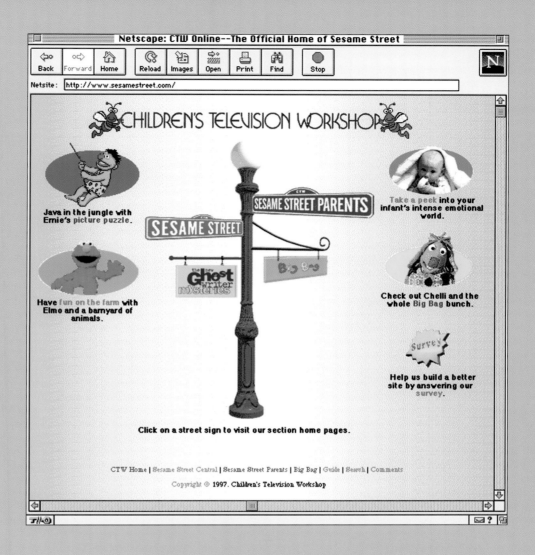

DESIGN FIRM: Children's Television Workshop

DIRECTOR OF ONLINE PRODUCT DEVELOPMENT: Karen Kane

TECHNICAL DIRECTOR: Leland Woodbury

PRODUCERS: Ramona Gonzales, Roger Widicus

ASSISTANT PRODUCER: Robert Ruiz

ONLINE EDITOR: Katie Magee

ART DIRECTOR: Russell Zambito

LEAD ARTIST: Jonathan Gladding

DESIGN CONSULTANTS: Cybergrafix, Steve Jaworski, Amy Yang

SOUND DIRECTOR: Miles Ludwig

PROGRAMMERS: Jeff Harington, Ben Wright

SITE ENGINEERING: Arcus Incorporated, Phoneware Inc.

PHOTOS: PhotoDisc Inc.

DIRECTOR OF FINANCIAL ANALYSIS: Teresa Turano

MARKETING MANAGER: Ellen Gold

VP INTERACTIVE PRODUCTION: Glenda Revelle

VP INTERACTIVE: Rob Madell

PUBLISHER: Nina B. Link

TOOLBOX

HARDWARE: Macintosh, Windows PC

SOFTWARE: Photoshop, DeBabelizer, GIF Constructor, Fusion, BBEdit, WordPad, RealMedia, Oracle, SWISH (site search)

SPECIAL FEATURES: GIF89a animation, Java games

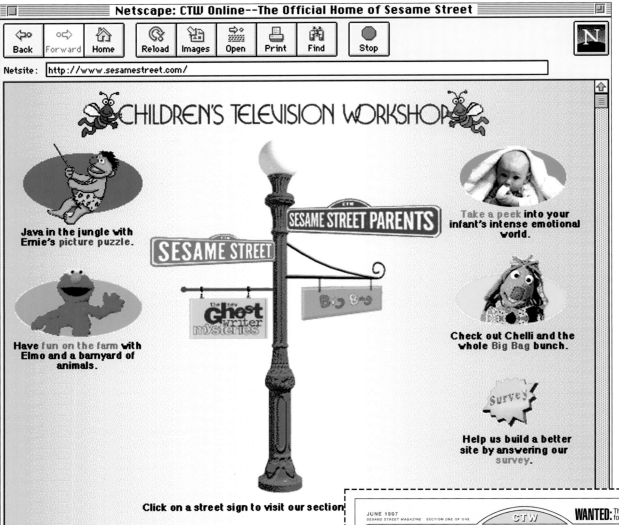

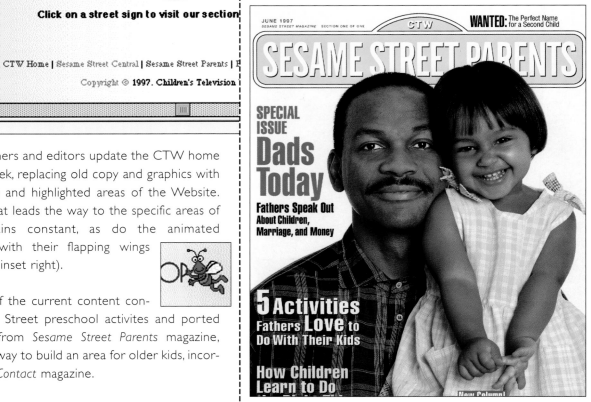

DESIGN: Designers and editors update the CTW home page once a week, replacing old copy and graphics with new animations and highlighted areas of the Website. The signpost that leads the way to the specific areas of the site remains constant, as do the animated "Twiddlebugs" with their flapping wings (see above and inset right).

Though most of the current content consists of Sesame Street preschool activites and ported print material from *Sesame Street Parents* magazine, plans are underway to build an area for older kids, incorporating *3-2-1 Contact* magazine.

Pick Up and Go!
By Laura Manske

Mini vacations that are only a tank of gas away.

It's summer--have you vacation yet? If you're parents of preschoolers have been too busy tyin to make plans in advanc Fortunately, there's a s mini-vacation. That's w family has been doing f and, like us, more and parents are thinking sm Mini-vacations, or wee getaways, tend to be les expensive, and you dor do much planning or pa Besides, they're great f with preschool-age chil Carole Terwilliger Mey

mother of two and the author of *Weekend Adventures in Northern California* (Card So here are some terrific ideas for getaways your family will love.

SUMMER IN THE CITY
Because cities are not a typical summer destination, it's a good bet that you'll find discounted hotel space. But that's not the only reason to go: You'll also find all kinds of free entertainment, such as concerts and street fairs. And cities, with their generous assortment of

Search • Discussions • CTW Home

NAVIGATION: The CTW team feels that easy navigation is an important design issue, so it has tried to make the viewer experience as simple and intuitive as possible. The most challenging area of the site was the Sesame Street Parents section, where frames are implemented. The pages are broken into three frames: the navigation frame where the seven major content buttons are located, a narrow horizontal bar frame at the bottom, and the main viewing frame. The biggest problem is referencing articles in the viewing area, which the designers

are in the process of improving. Currently, when a viewer tries to bookmark an article in this area, the main frame is the only one bookmarked. Viewers then must find the article again. Sophisticated Web users often find frames to be problematic, while novice users may find they allow for easier navigation because the site's structure is on the screen at all times.

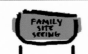

This Week's Features

Pick Up and Go!
Great ideas for quick weekend getaways.

Happy Feet
When kids move to music, they laugh and learn. You can help them make the most of the fun.

Secrets of Self-Portraits
When a child draws a picture of herself, what is revealed? More than you might think.

Browse Activity Topics
Click on any of the following subjects to access articles:
Arts & Crafts
Computers
Cooking
Events
Holidays
Make-Believe
Music, Art & Drama
Rainy Days
Sports
Travel

SESAME STREET PARENTS
- Activities
- Behavior & Discipline
- Child Development
- Education
- Family & Community
- Health & Safety
- Reviews & Products

Don't forget to visit...

SESAME STREET CENTRAL

FAMILY SITE SEEING

Take your child on a fun-filled tour of the Web's most exciting and educational destinations. This week, your little web surfer can explore the human heart, search for heroes, and publish a story.

CONTENT: One of the goals of the site was to create an automated process for taking print material and placing it into standardized templates and layouts, so pages don't have to be created from scratch every week. In many cases the editors repurpose information directly from the print magazine, so articles and copy have to be organized differently. Rather than dealing with departments and feature articles, the content has been segregated into seven broad categories (inset below). This makes the weekly articles and archives more accessible to viewers.

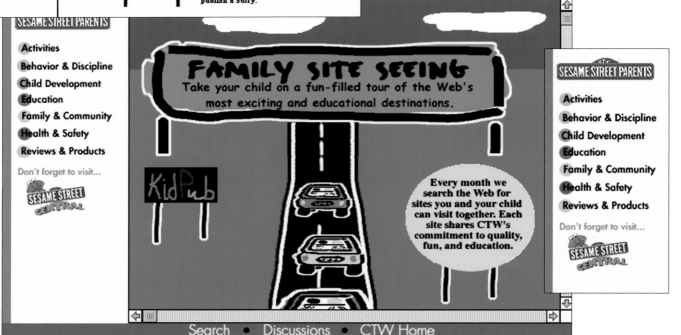

FAMILY SITE SEEING
Take your child on a fun-filled tour of the Web's most exciting and educational destinations.

KidPub

Every month we search the Web for sites you and your child can visit together. Each site shares CTW's commitment to quality, fun, and education.

SESAME STREET PARENTS
- Activities
- Behavior & Discipline
- Child Development
- Education
- Family & Community
- Health & Safety
- Reviews & Products

Don't forget to visit...

SESAME STREET CENTRAL

Search • Discussions • CTW Home

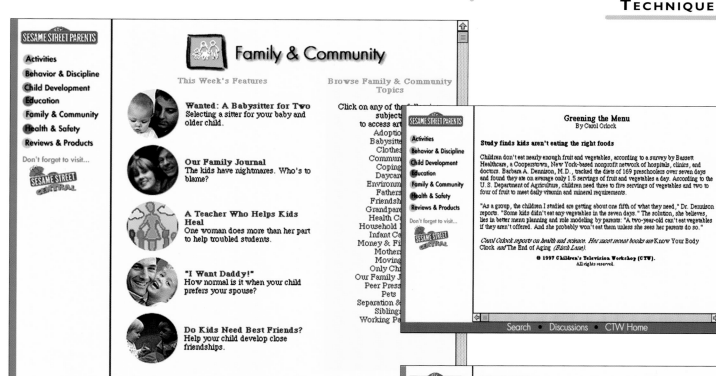

SESAME STREET PARENTS

- Activities
- Behavior & Discipline
- Child Development
- Education
- Family & Community
- Health & Safety
- Reviews & Products

Don't forget to visit...

SESAME STREET CENTRAL

Family & Community

This Week's Features

Wanted: A Babysitter for Two
Selecting a sitter for your baby and older child.

Our Family Journal
The kids have nightmares. Who's to blame?

A Teacher Who Helps Kids Heal
One woman does more than her part to help troubled students.

"I Want Daddy!"
How normal is it when your child prefers your spouse?

Do Kids Need Best Friends?
Help your child develop close friendships.

Browse Family & Community Topics

Click on any of the following subjects to access articles...

- Adoption
- Babysitters
- Clothes
- Community
- Coping
- Daycare
- Environment
- Fathers
- Friendship
- Grandparents
- Health Care
- Household
- Infant Care
- Money & Finance
- Mothers
- Moving
- Only Child
- Our Family Journal
- Peer Pressure
- Pets
- Separation & Divorce
- Siblings
- Working Parents

Search • Discussions • CTW Home

SESAME STREET PARENTS

- Activities
- Behavior & Discipline
- Child Development
- Education
- Family & Community
- Health & Safety
- Reviews & Products

Don't forget to visit...

SESAME STREET CENTRAL

Greening the Menu
By Carol Orlock

Study finds kids aren't eating the right foods

Children don't eat nearly enough fruit and vegetables, according to a survey by Bassett Healthcare, a Cooperstown, New York-based nonprofit network of hospitals, clinics, and doctors. Barbara A. Dennison, M.D., tracked the diets of 169 preschoolers over seven days and found they ate on average only 1.5 servings of fruit and vegetables a day. According to the U.S. Department of Agriculture, children need three to five servings of vegetables and two to four of fruit to meet daily vitamin and mineral requirements.

"As a group, the children I studied are getting about one fifth of what they need," Dr. Dennison reports. "Some kids didn't eat any vegetables in the seven days." The solution, she believes, lies in better menu planning and role modeling by parents: "A two-year-old can't eat vegetables if they aren't offered. And she probably won't eat them unless she sees her parents do so."

Carol Orlock reports on health and science. Her most recent books are Know Your Body Clock *and* The End of Aging *(Birch Lane).*

Search • Discussions • CTW Home

SESAME STREET PARENTS

- Activities
- Behavior & Discipline
- Child Development
- Education
- Family & Community
- Health & Safety
- Reviews & Products

Don't forget to visit...

SESAME STREET CENTRAL

Dr. Max Kahn

Health Expert Q & A

Q: "My four-year-old daughter is lactose-intolerant. Does this mean she should never consume milk and other dairy foods? If so, how can I make sure she still gets enough calcium?"--Mary Miner, Old Lyme, CT

A: Lactose intolerance, the inability to digest milk sugar, is highly variable in its severity. Your daughter may experience the symptoms-- bloating, excess gas, nausea, cramps or diarrhea--only after ingesting large amounts of milk sugar, or she may be uncomfortable after very small quantities.

She is most likely to have trouble with liquid milk, but any food with milk-derived ingredients will contain at least trace amounts of lactose. The most sensitive individuals may not be able to tolerate even these small amounts, but many people affected can eat modest servings of cheese or yogurt without difficulty. Start by feeding her small amounts of food or milk and see how she reacts. Symptoms usually appear within an hour or two after eating.

For children who really must avoid milk, there are excellent substitutes, particularly soy-based "milk," that are fortified with calcium and Vitamin D. Calcium-added orange juice is another alternative. Some vegetables, like kale, broccoli, brussels sprouts, and collard greens, have relatively high levels of calcium, but it's usually impractical to rely on them alone for a child's high calcium requirements. Calcium supplements are available; try the chewable antacid tablets

Search • Discussions • CTW Home

INFORMATION: Reclassifying the information that comes from *Sesame Street Parents* magazine and other areas of CTW required a new structure for the content. Creating a structure that could incorporate the magazine as well as original features was a challenge for the design team. "I think just narrowing down the seven major categories was a challenge," Karen Kane says. "You could debate what to name the seven categories until the end of time. The concept sounds simple, but trying to define those categories in such a way that not only we like, but that hopefully the users will also intuitively grasp, is something we spent a fair amount of time on."

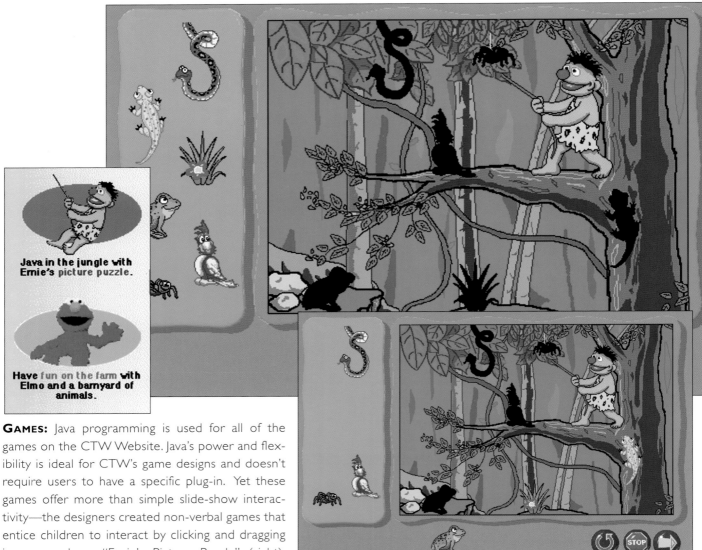

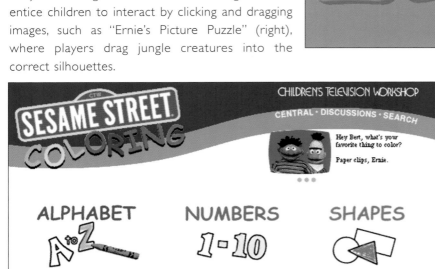

Java in the jungle with Ernie's picture puzzle.

Have fun on the farm with Elmo and a barnyard of animals.

GAMES: Java programming is used for all of the games on the CTW Website. Java's power and flexibility is ideal for CTW's game designs and doesn't require users to have a specific plug-in. Yet these games offer more than simple slide-show interactivity—the designers created non-verbal games that entice children to interact by clicking and dragging images, such as "Ernie's Picture Puzzle" (right), where players drag jungle creatures into the correct silhouettes.

SESAME STREET
COLORING

CHILDREN'S TELEVISION WORKSHOP
CENTRAL · DISCUSSIONS · SEARCH

Hey Bert, what's your favorite thing to color?

Paper clips, Ernie.

ALPHABET
A to Z

NUMBERS
1-10

SHAPES

Check out the Big Bag coloring pages for even more coloring fun!

CTW Home | Sesame Street Central | Sesame Street Parents | Big Bag | Guide | Search | Comments

Copyright © 1997. Children's Television Workshop

INTRODUCTION: An animated intro screen (such as the dancing red Elmo character, below) entertains young viewers as they enter the Java gaming areas. The familiar characters reinforce the Sesame Street identity.

GOALS: CTW's corporate mission is to educate and delight kids and their families. Currently the company is repurposing information from other sources, but its goal is to make the online identity a separate business. "We have the challenge of creating an online business," says Roger Widicus, CTW producer. "To that end, we really want to develop as many interactive online educational games as we can, and we're starting with pre-school content because we have more expertise and a stronger brand there. Ours is not a promotional site; it's intended to be a program/information site—a site unto itself that has its own reason for being."

 Education

This Week's Features

Parents' Preschool Jitters
10 common concerns--and good reasons not to worry about them.

Baby Talk
How your older child helps teach the baby to speak.

A Place for Amber
What happens when children with disabilities attend regular classes? For young Amber Miller, it has been an educational miracle. Part One of a two-part series.

Browse Education Topics

Click on any of the following subjects to access articles:
Giftedness
Inclusion
Learning Disabilities
Preschool
Reading
The Internet
Thinking

© 1997 Children's Television Workshop (CTW).
All rights reserved.

what is big bag?

coloring pages

the actors

kids activities

the creators

the shorties

the cast

show info

Big Bag airs exclusively on
CARTOON

DISTRIBUTION: One of the big changes that CTW is reviewing for future distribution of content is push technology. This technology allows viewers to sign on and download a package of pertinent, pre-requested content (such as the "Big Bag" area, left), rather than downloading one page at a time. Another form of the technology will allow CTW to update applications on subscriber's computers, sending only the updated material and letting users view content offline.

Health & Safety

SESAME STREET PARENTS

- Activities
- Behavior & Discipline
- Child Development
- Education
- Family & Community
- Health & Safety
- Reviews & Products

Don't forget to visit...

SESAME STREET CENTRAL

This Week's Features

Getting There Safely
Car and air travel can be hazardous to kids. Here's what you must know.

Better Pumping
A new idea may revolutionize breast pumping.

Halogen Hazard
Halogen lamps pose a serious fire hazard.

Expert Q & As

Browse Health & Safety Topics

Click on any of the following subjects to access articles:
Child Abuse
Dental
Diseases & Conditions
Expert Advice
Home Treatment
Nutrition
Pregnancy
Prevention
Safety
Safety Resources
Self-defense
Violence

Post It!
Parenting can be hectic so we've compiled these time-saving charts, lists, and forms to help you get organized. Choose from:

Search • Discussions • CTW Home

Primo Angeli Inc. has translated print materials it has designed—such as books, brochures, and packaging—into an elegant and dynamic portfolio Website. ▪ Primo Angeli Inc.'s thirty years of branding and design experience have made it one of the top marketing and communications firms in the industry. The 1996 Atlanta Olympics, Nestlé, Ben & Jerry's, and Guinness are just four names from a long list of premier print clients. ▪ In the past few years the design firm has, like many other large communications firms, focused a portion of its attention on the World Wide Web and how it can help clients explore the potential of the Web for branding and marketing. Web-based clients include Quantum, GlobalCenter, and StringFairy, to name a few. ▪ One of the company's most successful sites, and one it's happiest with, is its own self-promotional Website. The clean, clear, and easily navigable site has garnered many awards and peer recognition in the design industry.

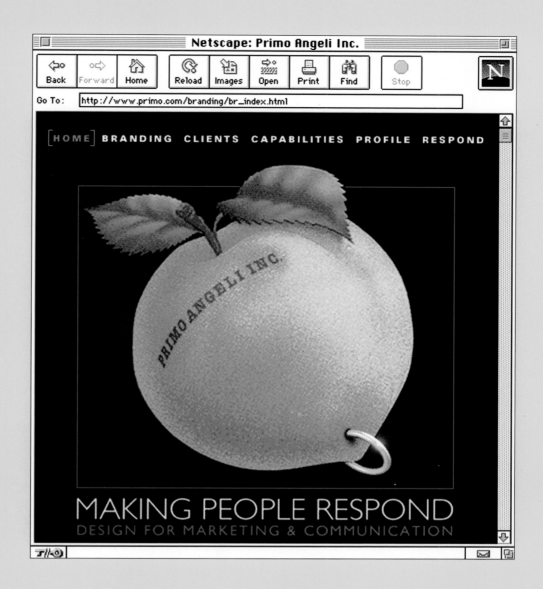

DESIGN: Primo Angeli Inc.

CREATIVE DIRECTOR: Carlo Pagoda

DESIGNERS: Primo Angeli, Ryan Medeiros,

Sara Sandström Shields, Brody Hartman

PRODUCER: Ryan Medeiros

COPY: Jean Galeazzi

PROGRAMMER: Ryan Medeiros

TOOLBOX

HARDWARE: Macintosh

SOFTWARE: Photoshop, DeBabelizer, GifBuilder

TYPEFACES: Univers Family

SPECIAL FEATURES: GIF89a animation

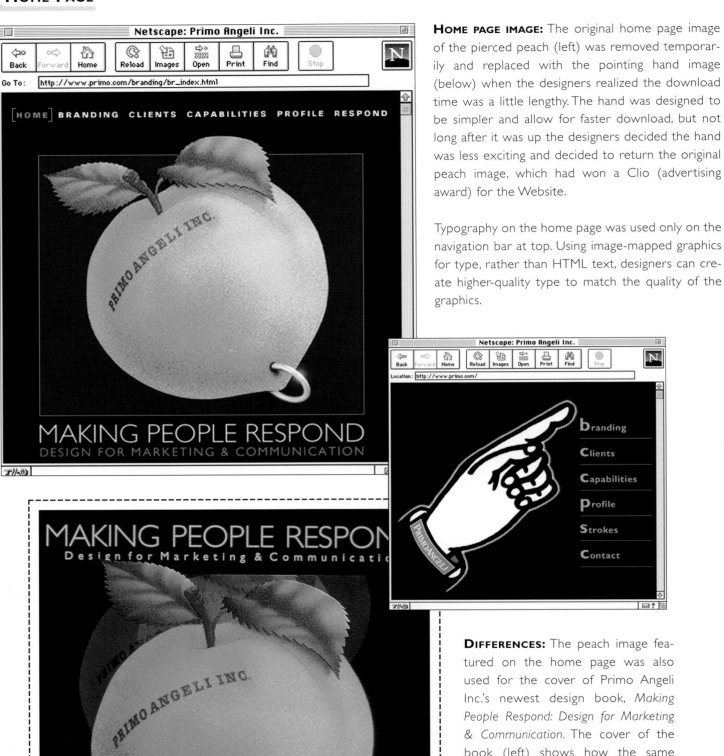

HOME PAGE IMAGE: The original home page image of the pierced peach (left) was removed temporarily and replaced with the pointing hand image (below) when the designers realized the download time was a little lengthy. The hand was designed to be simpler and allow for faster download, but not long after it was up the designers decided the hand was less exciting and decided to return the original peach image, which had won a Clio (advertising award) for the Website.

Typography on the home page was used only on the navigation bar at top. Using image-mapped graphics for type, rather than HTML text, designers can create higher-quality type to match the quality of the graphics.

DIFFERENCES: The peach image featured on the home page was also used for the cover of Primo Angeli Inc.'s newest design book, *Making People Respond: Design for Marketing & Communication*. The cover of the book (left) shows how the same image was used for both the cover and the Website.

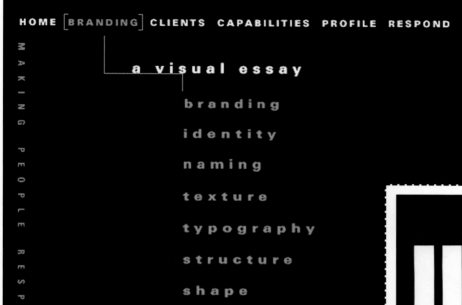

HOME [BRANDING] CLIENTS CAPABILITIES PROFILE RESPOND

M A K I N G P E O P L E R E S P O N D

a visual essay

branding

identity

naming

texture

typography

structure

shape

color

CHOOSING **A** **TYPEFACE**: The designers used Univers Bold Condensed for headlines, navigation bars, and text throughout the site. Univers was chosen for its clean and easy readability when used at smaller sizes on the Web, and the designers also wanted a font that wouldn't compete with the printed packaging and portfolio images.

PRIMOANGELI

UPDATE 1995

Since the publication of our book, *Designs for Marketing*, we've been busy and we're pleased to give you a preview of recent projects to be featured in our forthcoming book, *Making People Respond*.

HTML **TEXT**: One of the biggest problems with text on the Web is getting viewers to read it. Viewing text on a monitor is hard on the eyes and too much text can sometimes be daunting to time-conscious visitors. Primo Angeli, chairman of Primo Angeli Inc. and lead designer, says, "We decided not to play too much with typographic variety, but to let the images speak a bit stronger." To this end, smaller text blocks (below right) and short captions were used throughout the site.

HOME [BRANDING] CLIENTS CAPABILITIES PROFILE RESPOND

M A K I N G P E O P L E R E S P O N D

Mismatch.

BRANDING CLIENTS [CAPABILITIES] PROFILE RESPOND

new media design)

The same marketing design and communication principles that apply to packaging and branding apply to the new electronic media, including the Internet, proprietary on-line services, CD-ROMs, laptop PC presentations, and interactive kiosks. Through graphics, brand design and brand identity, these media should communicate a memorable message with the same directness and immediacy of a package on the supermarket shelf.

LIMITATIONS: Primo Angeli Inc.'s philosophy is "The assignment dictates the style." The sequence of the print brochure shown below and on the following pages was designed to show a large sampling of the firm's packaging design and branding work. The firm's Website was created with the same idea in mind, but with a slightly different angle since the designers were working within new limitations. The firm wanted to project a general show of versatility so potential clients would see them as a creative design group rather than a firm with only one specific style.

The brochure below shows few constraints in color and layout, while the "about branding" area (above and top right) shows the limitations of the Web, which dictate the use of smaller images, repeated art for faster downloading, and short cutlines to emphasize specific concepts and ideas.

HOME [BRANDING] CLIENTS CAPABILITIES PROFILE RESPOND

MAKING PEOPLE RESPOND

A BRAND IS A BADGE OF HONOR.

about branding

HOME [BRANDING] CLIENTS CAPABILITIES PROFILE RESPOND

MAKING PEOPLE

The Brand

... is the company's face to the world; its expression - and any facelifts over time - must be crafted with extreme care to communicate the right message to new and loyal consumers about company standards, style, philosophy, and attitude. With the wrong touch, a powerful brand is transformed into a fleeting curiosity, and credibility is destroyed. ∎

• branding index

HOME BRANDING [CLIENTS] CAPABILITIES PROFILE RESPOND

MAKING PEOPLE RESPOND

portfolio
a sampling

olympics
quantum
crystal geyser
globalcenter
pete's wicked ale
quaker oats
henry weinhard's rootbeer
nestlé
henry weinhard's beer
zima
harden & huyse
mariani

COLOR: Primo Angeli chose a color scheme of black, white, and orange to allow for faster downloading and easier optimization. Like many design firms currently producing Websites, the designers at Primo Angeli chose to optimize the site for 16-bit color rather than 8-bit so its images would look as close to the original as possible.

HOME [BRANDING] CLIENTS CAPABILITIES PROFILE RESPOND

MAKING PEOPLE RESPOND

TASTE A PEEL?

ANIMATION: Ryan Medeiros, one of the lead designers and programmers of the Primo site, is aware of the bells and whistles available to designers. He decided to include only GIF89a animations in the current version of the Website in order to make downloads as fast as possible. The "Case Study" area features animations on each main page and several larger animations on subsequent pages, such as the "Olympic diver" on the Atlanta Olympics case study (above).

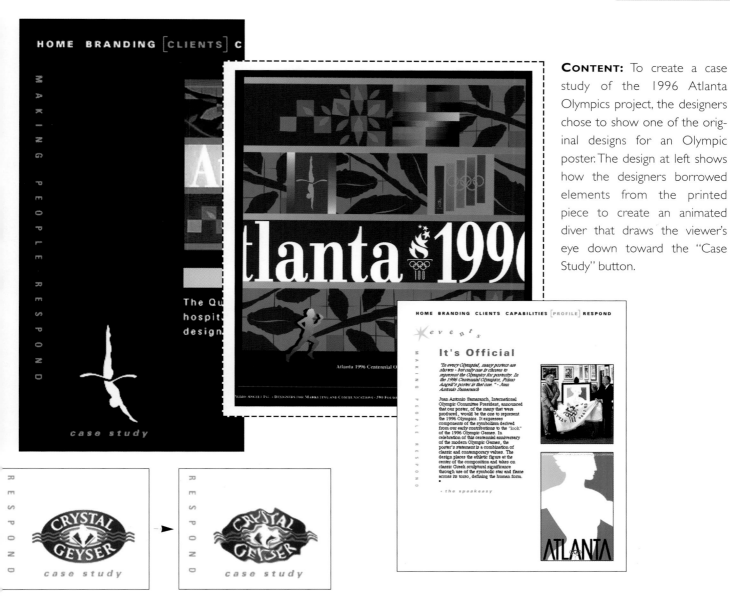

CONTENT: To create a case study of the 1996 Atlanta Olympics project, the designers chose to show one of the original designs for an Olympic poster. The design at left shows how the designers borrowed elements from the printed piece to create an animated diver that draws the viewer's eye down toward the "Case Study" button.

THE PROCESS

DESIGN: Primo Angeli notes the differences between designing for the Web and designing for print: "If you're doing a book, everybody has the same book, but with the Web you have different receptacles. You have different computers that have different capacities, so you have to design in a general way. You have to make a decision about whether you are going to design for just a few of those 16-bit people or for the 8-bit. It's harder to read type and there is much use of abbreviation. Designers creating for the Web have to work out creative compromises."

TOOLS: The designers used Illustrator, Photoshop, and DeBabelizer for image creation and optimization. In the case of pages such as the "In Some Circles..." branding area (right), the designers also utilized GifBuilder on the Macintosh for creating the animations.

Inside PAI

Client List

A&W International
Aleph Ltd. (Japan)
Ampex
AT&T Communications
Atlanta Committee for the Olympic Games
Banana Republic
Bank of America
Bernex Hind Pharmaceuticals
Beatrice/Hunt-Wesson
BellSouth Telecommunications
Boehringer Mannheim
Bond Brewing (Australia)
Borden
Bondin French Bread
Brown & Haley
California Milk Advisory Board
California Mineral Water Co.
Capri Sun
Cerveceria Hondureña, S.A. (Honduras)
Chevron Chemical
Citibank
Claris
Clorox
Coca-Cola USA
Coca-Cola Interamerican Corporation (Costa Rica)
Coca-Cola Foundation
Comsat
Coty
Crystal Geyser
Del Monte
DHL Worldwide Express
Disney Development
Dominion Breweries (New Zealand)
Drackett
Dreyer's Grand Ice Cream
Dunkin' Donuts
Eastman Kodak
Eddie Bauer Stores

THE RIGHT NAME. THE RIGHT RESPONSE.

about naming

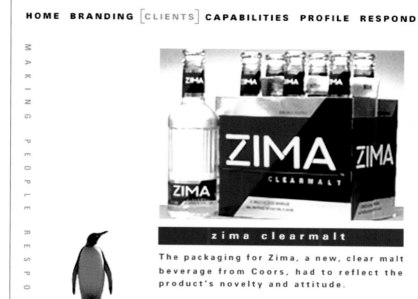

zima clearmalt

The packaging for Zima, a new, clear malt beverage from Coors, had to reflect the product's novelty and attitude.

case study

THE RIGHT NAME. THE RIGHT RESPONSE.

about naming

DESIGN: The Zima case study is an example of how the Web allows designers to create more dynamic layouts than are allowed by a flat printed brochure (right). In this case an animated penguin (doing a double-take at the packaging) keeps the viewer's attention.

The Publishers Depot case study illustrates the ability of Web technology to automate traditional print-based workflow. The process of acquiring stock photography, which every designer inevitably does, is typically a time-consuming activity that involves handling large amounts of original photography, many phone calls, courier delivery, and risk of losing the images. Publishers Depot removes the risk and streamlines the process of acquiring images by allowing users to search a huge database of images and get results in a matter of seconds. ▪ "We say that we've got three parts to what we do: we help people find what they want, we help people share it, and we help them to purchase it," says Publishers Depot Executive Vice President Jeff Weiss. ▪ To accompany the Website, Publishers Depot produces beautifully designed print catalogs. Each catalog showcases lists of stock photo houses presented on the Website, the navigation and search features of the site, and examples of how designers are using images they've acquired.

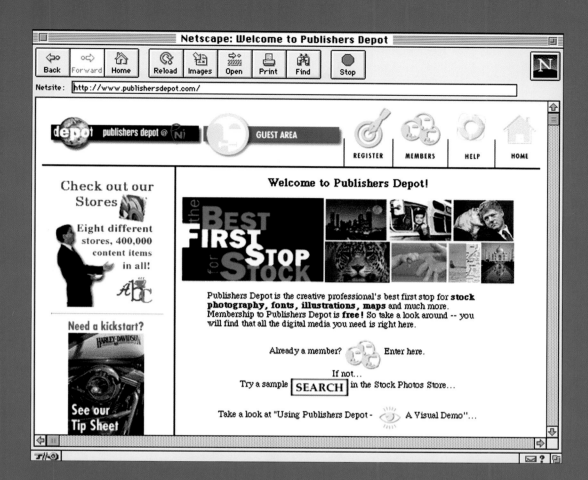

Design Firm: Publishers Depot in-house

Print Design Firm: JDG Design

TOOLBOX

Hardware: Macintosh, UNIX system

Software: Photoshop, HTML editors

Special Features: GIF89a animation, JavaScript

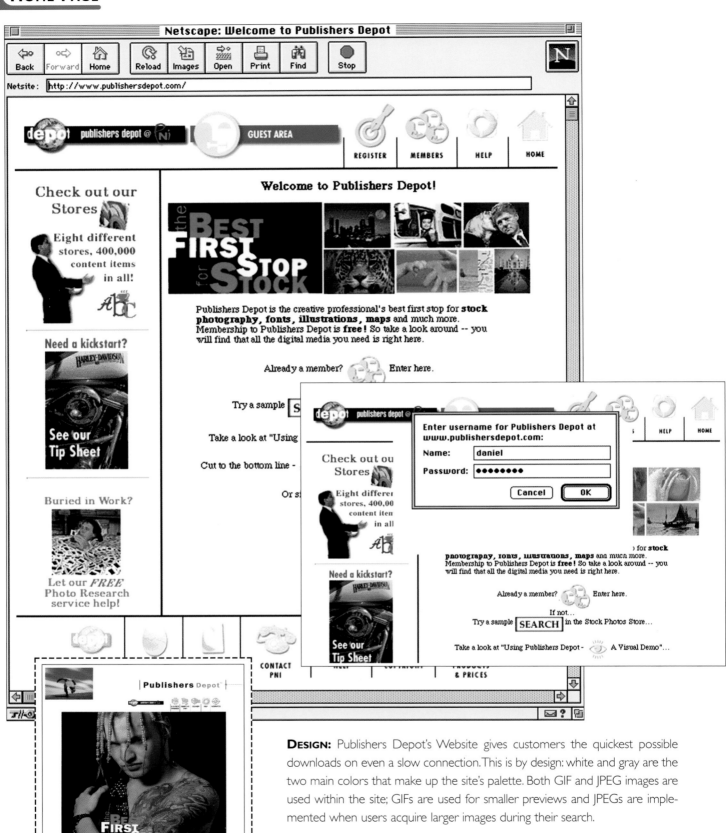

DESIGN: Publishers Depot's Website gives customers the quickest possible downloads on even a slow connection. This is by design: white and gray are the two main colors that make up the site's palette. Both GIF and JPEG images are used within the site; GIFs are used for smaller previews and JPEGs are implemented when users acquire larger images during their search.

To further accommodate users, navigation bars are situated at the top and bottom of each page, and header icons to the right of the Publisher's Depot header bar let users keep track of where they are within the site.

Using Publishers Depot-- A Visual Demo

[Page 1 of 9] ▶

Using the example of finding an image for a fictitious Web advertisement, this visual demonstration illustrates the easy steps it takes to license content from Publishers Depot.

Started - Where to "Shop"

...s area, Publishers Depot is conveniently divided into content stores. To find content you must first decide where to ...demonstration, bubble bath maker Celestial Mist needs an image suitable for a Web advertisement promoting its ...e product. They want a photograph, so from the **Navigator page** they choose to search in the Stock Photos conter

Step 1:
...k on the
...k Photos
...tore.

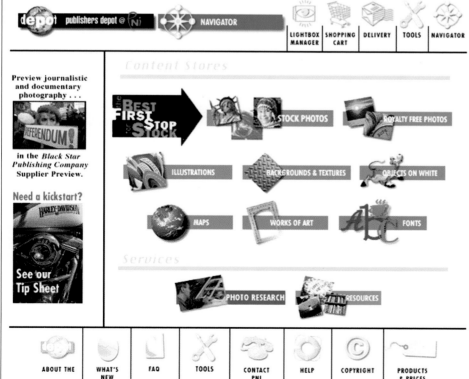

DESIGN: To make navigating the site a user-friendly experience, Publishers Depot has included a "Visual Demo" area that takes users through the site step-by-step and explains how each area is used (above). The audience for the site has changed somewhat since the new media of Web and CD-ROM publishing gained a foothold in the design field, but the largest majority of designers accessing the Website are still print designers in need of high-quality stock photographs.

SEARCHING: Publishers Depot incorporates patented proprietary software for searching and retrieving images. The company created its own software because no other applications on the market would allow customers to search using natural language and match the productivity of the company's own search engine. A keyword search for "mountains" works well; however, a natural language search for "quiet mountains by the water" is even more interesting and useful (below).

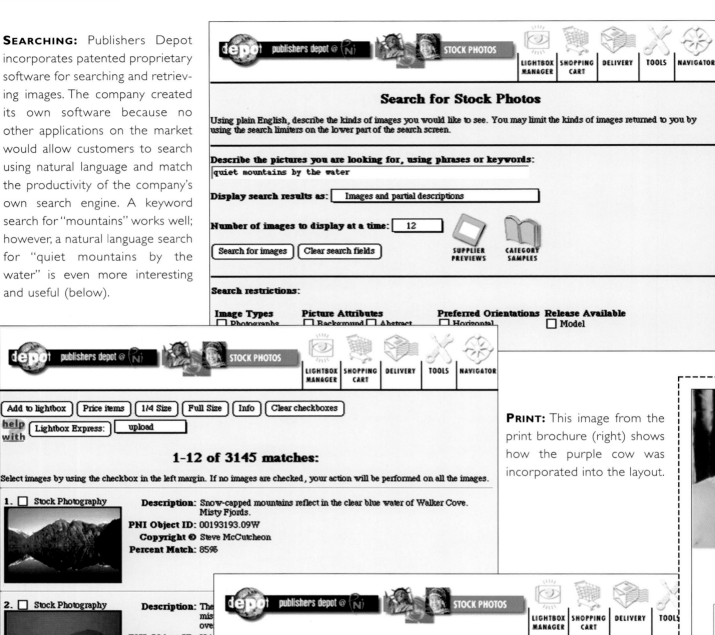

PRINT: This image from the print brochure (right) shows how the purple cow was incorporated into the layout.

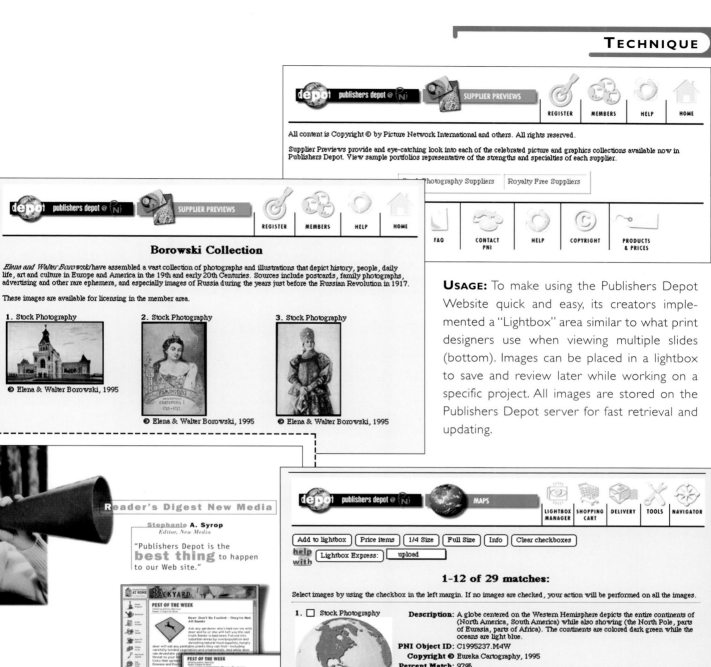

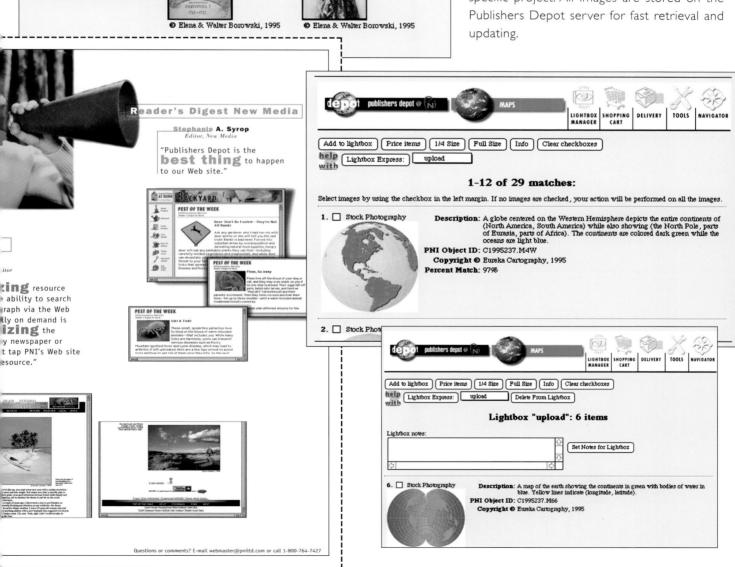

USAGE: To make using the Publishers Depot Website quick and easy, its creators implemented a "Lightbox" area similar to what print designers use when viewing multiple slides (bottom). Images can be placed in a lightbox to save and review later while working on a specific project. All images are stored on the Publishers Depot server for fast retrieval and updating.

CHALLENGES: The number of images that are placed on the site in any given month can range from 1,000 to more than 20,000. When the site was first designed there were many challenges in figuring out how to make such a large database of images easily accessible. "We had to figure out how to manage large objects, and we had to think about how to manage the search and retrieval of over half a million or more pictures, and have it be fast," says Jeff Weiss. "We also had to get pictures from our database onto the customer's desktop quickly as thumbnails, quarter images, and full-screen images. These problems were very significant, because if the Depot didn't work faster or better than the traditional environment, the customer would not use it. We had to exceed our customer's expectations."

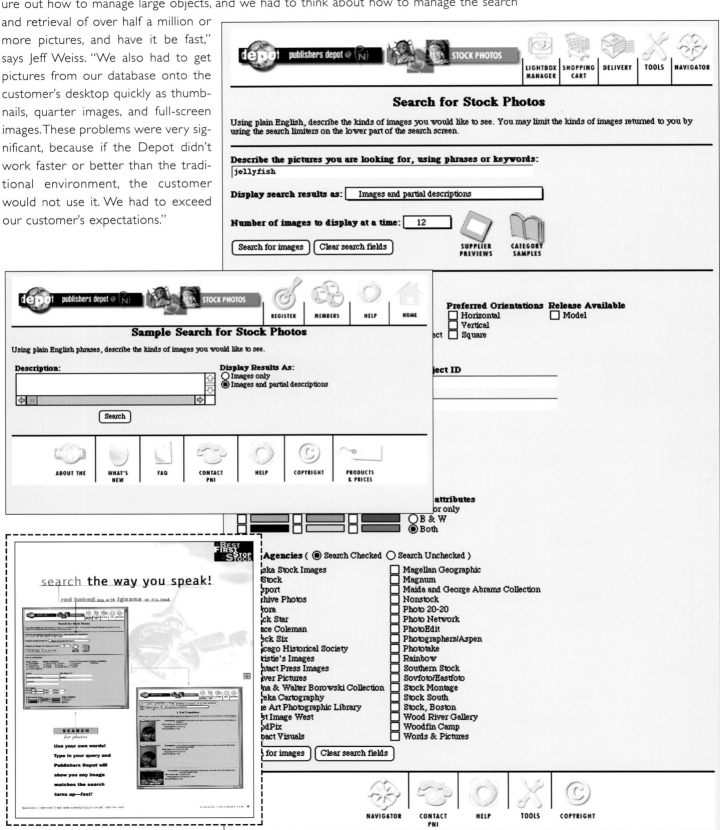

IMAGES: The majority of the Publishers Depot images come from traditional stock photography houses. Half of the current brochure (below) is filled with names and descriptions of the houses that supply the Website with images (right). These houses act as qualifiers for the designers who use the Website. Featuring the names of stock houses that designers may already be aware of sets a professional standard for Publishers Depot and displays the high-quality content on the site.

Content Stores

The Stock Photography Store.
The Stock Photos Store, representing 38 leading stock agencies, provides high quality stock images to anyone placing images into electronic products or print documents. Visit the Stock Photos store to find top-quality content with easy, time-saving licensing and delivery options. Give the Stock Photos Search engine a try.

The Royalty-Free Photos Store.
The Royalty Free Photos Store is provides economical, hassle-free royalty free licensing of a wide variety of images. Visit the Royalty-Free store for simple and affordable options that are popular with many designers and artists. At this time over 12,000 royalty-free images are available in Publishers Depot.

The Works of Art Store.
The Works of Art Store represents a Publishers Depot collection of fine art paintings, drawings and other *objets d'art*. Visit the Works of Art Store when looking for a distinctive creative design-- whether a classical painting or modern abstract work. Works of Art are available in both stock and royalty-free license types.

The Illustrations Store.
The Illustrations Store represents a Publishers Depot collection of original illustrations, line drawings and non-representational graphics. Illustrations are available in both stock and royalty-free license types, offering a broad range of pricing and usage options.

The Objects on White Store.
The Objects on White Store represents a Publishers Depot image collection of people and objects rendered on white backgrounds. There's no need to mask before use in combination with other visuals. Visit the Objects on White store for selections from both stock and royalty-free license types.

The Fonts Store.
The Fonts Store features a large collection of fonts, from traditional to unusual decorative fonts. Visit the Fonts Store for easy, fast access to all the fonts you'll need without any of the hassle.

The Resources Store.
The Resources Store is a valuable online reference source for publishers and other creative professionals. Visit the resources store for:
Portfolios- see samples of the work of top photographers, illustrators, graphic designers and agencies;
Directories, with over 11,000 searchable listings of creative services and professionals nationwide; and More!

HELP COPYRIGHT PRODUCTS & PRICES

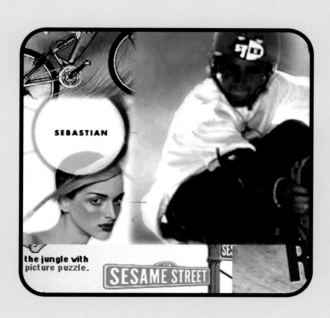

PRINT-TO-WEB XTRAS

MAGAZINES

CULTURAL

FORTEAN TIMES
http://www.forteantimes.com

MOTHER JONES
http://www.mojones.com

SPEAK
http://www.speakmag.com

COMPUTER

COMPUTER GRAPHICS WORLD
http://www.cgw.com

COREL
http://www.corelmag.com

HOTWIRED!
http://www.hotwired.com

INTER@CTIVE WEEK
http://www.zdnet.com/intweek

MACWORLD
http://www.macworld.com

MULTIMEDIA SCHOOLS
http://www.infotoday.com/
MMSchools

THE NET
http://www.thenet-usa.com

DESIGN

APPLIED ARTS
http://www.appliedarts.com

COMMUNICATION ARTS
http://www.commarts.com

HOW
http://www.howdesign.com

PRINT
http://www.printmag.com

PUBLISH
http://www.publish.com

PHOTOGRAPHY

BLIND SPOT
http://www.blindspot.com

PHOTO (French)
http://www.photo.fr

MISCELLANEOUS

NEXT GENERATION
http://www.next-generation.com

ROLLING STONE
http://www.rollingstone.com

BOOKS

CHRONICLE BOOKS
http://www.chronbooks.com

CREATING KILLER WEBSITES
http://www.killersites.com

LUMINARIA
http://www.luminaria.com

NEW RIDERS
http://www.mcp.com/newriders

SIMON & SCHUSTER
http://www.simonsays.com

CATALOGS

CHESAPEAKE
http://www.aztec.com/cchoice

EMIGRE
http://www.emigre.com

FINGERHUT
http://www.fingerhut.com

L.L. BEAN
http://www.llbean.com

LILLIAN VERNON
http://www.lillianvernon.com

NORTHWEST PASSAGES
http://www.northwestpassages.com

PATAGONIA
http://www.patagonia.com

UNITED COLORS OF BENETTON
http://www.benetton.com

IN-HOUSE PROMOS

360 PRODUCTIONS
http://www.view360.com

AGORA DESIGN
http://agora.comagora.com

AMMIRATI PURIS LINTAS
http://www.ammiratipurislintas.de/
index.html

AUTODESK—MULTIMEDIA
http://www.autodesk.com

BERGMAN-UNGAR ASSOCIATES
http://b2unit.kab.sdw.com/m

BRODYNEWMEDIA
http://www.brodynewmedia.com

CANARY STUDIOS
http://www.dnai.com/~canary/
index.html

CKS GROUP
http://www.cks.com

CLEMENT MOK DESIGNS/STUDIO
ARCHETYPE
http://www.cmdesigns.com

CLIFFORD SELBERT DESIGN
COLLABORATIVE
http://www.selbertdesign.com

COW
http://www.cow.com

DESGRIPPES GOBE & ASSOCIATES
http://www.dga.com

DIGITAL FACADES
http://www.dfacades.com

DREAMWORKS INTERACTIVE
http://www.dreamworksgames.com

EAGLE RIVER INTERACTIVE
http://www.eriver.com

FOCUS2
http://www.focus2.com

FOOTECONEBELDING
http://www.fcb-tg.com/fcb-tg/
fcbtg_homepage.html

FRANKFURT BALKIND
http://www.frankfurtbalkind.com/
index2.htm

GRAFFITI
http://WWW.gr8.com

PITTARD SULLIVAN
http://www.pittardsullivan.com

SUPON DESIGN
http://www.supondesign.com

ANNUAL REPORTS

3DO
http://www.3do.com/company/
ir/96annualreport

AMERITECH
http://www.ameritech.com/news/
ait_fin/annuals.html

ANNUAL REPORTS LIST
http://www.tanagraphics.com/
ti/ar_list

APPLE COMPUTER
http://www2.apple.com/
investor/96report

ARCO
http://www.arco.com/corporate/
numbers/ar96/%0D

AT&T
http://www.att.com/ir/
annualreports.html

BANK OF AMERICA
http://www.bankamerica.com/
batoday/annual_tos.html

BELL ATLANTIC
http://www.bellatl.com/invest/
fin_info/1996/index.htm

BRODERBUND SOFTWARE
http://www.broderbund.com/
company/investor/96annual.html

CAMPBELL SOUP
http://www.campbellsoup.com/
financialcenter/annualreport

DELTA AIRLINES
http://www.delta-air.com/
gateway/about/annrpt

IBM
http://www.ibm.com/
AnnualReport/1996

IMAGE DISTRIBUTION

INDEX STOCK
http://www.index.com

PHOTODISC
http://www.photodisc.com

TONY STONE IMAGES
http://www.tonystone.com

WEST STOCK
http://www.weststock.com

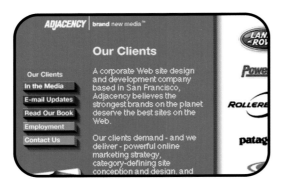

Adjacency: landrover.com, rollerblade.com
2020 17th Street
San Francisco, CA 94103
415.487.4520
http://www.adjacency.com

Cedro Group: trekbikes.com
3031 Tisch Way, Suite 100 Plaza East
San Jose, CA 95128
408.261.6222
http://www.cedro.com

Avalanche Systems: faoschwarz.com, cosmomag.com
304 Hudson St.
New York, NY 10013
212.675.7577
http://www.avsi.com

CO2 Media: mica.edu
3 N. Court Street, Suite 1
Frederick, MD 21701
301.682.6515
http://www.co2media.com

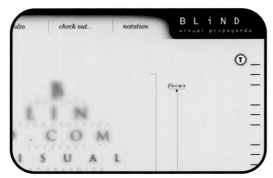

Blind Visual Propaganda: sebastian-intl.com
2020 N. Main St., Suite 235
Los Angeles, CA 90031
213.222.9509
http://www.blind.com

CTW Online: sesamestreet.com
1 Lincoln Plaza
New York, NY 10023
212.595.3456
http://www.ctw.org

Modem Media: jcpenney.com
228 Saugatuck
Westport, CT 06880
203.341.5200
http://www.modemmedia.com

Publishers Depot - publishersdepot.com
2000 14th St. North
Arlington, VA 22201
703.312.6210

Papermag: papermag.com
365 Broadway, 6th Floor
New York, NY 10013
212.226.4405
http://www.sociox.com

Rubin Postaer Interactive: honda.com
201Santa Monica Blvd.
Santa Monica, CA 90401
310.394.4000
http://www.rpinteractive.com

Primo Angeli Inc.: primo.com
590 Folsom St.
San Francisco, CA 94105
415.974.6100

VSA Partners Inc.: pathfinder.com/corp/ar/1996
542 S. Dearborn Street, Suite 202
Chicago, IL 60605
312.427.6413
http://www.vsapartners.com

RESOURCES

DESIGN RESOURCE
http://www.lynda.com
Web design tips and techniques by leading Web book author Lynda Weinman.

DESIGN RESOURCE
http://www.spctrum.com/cedge/resource.htm
Cutting-edge resources for Web designers.

DESIGN RESOURCE
http://www.photodisc.com
More than 32,000 royalty-free stock photos available from PhotoDisc. The site also features an easy-to-use search engine.

DESIGN SCHOOLS: U.S.
http://www.arts.ufl.edu/graphic_design/designschools.html
Schools in the United States with graphic design programs.

DESIGN SCHOOLS: WORLD
http://www.arts.ufl.edu/graphic_design/worldschools.html
Schools from around the world with graphic design programs.

DOWNLOAD: ANIMATED GIFS
http://www.wanderers2.com/rose/animate1.html?
Rose's Animtaed GIF Archive.

DOWNLOAD: BACKGROUND GIFS
http://eric.tcs.tulane.edu/images/backgrounds/index3.html
Excellent site containing hundreds of GIFS to use as Website backgrounds.

DOWNLOAD: DESIGN TOOLS
http://ccn.cs.dal.ca/~aa731/feathergif.html
Downloadable Macintosh Photoshop plug-in filter to create GIF images with blurry, transparent edges.

DOWNLOAD: DESIGN TOOLS
http://www.cooltool.com/maxanimation.html
Cool tools for creating Web pages and graphics.

DOWNLOAD: DESIGN TOOLS
http://www.alienskin.com/
Alien Skin Software tools and plaug-ins.

DOWNLOAD: DESIGN TOOLS
http://www.mindworkshop.com/alchemy/gifcon.html
Windows tools for creating GIFs or animated GIFs.

DOWNLOAD: DESIGN TOOLS
http://www.mit.edu:8001/tweb/map.html
Online graphic tool to make transparent GIFs.

DOWNLOAD: DESIGN TOOLS
http://www.netins.net/showcase/wolf359/plugcomm.htm
Web links to plug-ins and extensions for graphics designers.

DOWNLOAD: GIF ALPHABETS
http://www.dineros.se
Swedish font foundry featuring many unique GIF alphabets.

DOWNLOAD: JAVASCRIPT
http://www.essex1.com/people/timothy/js-index.htm
Archive of JavaScript examples.

DOWNLOAD: PLUG-INS
http://browserwatch.iworld.com/plug-in.html
One-stop shop for all the plug-ins on the net for Macintosh, UNIX, and Windows platforms.

DOWNLOAD: PLUG-INS
http://home.netscape.com/comprod/products/navigator/version_2.0/plugins
Netscape site for plug-ins.

DOWNLOAD: SHAREWARE
http://www.shareware.com
Large site featuring Mac and PC shareware and freeware.

DOWNLOAD: SOUNDS & MUSIC
http://www.geek-girl.com/audioclips.html
Downloadable sounds, music, and voices.

FREE HOME PAGE DIRECTORY
http://www.freehomepage.com/
A guide to setting up free home pages on the internet.

C/NET
http://www.cnet.com/
A computer network offering online information about current and future technologies and computer related information.

CREATING KILLER WEBSITES
http://www.killersites.com/
An online guide and companion to the *Creating Killer Websites* book.

HTML WRITERS GUILD
http://www.hwg.org
Organization for HTML programmers and designers.

JOB SEARCH
http://mactemps.com
Employment opportunities around the world.

LINKS: ICONS, BUTTONS, ETC.
http://eglobe.com/~melissa/links.html
Links to sites with good downloadable icons, buttons, and textures.

WEBSITE DESIGN AND PRODUCTION
http://www.geocities.com/SiliconValley/Heights/1288/index.html
Learn how to make your own web page with HTML, JavaScript, and graphics resources.

WEBTV
http://www.webtv.net/html/home.about.html
Information about WebTV, a service that provides access to the Web through television.

A

ACCESS TIME: Amount of time it takes a CD-ROM drive (or other storage device) to locate and retrieve information.

B

BANDWIDTH: Data transmission capacity, in bits, of a computer or cable system; the amount of information that can flow through a given point at any given time.

BANNER: A graphic image that announces the name or identity of a site (and often is spread across the width of the Web page) or is an advertising image.

BAUD RATE: Speed of a modem in bits per second.

BROWSER: A program that allows users to access information on the World Wide Web.

BUTTONS: Graphic images that, when clicked on or rolled over, trigger an action.

BYTE: A single unit of data (such as a letter or color) composed of 8 bits.

C

CACHE: A small, fast area of memory where parts of the information in main, slower memory or disk can be copied. Information more likely to be read or changed is placed in the cache, where it can be accessed more quickly.

CD-ROM (Compact Disc-Read Only Memory): An optical data storage medium that contains digital information and is read by a laser. "Read Only" refers to the fact that the disc cannot be re-recorded.

CGI (Common Gateway Interface): Enables a Website visitor to convey data to the host computer, either in forms, where the text is transferred, or as image maps, where mouse-click coordinates are transferred.

CMYK: Cyan, magenta, yellow, black (*kohl* in German), the basic colors used in four-color printing.

COLOR DEPTH: The amount of data used to specify a color on an RGB color screen. Color depth can be 24-bit (millions of colors), 16-bit (thousands of colors), 8-bit (256 colors), or 1-bit (black and white). The lower the number, the smaller the file size of the image and the more limited the color range.

COMPRESSION: Manipulating digital data to remove unnecessary or redundant information in order to store more data in less space.

D

DPI (Dots-per-inch): The number of halftone dots per inch or the number of exposing or analyzing elements being used. 72-dpi is the resolution of computer monitors.

F

FRAMES: Multiple independently controllable sections on a Web page.

G

GIF (Graphics Interchange Format): A file format for images developed by CompuServe. A universal format, it is readable by both Macintosh and PC machines.

GIF89A ANIMATION: GIF format that offers the ability to create an animated image that can be played after transmittal to a viewer.

H

HOME PAGE: The Web document displayed when viewers first access a site.

HTML (HyperText Markup Language): The coding language used to make hypertext documents for use on the WWW.

HYPERLINK: Clickable or otherwise active text or objects that transport the user to another screen or Web page.

HYPERTEXT: A method of displaying written information that allows a user to jump from topic to topic in a number of linear ways and thus easily follow or create cross-references between Web pages.

I

IMAGE MAP: A graphic image defined so that users can click on different areas of the image and link to different destinations.

INTERACTIVE: Refers to a system over which the user has some control, which responds and changes in accordance with the user's actions.

INTERFACE: Connection between two things so they can work together; method by which a user interacts with a computer.

INTERNET: A global computer network linked by telecommunications protocols. Originally a government network, it now comprises millions of commercial and private users.

INTERNET SERVICE PROVIDER (ISP): Company that enables users to access the Internet via local dial-up numbers.

J

JAVA: Programming language expressly designed for use in the distributed environment of the Internet.

JAVASCRIPT: An interpreted programming or scripting language from Netscape.

JPEG (Joint Photographic Experts Group): An image compression scheme that reduces the size of image files with slightly reduced image quality.

M

MEGABYTE (MB): Approximately 1 million bytes.

MODEM (modulator-demodulator): A device that allows computers to communicate with each other across telephone lines.

MPEG (Moving Pictures Experts Group): A video file compression standard for both Windows and Macintosh formats.

MULTIMEDIA: The fusion of audio, video, graphics, and text in an interactive system.

N

NON-LINEAR: Refers to stories, songs, or films, the sections of which can be viewed or heard in varying order, or which can have various endings depending on what has preceded.

P

PALETTE DETERIORATION: Refers to the degradation of colors in the system color palette when graphics are over-optimized for Web implementation.

PLUG-INS: Programs that can easily be installed and used as part of Web browsers.

R

REPURPOSE: To adapt content from one medium for use in another, i.e., revising printed material into a CD-ROM.

RESOLUTION: Measurement of image sharpness and clarity on a monitor.

RGB (Red, Green, Blue): Display format used with computers. All colors displayed on a computer monitor are made up of red, green, and blue pixels.

ROLLOVER: The act of rolling the cursor over a given element on the screen, resulting in the display of another element or the beginning of a new action.

S

SEARCH ENGINE: A program that allows a user to search databases by entering keywords.

SHOCKWAVE: Macromedia add-on that creates compressed Web animations from Director files.

SITE: A WWW location consisting of interlinked pages devoted to a specific topic.

SPLASH PAGE: An opening page used to present general information for the viewer, such as plug-ins or browser requirements.

STREAMING AUDIO: Sound that is played as it loads into the browser.

STREAMING VIDEO: Video that plays as it loads into a browser window.

T

T1 AND T3: High-speed digital channels often used to connect Internet Service Providers. A T1 runs at 1.544 megabits per second, a T3 line runs at 44.736 megabits per second.

THROUGHPUT: The rate of data transmission at a given point, related to bandwidth.

TRANSFER RATE: The rate at which a CD-ROM drive can transfer information.

TRANSPARENT GIF: A GIF image with a color that has been made to disappear into or blend into the background of a Web page.

U

URL (Universal Resource Locator): Standard method of identifying users or computers on the Internet. May be either alphanumeric or numeric.

V

VIDEO CONFERENCING: Using online video to connect with one or more people for communicating over long distances.

VIRTUAL REALITY: A simulation of the real world or an imaginary alternative presented on the computer.

VRML (VIRTUAL REALITY MARKUP LANGUAGE): The coding language used to create simulated 3D environments online.

W

WWW (World Wide Web): Graphical Internet interface capable of supporting graphics within text, sound, animation, and movies, as well as hypertext linking from page to page.

CREDITS

TIME WARNER CREDITS

© 1997 Time Warner Inc.
Design (Print and Online Versions): VSA Partners Inc., Chicago, IL
Printing: The Hennegan Company, Florence, KY

Cover Image:
Fred Flintstone: © and ™ Hanna-Barbera Prod., Inc.
Bugs Bunny: © and ™ Warner Bros.

Original Photography:
Executive portrait: James Salzano (p. 3)
Product/Studio Photography: Bart Witowski (pp. 4, 8, 17)

Page 5:
Batman Images
TV Animation: The Adventures of Batman & Robin: ™ and © 1997
DC Comics
Theme Parks: Six Flags: ™ and © 1997 Six Flags Theme Parks, Inc.,
and Batman: ™ and © 1997 DC Comics
Remaining images and products courtesy of Warner Bros.
Sports Illustrated Images
Images and products courtesy of Time Inc.
CNN Images
CNN International: Mark Hill, © 1997 CNN Inc.
Bernard Shaw: Andrew Eccles, © 1996 CNN Inc.
CNNfn: Lou Bopp
CNN Interactive screen: courtesy of CNN Interactive
CNN Airport: courtesy of CNN Airport Network
Headline News: courtesy of CNN Headline News
Looney Tunes Images
Theme Park: Six Flags: ™ and © 1997 Six Flags Theme Parks Inc., and
Looney Tunes: ™ and © 1997 Warner Bros.
Cable Networks: "Merrie Melodies," "Looney Tunes," "Bugs Bunny,"
are the exclusive property and trademarks of Warner Bros. Used by
permission.
© 1997 Cartoon Network Inc. A Time Warner Company. All rights
reserved.
Remaining images and products courtesy of Warner Bros.

Pages 6-7:
All images courtesy of Time Inc.

Pages 8-11:
All images courtesy of Warner Bros.

Pages 12-13:
Madonna: Herb Ritts
Jewel: Andrew Southam
Seal: Tom Howard
Tracy Chapman: Christine Alicino

Pages 14-15:
Gotti: Craig Blankenhorn/HBO
Oscar De La Hoya: Anthony Neste/HBO
The Larry Sanders Show: Darryl Estrine
If These Walls Could Talk: Matthew Rolston
Gloria Estefan: The Evolution Concert: Neal Preston/HBO

Pages 16-17:
CNN control room: Mark Hill, © 1997 CNN, Inc.
CNN Financial Network: courtesy of CNNfn
Pager: Mark Hill, © 1997 CNN, Inc.
Christiane Amanpour: courtesy of CNN

CNN/SI: Mark Hill, © 1997 CNN Inc.
Computer screen: courtesy of CNN Interactive
Headline News: Lynn Vaughn, courtesy of CNN Headline News

Pages 18-19:
Atlanta Braves: © 1996 Chris Hamilton Photography™. Used by per-
mission of MLBP Inc.
Scooby Doo: © and ™ Hanna-Barbera Prod. Inc.
Gone with the Wind: © 1939 Turner Entertainment Co.
Shine: Lisa Tomasetti © 1996 New Line Cinema Corp.
Atlanta Hawks: ™ Atlanta Hawks © 1997 NBAP
Andersonville: Doug Hyun © 1996 Turner Pictures Worldwide Inc.

Page 20:
Road Runner: ™ and © 1997 Warner Bros.